The Expressive Body in Life, Art, and Therapy

T0385284

of related interest

Authentic Movement
Essays by Mary Starks Whitehouse, Janet Adler
and Joan Chodorow
Edited by Patrizia Pallaro
ISBN 978 1 85302 653 9

Expressive Arts with Elders
A Resource, Second Edition
Edited by Naida Weisberg and Rosilyn Wilder
Forewords by Stanley Cath and George Sigel
ISBN 978 1 85302 819 9

Using Voice and Movement in Therapy
The Practical Application of Voice Movement Therapy
Paul Newham
ISBN 978 1 85302 592 1

Foundations of Expressive Arts Therapy
Theoretical and Clinical Perspectives
Edited by Stephen K. Levine and Ellen G. Levine
ISBN 978 1 85302 463 4

The Metaphoric Body
Guide to Expressive Therapy through Images
and Archetypes
Leah Bartal and Nira Ne'eman
ISBN 978 1 85302 152 7

The Expressive Body in Life, Art, and Therapy

Working with Movement, Metaphor, and Meaning

Daria Halprin

Foreword by Jack S. Weller

Jessica Kingsley Publishers
London and Philadelphia

First published in the United Kingdom in 2003
by Jessica Kingsley Publishers
116 Pentonville Road
London N1 9JB, UK
and
400 Market Street, Suite 400
Philadelphia, PA 19106, USA

www.jkp.com

Copyright © Daria Halprin 2003
Printed digitally since 2009

The right of Daria Halprin to be identified as author of this work has been asserted by her in
accordance with the Copyright, Designs and Patents Act 1988.

All rights reserved. No part of this publication may be reproduced in any material form
(including photocopying or storing it in any medium by electronic means and whether or not
transiently or incidentally to some other use of this publication) without the written
permission of the copyright owner except in accordance with the provisions of the Copyright,
Designs and Patents Act 1988 or under the terms of a licence issued by the Copyright
Licensing Agency Ltd, Saffron House, 6–10 Kirby Street, London EC1N 8TS. Applications
for the copyright owner's written permission to reproduce any part of this publication should
be addressed to the publisher.

Warning: The doing of an unauthorised act in relation to a copyright work may result in both
a civil claim for damages and criminal prosecution.

Library of Congress Cataloging in Publication Data
Halprin, Daria.
 The expressive body in life, art, and therapy : working with movement, metaphor and
meaning/Daria Halprin.
 p. cm
 Includes bibliographical references and index.
 ISBN 1-84310-737-6
 1.Arts--Therapeutic use. I. Title.
 RC489.A72 H355 2003
 616.89'165--dc21

 2002023995

British Library Cataloguing in Publication Data
A CIP catalogue record for this book is available from the British Library

ISBN 978 1 84310 737 8

Contents

To my husband, Khosrow Khalighi,
and my children, Ruthanna and Jahan,
who have transformed my life
with their abiding presence and love

Acknowledgments

I have many to thank for making this book, and my work, possible. My parents, Anna and Lawrence Halprin, have passed the spirit of their creativity and their work on to me.

I want to extend my deepest appreciation to the students of the Tamalpa Institute for the inspiration of their learning and their commitment to this work, as well as to thank the clients who have trusted me as a guide in their struggles and unfoldings. Some of these students and clients have generously agreed to let me include photographs of their artwork and dances in the book, namely Michael, Kate Romang Beechen, Kurt Beechen, Dianne Carriere, Petra Eischeid, Danielle Genevieve, Sandy Glajchen, Rose Lorie, Cameron Kincaid, Martin Kirch, Roberta Mohler, David Nelson, Jaime Nisenbaum, Katrina Obenheimer, Camillo Schumacher, Nathan Schuman, Katrina Stetler, and Petronella Voorberg.

Colleagues at the Tamalpa Institute – Ken Otter, Jamie McHugh, and Soto Hoffman – and at the European Graduate School – Paolo Knill, Stephen and Ellen Levine, Margo Fuchs, and Majken Jacoby – have provided a totally enriching source of collaboration, experimentation, discourse, and play. I have been able to depend on Jaime Nisenbaum for many years of dialogue on the work; he has helped me manage the Tamalpa Institute and given me constant encouragement and support in bringing this project to fruition.

I could not have written this book without the invaluable editorial feedback I received from friends, family, and colleagues – Erica Apollo, Chris and Lou Armstrong-D'Jangles, Rana Halprin, Ruthanna Hopper Khalighi, Jahan Khalighi (who also sketched out all of the graphs for me), Khosrow Khalighi, Rachel Kaplan, Jaime Nisenbaum, and Elisabeth Osgood. My editor, Nancy Grimley Carleton, held the big picture as well as attending to every small detail. In addition to his editorial remarks, my husband, Khosrow Khalighi, patiently held my hand and made me laugh throughout.

My spiritual teacher, Oscar Ichazo, founder of the Arica School of Knowledge, has imparted precious teaching and inspiration for over twenty-five years. My gratitude to him for his remarkable work cannot be expressed in words.

Foreword

I have known Daria Halprin for many years and have watched with appreciation as her pioneering work at Tamalpa Institute and other institutions in Europe and the United States, including our program at the California Institute of Integral Studies (CIIS), has grown and matured. We are both working in the field of expressive arts therapy, traveling on bridges between life and art in close proximity here in the San Francisco Bay Area. But in reading this book I realize that something new is happening. This book is not only about Daria Halprin's particular approach, it is also a testimony to the fact that the field of expressive arts therapy is coming of age.

One of the key defining characteristics of expressive arts therapy is the integration of multimodal arts processes with psychotherapy. As each practitioner draws from the palette of all of the arts – visual arts, music, drama, dance-movement, poetry and literary arts – there are naturally many different emphases on different arts modalities, different ways of combining them, different orientations to psychology and psychotherapy, and various personal styles of working. In the past twenty-five years this has led to a number of developed, equally valid *approaches.* Daria Halprin defines her work in this context. In this book she presents a rich, in-depth study of her approach to movement-based expressive arts therapy.

A constructive criticism of this type of therapy as an emerging field is that there is a lack of theory, of a developed historical and theoretical base of operations. This claim cannot be made about the approach presented here. The first third of the book is a provocative and thorough study of the antecedents, context, history, and theory of this movement-centered approach. From the shamanic ancient roots to psychology, somatic psychology, the arts, dance, social-historical movements, creativity theory, psychotherapy, new paradigms in science – all are explored as the historical, theoretical and methodological foundations of this approach. While

some of this history and theory is specific to dance/movement-centered approaches, most is applicable to the whole field, and in fact it covers a large part of the historical and theoretical foundations of all of expressive arts therapy. To my knowledge, this is the first time that so much of this material has been so clearly articulated, and this alone is a significant contribution to the field.

The heart of the book is an in-depth description of methods, practices and examples of this approach. The material is strong and clear, and is supported by what feels to me to be like girders of a building. There are models, maps, and frameworks, as well as guiding principles, systems, ethics, methods, and metaphors. These create a supportive infrastructure that has clearly been tested, developed, and refined over a long period of time. This is a mature, well-seasoned approach; it has both great depth and breadth, we can feel the deep roots and the years of experience with embodied, movement-based work.

It needs to be stressed that this is an *embodied* work. At times, as I was sitting reading, I felt physical and imaginal stirrings in my body, as though I was actually moving through the exercises described. Sometimes I would stand up and begin to move. In this approach the moving body is the center of healing and growth, and it is a metaphoric body which speaks to all aspects of our lives. This is of great importance in our increasingly disembodied society. The moving, metaphoric body is also the link to art, poetry, story, and painting, for this is an *arts-based* approach.

At the beginning of the book we find this approach grounded in a very personal life, for Daria Halprin courageously shares her own history and story. Reading about the ground of her approach in her personal life results in our having a more acute, personal sensitivity to all that follows. As we learn of her journey on the bridge between life and art, we also become more attuned to the life/art bridge that all of the expressive arts invite us to cross.

This book marks, I believe, the period of the coming of age of expressive arts therapy in relation to our global society. It makes a significant contribution to practitioners, students, and teachers in this field, and it also makes a broader contribution to what is referred to as "living artfully in a fragmented world." Anyone walking the path of growth and transfor-

mation will benefit from this embodied, arts-based approach. For me, and I hope for all of us, the arrival of this book is cause for celebration!

Jack S. Weller
Expressive Arts Therapy Program Director
California Institute of Integral Studies
San Francisco, California

Preface

My introduction to this work began in my childhood, as a student of my mother, the dancer Anna Halprin. During the 1950s, at her school, the San Francisco Dancers' Workshop, Anna turned her focus as a dancer to the everyday life themes and struggles she found most compelling. She used the most personal material of those she was working with as the basis for movement, dance, performance, and community rituals. In 1978 Anna and I co-founded the Tamalpa Institute, where I developed a training program in movement-based expressive arts therapy upon which this book is based.

My early training took place within the context of an experimental artistic laboratory spanning the 1950s and 1960s. I grew up in a highly alternative context. By early adulthood, I felt a compelling need to create a framework to stabilize the powerful effects of my artistic background. Both personally and professionally, I wanted to strengthen and bridge the connection between art making and conscious living. I saw that in my own life, as well as in the lives of others, there was a gap between the extraordinary experiences we created in the studio and the lives we lived outside. From 1975 to 1990, my work focused on narrowing this gap.

My question was: How could movement, art, and performance, in addition to being artistically interesting and creatively stimulating, benefit people in ways which might be healing to the soul, to their relations with others, and to their psychological well-being? I was interested in discovering structures to help "ground" the creative experiences and insights generated through artistic exploration in the soil of our daily lives.

For some years, students had asked me to provide some form of documentation of the principles and thinking underlying my approach to expressive arts therapy. I believe that this request for documentation, coming at a time when the field of expressive arts therapy was at its educational and professional beginnings, was essentially a call for help. How do we tell people what we are experiencing and what we are doing in this

work? How can we possibly describe it? I made my first attempt in 1987 by creating a student manual, *Coming Alive*, which outlined what I had been teaching at Tamalpa Institute; this was made public two years later (Halprin 1989).

Over the last two decades, practitioners have been engaged in an ongoing search for ways to describe, in theory, word, and practice, the power and mystery of the arts in teaching us new ways of knowing and healing. In the 1980s, many of us struggled to find a way to transfer our learning into a descriptive language that adequately conveyed our experience with art as a transformative process. We were also concerned about how to convey the philosophies and theories underlying such work, in order to establish a new approach to therapy. As the field continues to evolve and define itself, people want a language to understand and explain how the arts offer new ways of facilitating change.

For years I resisted the call to write, in large part because I was still searching for that descriptive language myself. Now, many years later, my own understanding has grown and, with it, a new interest in attempting to put into words what cannot truly be captured except in the lived and living experience as the work happens. I intend for this book to serve those interested in using creativity and the arts for their personal growth and therapy as well as those who wish to incorporate expressive arts into settings where therapy, education, health care, or group and community facilitation take place.

I hope to give readers a simple theoretical foundation, to share my thinking and understanding, and to offer practical models in the application of this approach. I have also designed the book to be used by readers as a guide for exploring personal issues or for working with clients and students in private sessions, classes, and workshops. I hope it will encourage readers to pursue their own experiences in movement-based expressive arts therapy and education, as that is the only way to "take it off the page."

Although I suggest many steps you can take on your own, with others, or in a group setting, I want to make clear that the movement-based expressive arts are a wide, deep, and complex practice. The field is worthy of lifelong study. As with any field where the purpose is healing and change, and the quest is for embodied knowledge,

working under the guidance of teachers and therapists, and pursuing further opportunities for in-depth study, is essential.

In the text I have chosen to use the pronoun "she" to refer to a person of either sex. I do not in any way mean to exclude male readers.

May this work benefit you in living artfully and in bringing artful living into the world.

Daria Halprin
Tamalpa Institute
Kentfield, California

PART ONE

Introduction

Movement as Metaphor

The Buddha said, "The whole universe, oh monks, lies in this fathom-long body and mind."

Ayya Khema (1991, p.54)

The foundation of this approach to movement-based expressive arts therapy is a view of the body and its primary language, movement. This view includes our understanding of how the body reflects our way of being as humans. We are a multiplicity of physiological and anatomical functions, emotional responses, cognitive and imaginal thinking, soul, and spirit. We are motivated by a compilation of life experiences and possibilities which include both destructive and creative imprints, impulses, and desires.

Just as the physical body gives us a literal and concrete structure that expresses who we are, so every part and function of the body can also be understood as metaphors for the expression of our being. We feel and observe our life experiences through our bodies. Focusing on the body and its language of expressive movement, we are able to draw our awareness to sensation, posture, gesture, emotion, and thought in concrete ways. The musculoskeletal structure shapes our characteristic body posture by containing, holding, and protecting our organs and nervous system. All of the stresses of our lives are stored in and affect the body, often creating distress and imbalance, which are reflected in our emotional and mental states. Our bodies contain our life stories just as they contain bones, muscle, organs, nerves, and blood.

Central to this work is a core philosophy: The entire repertoire of our life experiences can be accessed and activated through the body in

movement. Since movement is the primary language of the body, moving brings us to deep feelings and memories. The way we move also reveals disabling and repetitive patterns. Whatever resides in our body – despair, confusion, fear, anger, joy – will come up when we express ourselves in movement. When made conscious, and when entered into as mindful expression, movement becomes a vehicle for insight and change. As creative and mindful movers, we are able to explore whatever rises to the surface, experimenting, opening up, and investigating ourselves in new ways. In this moving out of unconscious material, we bring all that we have not been aware of into clearer view.

In this approach to movement-based expressive arts therapy, people learn a practice which teaches them how to access and understand the messages of their bodies within the larger context of what is happening in their lives. Not only can we cultivate awareness and the ability to witness what is happening in us by focusing on the body, using expressive movement we can respond consciously and work creatively with whatever arises. By going to the deepest levels of our physical, emotional, and thinking body, we can free ourselves of some of our conditioning and history. Movement then becomes the metaphor for our way of living our life stories.

There are many profound and effective practices for working with the body and movement. In this approach, we work with movement as metaphor from an artistic point of view, actively using the principles of creativity and art making. The material of the work is the real-life issues and concerns as they arise out of and are expressed in movement, drawing, and dialogue. By working in a nonlinear and highly creative way, we expand our normal or ordinary field of play and ways of thinking so that we generate new resources and arrive at a more complete under-standing of the self.

In this practice, we immerse ourselves entirely in the experience of the moment: giving ourselves over to sensation, feeling, image, or thought. The stuff of our lives acts as the muse who calls us to the dance, the poem, the painting, or the stage. We wait without reservation or judgment, and welcome whatever in us wants to come forward. As artists do, we cultivate a willingness to fight, surrender, deconstruct, rebuild, not know, let go of our attachments to what will happen, take risks, look at

the underbelly of things, and welcome the shadow as much as we long for and celebrate the light. We grapple with and play with our personal material until a breakthrough occurs, and a new form or way of being is shaped.

This attitude of the artist as seeker brings us into a creative confrontation with ourselves and with our lives. We may experience it as destabilizing when our old ways of thinking and behaving are challenged. We may encounter a period in which we are stripped of our old costumes, and have nothing new in the closet to wear. However, in our creativity lies passion and hope, which motivate and inspire us to shape new postures, like a dancer who shapes her movement, or a painter who works with paint to bring a vision to life.

A dance, for instance, becomes the field of play upon which we are able to safely project our responses and relive some of the disturbing situations in our lives. Feelings and experiences are transformed through this dynamic use of creativity. In improvisation, we can try things out, make discoveries, take risks, do it again if it does not feel right, be silly, brave, nasty, or enraged, tear things apart, put it all back together, or make love and war in the imaginal field of the expressive arts studio. We can express feelings that need release, face demons of the past or the present, or feel the pure joy of our bodies, minds, and spirits in communion. We create models for new ways of learning, knowing, and expressing.

In this way, our lives feed our art by making it real and authentic, and our art opens and reflects back to us images of who we have been, who we are, and who we might become. As we find our integrity in the ways we shape our bodies, movements, images, and feelings through art, with time and practice we are able to shape more creative relationships with ourselves and others.

The way we work with creative process and the arts is, however, very different from that of the artist who immerses herself in art for art's sake, or who shapes her art in order to deliver a message to her audience. We work with the arts metaphorically, as a way of identifying, reflecting on, and changing our conditioning. We work with art and the creative process as a paradigm for addressing suffering. In such a practice, we place our focus on the process itself, and on the insights that emerge, rather than on the outcome or product.

We transfer principles and practices of the arts as creative process in order to facilitate awareness, insight, and positive change. To fulfill this purpose, we need to frame our experiences so that therapeutic value and sustainable learning become possible, just as a painter uses a frame to mount a canvas.

The framework through which we practice this work must serve the purpose of strengthening what we call the life–art bridge, that being the metaphoric relationships between our art making and our life circumstances. With framework and structure, immersion in the arts becomes a therapeutic and educational experience in which art is transformational and healing.

In addition to having an understanding of and willingness to work with the principles of art and creativity, practitioners in the field of expressive arts therapies need philosophical, theoretical, and practical frameworks. We need an embodied understanding of working with the metaphoric qualities of body sensation, expressive movement, images, and words. A methodology of learning which teaches how to understand movement as metaphor imparts a knowledge of the body and gives us the tools we need to see all the ways in which movement reflects who we are.

In learning this practice, we work with the following principles or ideas:

- Our bodies are our vehicles of awareness.

- There is a relationship and interplay between the physical body, emotions, and thinking.

- Body sensations, postures, and gestures reflect our history and our current ways of being.

- When we engage in expressive movement/dance, the ongoing themes and patterns from our lives are revealed.

- When we bring sound into our movement, we are giving voice to our feelings and stories.

- When we work on our art (whether a dance, drawing, poem, or performance), we are also working on something in our lives.

- The symbols we create in our art contain valuable messages which speak to the circumstances of our lives.

- The ways we work as artists teach us about the ways we relate to ourselves, others, and the world.

- When we enact positive visions through our art, we create images and models that can become guiding forces in our lives.

- As we learn how to work with the principles of creativity and the practice of the arts, we are able to apply what we learn to all aspects of ourselves, including the challenges in our lives.

Through movement and multimodal art mediums (drawing, poetic writing, music making, singing), we are able to bring forward the material of our lives, reveal what has been hidden, and express old stories in new ways. The passion and creativity of the arts allow us to live with our suffering and find release through creative play. In such a process, we can symbolically face the demons of the past and the present. As our body posture changes, so does our posture in life. As we dance out our anger, we see it more clearly and find a more constructive expression for it. As we become attuned and aligned physically, emotionally, and mentally, we grow closer to fulfilling our potential as human beings. We can say, then, that a life well lived is the aim of this work. Such an aim speaks to an intrinsic interdependence between art, psychology, and spirituality. In describing the theories, methodologies, and practices of this work, I also hope to illuminate this essential interdependence.

In the following chapters, I will explore the following core questions essential to making this an embodied practice bridging our art and our everyday lives:

- What is happening in my body?

- What is calling for change?

- How is my body carrying my life story?

- How is my movement revealing things about my life?

- How can my art help me shape and change the way I relate to whatever disturbs me?

- How can I live in authentic and moving ways?

This book approaches these core questions directly in Part One (Introduction), which explores a meta-view of movement in Chapter 1 (Movement as Metaphor). In Chapter 2 (How I Got Here), I talk about how this work arose out of my own personal struggles and needs. Part Two (Roots and Cross-Pollination) shifts focus to examine the historical context and the trends in psychology, somatics, dance, and modernism/postmodernism that most directly affected the development of this approach to expressive arts therapy.

Part Three returns to the core questions, emphasizing the practice of the work itself. Chapter 8 (Creativity, Art, and Therapy) proposes the psychological relevancy and healing power of art processes. In Chapter 9 (Maps and Methods of the Practice), I describe the basic theoretical models of the work. The psychokinetic imagery model presents the work as an intermodal arts practice and is followed by workbook exercises. In Chapter 10 (Body Part Metaphors), I present a complete expressive arts system for working with the physical body and associated metaphors. Exercises accompany each body part. Chapter 11 (Living Artfully with the Wounded Self) offers a way of applying this work in a therapeutic framework that incorporates all of the theories and models of this practice. Chapter 12 offers two case studies to give readers a sense of how this work looks in one-on-one settings.

In the concluding chapter (Art as a Healing Force in the World), I attempt to place the practice of movement-based expressive arts therapy within the overall context of the importance of the healing arts in the world at large.

CHAPTER 2

How I Got Here

Be careful lest in casting out the devils you cast out the best thing that's in you.

Friedrich Nietzsche (in Kaufman 1982)

My personal life is the ground from which this work has grown. My approach to movement-based expressive arts therapy is a phenomenological one – that is, it is based on subjective, lived experience. Stephen Levine (2000) describes phenomenology by remembering Edmund Husserl's advice to let our thinking be guided by what is revealed through the experience of our lives. Levine (2000) goes on to say, "Such an uncovering demands that we enter into a dialogic relationship with that which we seek to understand, a relationship in which not only the being of the thing we study but also our own being comes into question" (p.88). I have developed the structures and theories of my approach through precisely this kind of study and questioning.

My personal struggles brought me to certain key questions: How do we reintegrate ourselves when we have fallen apart? How can we bring disowned and unhealthy parts of ourselves into creative dialogues where healing can occur? Although some consider it a risk for a therapist or teacher to reveal her own story, I would like to describe in a personal way the ground out of which my work arose. I do so with the hope that this will encourage others to find value in their own stories and to consider how the arts can provide an inspiring way to move with and transform our suffering. In this spirit, I offer some of the private places of my own suffering through a brief autobiographical sketch.

I used to say that I felt as if I had been born into a circus family. I had an image of having spent most of my childhood under the big tent, surrounded by the freaky and the surreal, which had their own peculiar kinds of beauty. I later came to understand that the feeling of being born into this sort of life had as much to do with the way my work became my calling as it did with the weird and colorful circumstances of my childhood family life. For in my childhood, while other children dreamed of running away and joining the circus, I dreamed of running away and joining "the normals."

From my earliest years, I was trained in dance and immersed in the avant-garde art scene. My parents were innovators and public figures in their respective fields. I suspect that the drive and passion they shared for their work kept them together as much as it created a competitive, highly combustible, and achievement-oriented atmosphere in our home.

Our family was atypical, informed by wildly experimental, radical, cutting-edge intellectual and artistic endeavors on the one hand, while on the other bound by conventional Jewish expectations and beliefs, stereotypes, and family neurosis. The paradox between the two family faces, and the dichotomy between private life and public persona, created tremendous tensions and confusion, which undermined the interesting milieu to which we were privy.

As a child, I had what seemed to be a natural inclination toward drama and artistic immersion. When I was six years old, I began performing in my mother's dance company. My father built a studio and dance deck so that our mother could "be at home" with my sister and me while she worked. The result was that my sister and I were "at home," surrounded by our mother's various students and colleagues while they worked.

My sister has described sneaking among the bags of these people, whom she perceived as unwelcome intruders, to glean some small morsels of nourishment or treasure for herself. A more extroverted type, I simply joined the crowd. My earliest memories are of dancing just about every day. When you are born into a "circus family," part of the scenery is the assumption that you, too, want to perform on the trapeze. Indeed, having a child trapeze artist makes the act that much more riveting.

In any family, sorting out the good from the bad is complicated. Our family, in spite of and because of its multidimensional facets and constant involvement with the art world, was no exception. Our mother was a devoted and remarkable dance teacher and a great believer in the power of the imagination. She included us in her dancer's life in every conceivable way. She formed a children's dance cooperative, which she taught for as long as we were of an age to participate in it, and took us on tour as performers throughout Europe.

Our father was dedicated to his work as an environmental designer, and we were educated by his abiding love for nature and by his extraordinary intellect. Every year we trekked into the mountainous Sierra wilderness and camped on the magnificent California coastline. We traveled through Europe, absorbing our father's perspective on design, aesthetics, history, and culture. Although my parents' passion for their work often overshadowed other considerations affecting our upbringing, their interests were undeniably fascinating and enriching.

As we two children got older, there were daily rehearsals and workshops; my mother's students, artist friends, and collaborators were constantly coming and going. "Happenings," rituals, communal nudity, open sensuality, and intense emotional catharsis were commonplace; our everyday life was imbued with the avant-garde experimental milieu of the 1960s. In the artistic realm, just about every old structure was tested, turned upside down, and altered. However, there was a great discrepancy between what was allowed and overtly encouraged in the studio or workshop and what was expected and took place at home. This gap was almost impossible for us to understand as young children and teenagers.

I became more used to living and participating in an adult world than in the world of other children. By the time I was a teenager, I had performed and toured internationally with the Dancers' Workshop Company and had worked with a number of the leading artists of the times. Throughout my childhood, I worked intimately with adults, most of whom fit very nicely into the "crazy artist" niche. I performed nude onstage just as I was entering the most sensitive adolescent years. I was exposed, both literally and metaphorically, to all kinds of adult situations before I had had a chance to develop a firm sense of my own self. I often found myself in very compromising situations which I was unprepared to

handle. That I got through my teenage years relatively unscathed while being totally unprotected and overexposed was, as I think back on it, remarkable. However, a pattern was set in place which became apparent and more destructive in my early adulthood.

I was confused and angered by the contradiction between my family's private and public lives. I was used to being sexualized and objectified by adults, as if I were a piece in someone else's work. I lived in an environment where outbursts took place at any moment. Boundaries were obscure, whether between the needs of the child and adult, between reality and imagination, or between acting out and healthy behavior. I entered young adulthood with a brewing and deep-seated fragility, which I masked in the persona of the rebel and the performer.

San Francisco in the 1960s was a hotbed of experimental and innovative work in music, theatre, and literature. A precocious participant in the scene, I had been included in the happenings of the Beat Generation and the stage events of the San Francisco Committee. I had appeared in a documentary film with the Dancers' Workshop on avant-garde theatre in America.

In the late 1960s, the avant-garde Italian film director Michelangelo Antonioni (*L'Avventura, The Red Desert, Blowup*) came to this country to research and prepare for his film on America. Looking toward the West Coast art scene for resource material and people, he had seen the Dancers' Workshop documentary. Against the backdrop of my inability to differentiate between art and life, I met the remarkable fate of being "discovered" by Antonioni and cast in his film *Zabriskie Point*.

The term "discovered" is telling, in that it suggests that you really do not exist until someone finds you and puts you onstage. This fit just fine with my picture of life. Going to Hollywood to be in films intensified all of the "about to break downs" that were just waiting to happen in me. Hollywood, in some ways, was not so dissimilar from the culture of my childhood home – with its mix of paradoxes, people who shared certain characteristics with the cast of characters I had grown up around, and total lack of a true bridge between art and life. What was different from home was that there was no love to balance the rest out.

I think I stepped into adulthood having skipped way too many grades. Although I had received amazing training as a dancer/artist, I

had absolutely no training in my own personhood. The world I stepped into demanded a strong boundary defense and a strong personality structure, both of which I lacked. Although I had experienced the artist's life and had traveled extensively at an unusually young age, I was fairly naïve in the ways of the world. I had developed a pattern of performing the role in the play or story of the moment, and responding as brilliantly as I could to whomever I perceived to be the director. This pattern shaped my life throughout my twenties.

During my years in Hollywood, I met and married my first husband, an actor/director who, like myself, was a rebel and an alternative artist. Echoing my home environment, our relationship was forged by our shared artistic and political values and by the combustible fires of two highly artistic, sensitive, and unstable people. At the time my first husband was an alcoholic, drug abuser, and prone to violent outbursts. In my play, he was the beast to my beauty, the Hades to my Persephone. My instability lay in my own split between public persona and private life, and my tendency to privilege the highly narcissistic artist and all-important art over my own self.

In response to the constant mental, emotional, and physical trauma, I went into a state of disassociation from my emotions and body. Like many others who have suffered from trauma, I lived in a constant state of fear, numbness, and shock. What was driving me toward self-destruction shifted with the birth of my first child. I left the marriage. My search for personhood began out of total necessity and in response to crisis.

I had to start rebuilding from the ground up. I blamed my background, and decided that the arts were too dangerous for me, that being an artist was what had gotten me into trouble. In a certain way this was true, and so I turned to another path. I entered therapy with a vengeance. Throughout the 1960s the Dancers' Workshop Company had worked with the founder of gestalt therapy, Fritz Perls. As a teenager, I had been exposed to his work and for a time was his client, and so I returned to those roots.

In 1973 I entered into a form of personal therapy which combined a gestalt and somatic, or body-centered, approach. Paradoxically, my long training in movement and dance did not in any way protect me from the fragmentation and disembodiment that I went through. It felt singularly

important that I choose an in-depth form of therapy which would help me regain a sense of my physical body and also assist me in reconnecting my body, mind, and emotions. Gestalt therapy, based in nonverbal forms of enactment and role-play, felt familiar and added a very important new step in the process of psychological awareness, consciousness, and working things through. The relationship with the therapist was the first in which an adult focused on my experience and search for self. This was to be a key element in my development and in my healing.

Out of my devotion to this new path – the first direction in my life that I had chosen intentionally for my well-being – came the dream of creating better ways in which art and psychology could meet. In 1975 I began training in psychology. During my early years of professional practice, my work reflected my response to my own wounding experiences. Over the years, that reflection expanded to include the wisdom I have gained from both my own history and the history of the students and clients with whom I have had the good fortune to work. Today my work also reflects the many ways in which all of us are able to grow beyond our history into new territory.

This work has been my inheritance, my nemesis, and my calling. I have struggled with the entanglements of it for many decades and found, in the infinite space that has opened up between the knots, a life's work and a life's study.

From my story to the work

Several years ago, the Buddhist nun Ayya Khema challenged me with two questions during an interview: What got you here? What are you learning? It strikes me that over the last twenty-five years I have attempted in one way or another to grapple with those very questions. In my twenties, when I began to work on myself, I wanted to understand what led to my wounds and how I could change. I took these questions with me everywhere – into therapy, into the studio, and into my movement, drawings, and poetry. At the time, I thought I would give it a year or two, get over it, and then go on to have a "good" life.

I came to realize that this quest was lifelong, which at times filled me with dread and despair. One of the callings that brought me back to my

original experiences as an artist was discovering how the arts held and inspired me while the slow and often painstaking process of confrontation, change, and growth took place.

The movement-based expressive arts therapy that I teach has grown out of the discoveries I have made as an artist in my own therapeutic process. Movement and art are vehicles of passage which can help people slowly and sensitively reenter their bodies and reconnect with their feelings. Serving as a kind of medicine, movement allows us to tolerate an intense meeting of our story and our suffering. Through acts of creative expression, we transform suffering into embodied learning and change. Movement enactment serves as a language for working with conflict. The symbols of our artwork speak *for* us as much as they speak *to* us. Poetry helps us make sense of things and gives a powerful voice to all that needs to be told. The studio acts as a safe haven where the arts are allies and advocates.

As my own life history shows so dramatically, no matter how much experiential knowledge, artistic experience, and training a person might have, integrating it into daily life is often a daunting challenge. Ultimately, whatever happens in the studio and in our lives as artists can only be therapeutic and transformational if we can make and sustain a life–art bridge. My own struggles with this bridge left me with certain sensitivities and biases which led me to a number of considerations as a teacher and therapist, and to the articulation of skills which I believe are necessary to this process.

I retraced my own steps, investigating what had worked for me and what had not. I started by centering my work around five intentions:

1. Facilitating people in developing a sensitivity to their bodies and imaginations, and in expanding their range of expressive movement.

2. Evoking the metaphoric connections between physical experience, emotion, imagination, and life themes.

3. Working with and integrating the physical, emotional, and mental experiences within the context of life circumstances.

4. Forming a bridge between art expression and psychological development.

5. Integrating learning in the studio or therapy session into daily life.

In my own life, I had experienced a profound loss of awareness and a fragmentation which made it impossible for me to respond appropriately to my circumstances. I found it important, therefore, not to assume that people are in touch with a vital awareness of what is happening in their bodies, emotions, and minds. I was particularly committed to an intentional separating of these three realms of experience and expression – physical, emotional, and mental – so that whatever is present or missing can be discovered and thoroughly explored. I delineated a model which I called the *three levels of awareness and response*. My intention was that this model would facilitate greater awareness by bringing attention to each level so that the relationships and creative dialogues between the physical, emotional, and mental levels of experience could be opened up and enlivened. I describe the three levels of awareness and response map in detail in Chapter 9.

Using a movement-based expressive arts approach as a therapeutic practice involves working with shadow material, confronting ourselves and the patterns and behaviors which lead us to certain life situations. We use movement, drawing, and poetry to catalyze these confrontations, and, as I had found in my personal life, the art "holds" the conflict for us so that we can achieve some distance from it. This *intentional* distancing, rather than being a way of cutting ourselves off from the material we need to work with, allows us to enter into conscious dialogue with it.

But going into the encounter with the art is not enough. We also need to identify what is happening in and around us so that we can cultivate the ability to self-witness and make new choices.

Sustainable change occurs over time and requires, as I have suggested, more than the art itself or the art-making process alone. We work toward true and sustainable change by working with evoked material therapeutically. Through consistent, repetitive practice and reflection, it is possible to stabilize new imprints that we can then apply outside the studio. In Chapter 9, I discuss the progression of five steps or phases of therapy:

identification, confrontation, release, change, and growth. As I worked with each body part in my own personal practice, I discovered themes that were uniquely relevant to the particular life struggles I had experienced. Out of this research, a kind of body mythology arose. When I began to teach, I found that the themes I had identified for myself served as metaphors which allowed others to enter into the personal material that they most wanted or needed to explore. In working on each body part, one at a time, and on the relationships between and among the body parts, encounters with different aspects of our life experiences are provoked. It is as if each body part, as well as the duets, choruses, and symphonies between and among the body parts, has a particular piece of a story to tell. Exploring part by part, we uncover and reveal a whole picture of our lives. Our body parts and our dances serve as archetypes for our life story – the templates for our personal myth. I demonstrate this model in Chapter 10.

Given the difficulties I encountered in moving between the world of art and the everyday world of relationships in my personal life, I found it imperative to articulate a way for people to integrate movement-based expressive arts into a careful investigation of their wounded parts or wounding experiences. This aspect of the work includes an examination of the wounded part of the self, that place where our suffering holds us in its strongest grip. In Chapter 11, the model I present suggests a way to bring art to the shadow by developing conscious dialogues between suffering, self-awareness, creativity, and psychological insight.

My own early immersion in the arts had, in a sense, destabilized me. In my work with movement-based expressive arts, I became quite sensitive to this possibility in others. Engaging in the arts opens people up in provocative and experimental ways. It is therefore crucial that we pay attention to stabilizing and integrating all that is evoked on physical, emotional, and mental levels. This focus on stabilization and integration became a central ethic of my practice.

I have used my personal story as a resource in shaping my work in movement-based expressive arts therapy. My story affects what I bring to the practice as a teacher and as a therapist. As we practice together, clients and students access their life stories as the material we engage with

through the arts. Together, we explore the person and the personality by listening to the messages that the body and imagination have to offer.

The language of the self and the soul speaks in the images of our drawings, dances, and poetry. When we discover a way to listen to these messages and to be changed by them, when we dare to confront the personal and collective shadow, we can release the old stories so that new ones can emerge. As I discovered in disowning my shadow and in facing it, art that arises from and is connected to the real and compelling circumstances of our lives can illuminate the darkness. Then we can say that our art is healing. In joining expressive arts and therapy, we can attempt to heal the splits in ourselves. Perhaps, in this way, we and the life we fashion become our greatest works of art.

PART TWO

Roots and Cross-Pollination

Historical Context

I laugh when I hear that the fish in the water is thirsty.

You don't grasp the fact that what is most alive of all is inside
your own house;

and so you walk from one holy city to the next with a confused
look!

Kabir will tell you the truth: go wherever you like, to
Calcutta or Tibet;

if you can't find where your soul is hidden,

for you the world will never be real!

<div align="right">Kabir (trans. Bly 1971, p.9)</div>

Having given you a glimpse of the personal history out of which my work
in movement-based expressive arts therapy arose, I now want to look
beyond the personal to a broader philosophical and theoretical back-
ground. The loss of the embodied experience as a source of knowing
relates to the larger historical context as much as to the story of our own
personal struggles.

In Part Two, I touch upon some basic ideas from some of the pivotal
thinkers, schools and approaches that most directly influenced the early
formulations of my particular approach to movement-based expressive
arts therapy. By no means is this a thorough or complete investigation of
an immense and broad subject. My primary intention is to give beginning
students and readers from the general public who may not have studied
these concepts, a general review and glance at the evolving culture that
shaped my thinking.

Every movement of thought is formed around essential philosophical questions. There are three central questions to keep in mind as you read. You will recognise them in the investigations and responses that run throughout the various approaches and movements in our survey. How can we understand and explore the tensions and conflicts between opposing forces in the individual and in the society? How can these forces be reconciled in creative and productive ways, and what part does the body, emotion and imagination play in this search? You will meet these questions again in Part Three where I present the practice itself. Following the movement away from the body and art as locus of experience, the loss of the holistic perspective in favor of the mechanistic view, and the return to an examination of human expressiveness and its connection to creativity, our survey will reveal an evolution and revaluation which reunites art and psychotherapy.

Ancestral roots

Since the dawn of our history, human beings have endeavored to understand and express themselves in relationship to the social and natural environment, and in relationship to the self. This endeavor encompasses the need to alleviate human suffering, address our most existential questions, and reaffirm harmony and wholeness. In ancient times, this quest found expression in the domain of the arts, in healing practices, and in ritual. We might say that therapy, healing, art, and the sacred have been connected for thousands of years.

Traditionally the shamans of the tribe were responsible for answering and maintaining the psychic needs of their community. J. Meerloo (1968), in *Creativity and Externalization*, has written:

Centuries ago, the play with rhythmic chant and rhythmic movement became a religious rite supposed to liberate man from the fear and burdens of separateness and death. The dance of the medicine man, priest, or shaman belongs to the oldest form of medicine and psychotherapy in which the common exaltation and release of tensions was able to change man's physical and mental suffering into a new option on health. (p.69)

In ancient times, both the healing process and artistic expression were an integral part of the community's daily life. For centuries and in all cultures, the use of ritual became what we might call an art form through which people evoked the spiritual, confronted life-threatening challenges, celebrated the life force, and passed down through the generations the wisdom and traditions of culture and human knowledge.

The needs of the individual were related to and part of the collective experience and found expression in painting, storytelling, dream sharing, and dance. Art was an intrinsic part of individual and group functioning and served as a language for communicating with and acknowledging all aspects of life. Art played a significant role in the integration of the individual, family, and group – from the ceremonial marking of passages into life and death, marriage, and war to the treatment of disease and the interaction with the forces of nature – as well as a means of prayer and connecting with the divine.

In eastern cultures, the great Sufi mystics used stories, poetry, and dance as teaching tools and spiritual practices. The Japanese culture is rich with examples of art appearing in all aspects of life, including medicine, theatre, gardening, architecture, sexuality, spirituality, and warfare. Greek philosophers such as Plato framed the practice of the arts within their philosophical search for truth and meaning. Plato, in *The Republic*, banished the poets from the city for turning their art toward decorative purpose rather than toward the real and deeper issues of human existence (Levine and Levine 1999; May 1969). Socrates, as he waited to meet his death, returned to poetry for his final contemplation and teaching.

Influenced by the Cartesian view of separation between body/mind, humanity/nature, and objective/subjective "realities," western civilization succumbed to centuries of dualistic thought. Although philosophers and mystics continued to honor paths of wisdom related to consciousness and spirit, the mainstream understanding of the human condition narrowed and was largely placed in the authoritative and controlling hands of specialists – clergy, scientists, and doctors who held to a "mechanistic" view of human existence. Value systems reflected a disembodied relationship with body, emotions, and spirit. Things related to the senses, to healing, and to the arts of the people (folk art) were considered superstition, heresy, or the province of ignorant primitives. The arts fell under

the control of the wealthy and powerful, who turned them toward the purpose of representing the power structure, and providing superficial entertainment, sensual outlet, and a means to compensate for the lack of fulfillment and free expression.

With the advent of discoveries in science and medicine which allowed humanity to exert new levels of control over the environment, and under the growing influence of Christianity, the mechanistic view replaced a more holistic perspective. The belief systems of science, medicine, art, and religion compartmentalized human needs and knowledge into separate areas of concern and disenfranchised the body as locus of experience.

The progression of human history is marked by the separation between body, mind, and spirit and by the attempts to identify and heal these splits. Art, and its place in our lives, has also suffered from this historical context of separation. Unlike our tribal kin, in modern times we have tended to perceive artistic expression as the responsibility and privilege of a select few. Just as dualistic thought disenfranchised the body, so art was considered the special province of the "professional" artist. We gave over to the artist the task of reflecting our collective shadow, of exploring and giving meaning to our social ills and needs through art making and performance. One of the tasks of the artist has been to confront society with its disturbing dilemmas and to call attention to unexpressed collective needs. To a great extent, however, the healing power of the arts has been lost. Much of our art today has become another commodity in the marketplace, based on the criteria of entertainment, fads, and manipulation, rather than on raising consciousness or solving social dilemmas.

On one hand, we see our materialism reflected in both the artwork and the artists of our times. We can also see how art demands that we confront and grapple with our world, and how art can evoke the highest of aspirations. Both types of art are reflections of our own dichotomies and the world we create out of them.

The lack of available resources in working creatively with conflict, disturbance, and disease is an ever-growing problem that we need to address in the context of our postmodern times. For example, the arts can answer an important psychological and social need for the symbolic,

rather than the actual, enactment of aggression. The process of art making and symbolic enactment redirects our destructive energies and impulses, allowing us to encounter and work through the conflict creatively as well as to change our perception of the issue itself. This "decentering" process shifts us from our established positions and experiences, changing our perceptions as well as opening up new possibilities. The art, as a piece of work and as a creative process, holds the energy and the material of the conflict so that we can consciously "look at it," "dialogue with it," and "transform it" in ways that are constructive, illuminating, and life-affirming. In this light, the arts should, once again, be reintegrated into both individual and community life.

Beginning in the early twentieth century, pioneering thinkers in a number of fields began to reintroduce and reconceptualize the holistic perspective of our ancestors, thereby reclaiming the creative purpose and power of the arts to heal, to educate, and to facilitate consciousness.

The search for embodied living and holistic understanding in a highly technological world calls for a reintegration of ancient wisdom with the knowledge, skills, and challenges of the present times. The cross-pollination between fields involved in this search has created new insights and discoveries which challenge the centuries-old splits between principles of psychology, art, medicine, education, politics, and spirituality, resulting in new, interdisciplinary approaches. The alliance between art and healing, one such new paradigm, finds its theoretical roots in some of the major schools of psychology.

Psychology

The healthiest form of projection is art.
Fritz Perls (to Esaten Institute workshop members in 1965)

While many schools of thought and practice have contributed important knowledge to the field of psychology, here I will give a general survey of some of the schools whose philosophies and methodologies have most directly informed the approach to movement-based expressive arts therapy that is the subject of this book.

Psychoanalytic and neopsychoanalytic schools

The psychoanalytic movement grew out of the scientific model of medicine and the mechanistic worldview. Catalyzed by the seminal work of Sigmund Freud (1865–1939), psychoanalytic theory underwent a series of radical turns throughout the early and mid-twentieth century. Freud (1952) began his studies in the sciences – biology, physics, and chemistry – and came to psychology by way of neurology. Some of his work refers back to this scientific base, seeing disturbance of the mind as related to neurological issues and offering a model of the human mind based on the physiology of the reflex arc (Corsini 1989; Freud 1963). Going beyond the medical model, Freud's most significant contributions from the point of view of movement-based expressive arts therapy were his introduction of the unconscious, free association techniques, and dream work as methods for "working through" unconscious material. These developments represented a significant departure from the linear,

cause-and-effect diagnosis and treatment of psychological disturbances that had previously held sway.

Freud (1923) defined the parts of the self or personality structure in his well-known *id–ego–superego* model. Freud saw the id not only as being "inherited at birth" and "fixed in the constitution," but also as being based in the somatic organization of the instincts and drives. He described the ego as being "in control of voluntary movement" and having the task of self-preservation in relation to our perceptions of reality, and the superego as the supreme controller shaped by external authority figures (Freud 1923, pp.13–68). For Freud (1901, 1915), stored experiences connected with memory result in patterns of adaptation, modification, and control, allowing the individual to be in contact with the world.

What is of particular interest to us is articulated by Paul Antze (2001), who discusses Freud's thinking on the significance of memory, as "powerful scenes situated in the field of early childhood" (p.105). Antze has also pointed out that as Freud's work matured, he began to look at memory not so much from the point of view of specific trauma but in relation to the adult life. Freud's metaphor of the analytic process as an "archaeological excavation" continues to be relevant to approaches in which creative encounter with memory allows us to work through the disturbances of our daily lives.

Alfred Adler (1870–1937) credited Freud with the development of a dynamic psychology. While recognizing Freud for his development of a model for viewing symptoms and for explicating the significance of dreams, Adler's (1927) approach differed significantly. Whereas Freud emphasized the role of psychosexual development, Adler focused on the effects of the childhood experience from the viewpoint of the perception formed by the child of her family constellation and her struggle to find a meaningful place within it. Adler introduced the idea of viewing the person holistically, as a creative, responsible, and "becoming" individual who is able to move toward actualizing goals.

The Adlerian approach suggested that the inability to move forward in this respect results in feelings of defeat; the therapeutic process, therefore, needs to encourage creative mobilization and choice making. Adler saw the unconscious and the conscious not as opposites but as aids in allowing the individual to develop a new lifestyle and engage in life

tasks which allow for change and growth. Correspondingly, for Adler the question was not how the body affects the mind or vice versa, but rather how the individual *uses* the body and the mind in the pursuit of life goals.

Adler (1927) defined conflict in terms of movement, a one step forward and one step backward dilemma resulting in the trap of "dead center," with the person unable to move. Helping the individual to see, understand, and reorganize her responses to this dilemma ignites the ability to actualize. Adler believed in the significance of the individual to the social body; the individual struggle to actualize must be viewed, therefore, within the context of her "cultural" surroundings. For Adler, the ability of the individual to participate in and contribute to society was of paramount importance both on psychological and spiritual levels. Adler evoked Nietzsche's concept of the will to power, which Adler spoke of as normal striving for competence.

Like Adler, C. J. Jung (1875–1961) broke away from Freud, developing a different model for defining the unconscious according to parts of self engaged in a harmonious or conflicted play of opposites. The *shadow*, according to Jungian psychology, is unconscious and contains all of the "dark" aspects of self which we least want to recognize (Jung 1964). The shadow is expressed through projection. The *anima*, which Jung called the projecting factor of the feminine archetype found in men, and the *animus*, or the projecting factor of the masculine in women, revealed and illuminated the unconscious.

For Jung (1957, 1961, 1979), the unconscious had both destructive and creative potential; the play between the two potentials could be both a source of disturbance and, when we are able to recognize the projection, a means of achieving greater consciousness and transcendence. Jung believed, therefore, that the conscious and the unconscious are equally valuable. If one is suppressed or "injured" by the other, we cannot achieve wholeness. Jung's concept of the *transcendent function* pointed toward the necessity of union between opposites.

Comparing his use of archetypes to the Platonic *eidos*, Jung suggested that the archetype holds preexisting collective unconscious energies and images. Through myth and myth making, and, on the personal level, in dreams, Jung believed that this *collective unconscious*, or universal material, is brought to consciousness and becomes a source of knowledge and

understanding. Jung's theories helped lift the study of human conscious-
ness and personality out of an either/or dichotomy and stressed the inte-
gration of the lower and higher aspects of human nature and personality.

Jung (1964) felt that the individual could best meet the workings of
the psyche through archetypes, myths, symbols, and dreams, rather than
through the exploration of repressed memory. Whereas Freud believed
that dreams were the "hiding place" of the unconscious and the baser
impulses, Jung saw dreams as metaphorical unfoldings of the life drama,
serving the function of revelation, with a positive value. For Jung,
symbols and dreams have meaning not only with regard to what we
repress or conceal but also with regard to what we might comprehend or
strive for.

Jung took the practice of psychology out of the context of the
severely disturbed and dysfunctional into the arena of the person
seriously interested in self-investigation. His active imagination tech-
niques served to bridge conscious and unconscious psychic material. His
work with active imagination through the exploration of dreams,
symbols, archetypes, and myths was an early innovation in the develop-
ment of the psychology and art model. Jung's early writings described the
use of various expressive arts mediums, including bodily movement,
painting, and writing as ways of working with images and symbols. He
suggested, for instance, that a mandala painting could be turned into a
dance, and that "symbolic enactment with the body is even more efficient
than ordinary active imagination" (von Franz 1980, p.126; Chodorow
1997).

Karen Horney (1885–1952) was greatly influenced by the work of
both Freud and Adler. A member of the psychoanalytic community's
"loyal opposition," Horney offered a new perspective on women's psy-
chology. Horney believed that people's capacity to change throughout
their lives was intrinsic to the therapeutic endeavor. She explored
concepts of personality based on structuring around a *false* or *idealized self*,
determined by the expectations and values of our social and cultural sur-
roundings.

Horney (1945) proposed a model based on contradictory trends and
relational tendencies defined by three basic attitudes: moving toward
people, moving against people, and moving away from people. Horney's

classification of neurotic needs provides a fascinating map both in its breadth and in the way it goes beyond a view of what is "abnormal," or lacking in value, to suggest a constellation of basic inner pulls at work in most people.

Like Horney, Erich Fromm (1900–1980) was also influenced by Adler and was interested in humanizing Freudian concepts by taking into account the impact of social and cultural forces on the individual. He called his school of thought *humanistic psychoanalysis.* Fromm (1941, 1955) believed that the most powerful force that motivates behavior was not to be found in the libido, but from the condition of existence, the human situation. Fromm examined the pull between inner contradictions and conflicts and the search for harmony.

According to Fromm, the most essential human need is that of relatedness, which is intimately connected with creativeness, the transcendence of passivity. He saw the struggle of the individual through the lens of freedom and submission, not only from the point of view of personal narrative but also from the point of view of sociopolitical narrative. His humanistic psychology inquired into the capacity of humanity and society to endure the often painful challenge of accepting progression and resisting regression. Interestingly, he suggested that this productive orientation is best expressed in productive work typified by art.

Existential and phenomenological psychology

Many schools of psychology consider William James (1842–1910) to be their founder. The first existential psychologist, James (1977) emphasized the plurality of experience as the way to understand human beings, and he validated not only sense perception but also *affectional, intuitive, imaginal,* and *spiritual* experiences. James influenced the phenomenological movement begun by the philosopher Edmund Husserl (1859–1938), embracing a truly holistic and interdisciplinary approach where ethics, aesthetics, mysticism, education, and consciousness all played vital and equally significant roles in psychological inquiry.

Otto Rank (1884–1939), a student of Freud's who continued and built on Freud's work, made important contributions to the phenomenological-existential school of psychology. Rank (1958) did a

study of mythology and the artist, and these artistic inclinations led him to a new approach in working with the historical dimensions of the client. Rank stressed the present-tense encounter with the client and the "in the moment" experience, precursors to gestalt and expressive arts therapy.

Rank's (1936) core theory was that human consciousness is driven by two basic concerns, fear of life and fear of death. These fears have to do with the person's anxiety about stepping out on her own and with her anxiety about attaching to others. As much as we are driven by these opposing fears, Rank believed we are also driven by desire for independence and adventure, as well as by the desire for safety and order. Therapy, he maintained, helped clients achieve a kind of balance between, and freedom from, the opposing grip of these fears and desires.

Three branches of psychology grew from the existential trunk. *Existential psychoanalysis*, which emphasizes social, spiritual, and philosophical growth, was developed by Medard Boss (1903–1990) and Ludwig Binswanger (1881–1966). *Existential-integrative psychology* was developed by Rollo May (1909–1992). *Humanistic existentialism* was developed by thinkers such as Carl Rogers (1902–1987), who developed his work beginning in 1928 and was active through the 1970s; Abraham Maslow (1908–1970); and Fritz Perls (1893–1970). Whereas existential psychoanalysis stressed the philosophical, spiritual, and social aspects of growth, humanistic existentialism emphasized individual growth and the positive potential for change through creative encounter.

Ludwig Binswanger (1963) and Medard Boss (1963) built their approach on the Heideggerian philosophy of *Dasein*, the basic nature of humanity's being in the world (Heidegger 1971). Binswanger's and Boss's model proposed three modes of world: *Umwelt*, the world of biological function and the physical environment; *Mitwelt*, the world of interrelationships with others; and *Eigenwelt*, the subjective world of self. These three modes of world are always present. When one way of being in the world is emphasized to the exclusion of the other two, a loss of awareness and presence results. This model also suggests that therapy must look at all three ways of being in the world, and their relationships with one another, in order to see the full picture of the individual in the world.

Out of existential psychoanalysis arose *existential-integrative psychology*, represented by the work of Rollo May (1976). The core findings of existential-integrative psychology are:

1. The human being is suspended between freedom and limitation. Freedom is characterized by will, creativity, and expressiveness; limitation is signified by natural and social constraints, vulnerability.

2. Dread of freedom or limitation (usually due to past trauma) promotes dysfunction or extreme counterreactions to either polarity (e.g. oppressiveness or impulsivity).

3. Confrontation with or integration of the polarities promotes a more vibrant, invigorating, life-design. This life-design would be exemplified by increased sensitivity, flexibility, and choice. (May and Schneider 1995, p.6)

May viewed confrontation with crisis in a positive light, suggesting that it brings forward the possibility for growth. He explored the place of myth, creativity, will (as in the courage to encounter life fully), and love within the context of the capacity of human beings to self-actualize. Borrowing from the classical Greek model, May (1969) used the term *daimonic* to express creative, destructive, and spiritual dimensions, and saw the daimonic as containing the possibility of all three. For May, to live fully required a capacity to encounter the daimonic and to engage with it creatively. The therapeutic process, May suggested, can help the client integrate the energy of these daimonic forces. The therapist's role is to help clients to become aware and then to transmute awareness into consciousness of self and the world, thereby developing the ability to "do something" about their condition.

The phenomenological approach drew from the philosophies of Søren Kierkegaard (1813–1855), Friedrich Nietzsche (1844–1900), Edmund Husserl, and Martin Heidegger (1889–1976). Philosopher-psychologists in this tradition proposed that not only must we study the person's experience, but even more we must consider the one experiencing. This perspective took psychology out of the reductionist realm of observable behavior and external circumstances to the inward experience of feeling, imagination, and meaning. The central question was the nature

of existence itself, shaped in large part by the need to synthesize and integrate polarities, such as Kierkegaard's (1957) characterization of the capacity to limit and extend, and Nietzsche's (in Kaufman 1982) Apollonian consciousness (repression and order) and Dionysian awareness (indulgence and abandon). Of primary interest was the possibility for people to shape dynamic and authentic lives by developing the capacity for responsiveness and authentic expressiveness. Husserl formulated this thinking into a new discipline, which he called *phenomenology*.

Phenomenological approaches call for immersion in actual experience, defined not as "reality as such," but as how the person actually experiences reality – what she thinks, feels, senses, and imagines in the moment. For the humanists, the shaping of the felt experience through full expressiveness to be shared with others became another important step in the therapeutic process.

This is of particular relevance to movement and art therapies, which rest on the foundational philosophy of phenomenology and arise out of the existential-humanist movement. Central to the therapeutic process is an understanding of struggle as an opportunity for creative confrontation and change, along with the development of full expressiveness and the sharing of experience with others through the artwork or enactment.

Humanistic psychology

The field of humanistic psychology grew out of the work of Kurt Goldstein (1878–1965), Abraham Maslow, Carl Rogers, and Fritz Perls. Building on the philosophies of James, Husserl, and existential psychology, this movement introduced terms such as *holistic, self-actualization, congruence, basic needs, the here and now, boundaries,* and *enactment* into the psychotherapeutic vocabulary. Humanistic thinking took psychotherapy even further in the direction of relevance to so-called "normal people" who are seeking the necessary conditions for greater psychological understanding, consciousness, and growth.

Kurt Goldstein – influenced by Jan Smuts (1870–1950) (Smuts 1926), who coined the word *holism*, and by Adlerian psychology – developed the concept of a holistic approach in which any part could be understood only in relation to the whole organism. Any shock or inter-

ruption to one part of the organism (or to a person's life), Goldstein (1940) said, must be explored within the whole field of the person. This concept put psychology on a very different track from the symptomatic orientation of medicine and psychiatry up to that point, and heralded a new way of thinking – the idea that everything ultimately influences and interacts with everything else.

Continuing to develop the phenomenological-existential approach, the humanist school of psychology shifted the psychotherapeutic orientation away from a strictly pathological view toward the exploration of human potential. Exploring human potential meant identifying optimal conditions which foster creativity and growth, developing models for exploring what a fully functioning human being might be, and generating methods for investigating the whole-parts dynamic. This movement declared that psychotherapy was no longer limited to treating mental illness or people in extreme crisis, but was relevant to "normal" people attempting to live healthier lives.

Abraham Maslow's (1954, 1968) humanistic considerations challenged Freudian psychology as representing the "sick half of psychotherapy," and instead promoted the search for the "healthy side" of psychology (1968, p.5). Maslow also stated that personality problems were the result of the crushing of the person's true inner nature; a valid orientation, he argued, would examine the discrepancy between the actual person and the potential person. He proposed a revolutionizing of psychology which would take into account what the human being is, what she could be, and what she would like to be – an integrating process which would include both the joys and the anguish of the human experience.

Carl Rogers, the founder of *client-centered therapy*, instituted a very new view of the client–therapist relationship. He believed that the therapist must create a relationship with the client based on warmth, *unconditional positive regard*, and caring. These qualities would become intrinsic to the success of the therapy and serve as a model for the broadest range of human relationships. Another central quality in Rogerian therapy was *empathy*, meaning that the therapist must understand experience, with its emotional content and meaning, through the frame of reference of the client. Rogers promoted the concepts of the *helping relationship* and the *empathetic listener*, and saw these qualities as being applicable not only to

the client–therapist relationship, but also to relationships involving a parent, a spouse, or a teacher, and to any form of relationship in which development and self-expression are valued.

Rather than offering tools for diagnosis, Rogerian therapy sees the conditions of self-worth, self-regard, and the intrinsic orientation toward growth as the basis for the therapeutic process. Rogers (1951) believed that distress and the restriction of authentic self-expression resulted from the *incongruence* between the natural forces of self-actualization and the ability to translate them into self-awareness and action. Rogers used the term *locus of evaluation* to describe the need for the individual to center the valuing process within the self rather than allow it to be determined by the perceptions and values of others.

Rogers (1961) defined psychotherapy as the "releasing of an already existing capacity in a potentially competent human being" (p.188). Active listening skills served to facilitate expression, and Rogers' emphasis on the important "I statement" has found broad applications in interpersonal, family, and group conflict resolution.

Gestalt psychology

Gestalt psychology provides a wealth of theories which have served as foundations for both the theory and practice of expressive arts therapy. The basic concept of gestalt psychology is that "expressive behavior reveals its meaning directly in perception" (Arnheim 1972, p.58). The principle of *isomorphism* central to this approach states that processes taking place in one form of expression (in any one medium, or on any one level of the person – physical, emotional, or mental) are similar in their structural organization to all of the others.

As a principle of the body–mind relationship, this means that bodily expression corresponds to emotional and mental states. For instance, where movement in dance expresses emotion and ideas, the creative act of forming movement expressively is a psychological as well as a kinesthetic process. Physical posture tells us something about the emotional and mental life of the body, its past and present. This highlights the significance of metaphoric reality and demonstrates the key role of all of the arts as expressive mediums. Expressive arts reveal the life of the "artist" as well

as having a revelatory impact on the observer. In therapy, this meaning of the artwork as it is felt, perceived, and comprehended unfolds in the collaborative dialogue between client and therapist.

Gestalt psychology also articulated *field theory*, the principle of the corresponding relationship and impact between the parts and the whole suggested by James and Fromm. Field theory recognizes that an impact on any one part affects the whole person, and that the constellation or reintegration of impacted or expressive parts informs the reorganization of the whole. Together, isomorphism and field theory support our notions regarding the exploration and understanding of sensory experience, perception, and expressiveness in working with a variety of art mediums in the exploration of the processes of the psyche.

Gestalt psychologists have emphasized that the sensory response to the environment and to others is a significant and valuable projective occurrence – a reflection of feeling, of past associations, of subjective responses, and of metaphoric interpretations by the observer. Gestalt psychology further supports the value which we place on the witnessing process, both self-witnessing and relational witnessing. I will examine these concepts more thoroughly when we look at the maps and methods in Chapter 9, where we will examine the relationship between sensory perception and art mediums as well as aesthetic witnessing.

Gestalt therapy

Fritz Perls (1969, 1971, 1973) co-founded gestalt therapy with his wife, Laura Perls, a former dancer. Perls "grew out of" the psychoanalytic movement, where he had undergone his study and training in Germany and was an assistant to Kurt Goldstein. He was directly influenced by gestalt psychology and by the work of Karen Horney and Wilhelm Reich (1897–1957). Perls came to the United States to develop an "action-oriented" therapy based on creative enactment. I was first exposed to his work during the 1960s, when he came to California. My experience as a client and my training in gestalt therapy informed the early development of my approach to movement-based expressive arts therapy. Perls practiced his experimental therapy primarily in group and workshop settings, where, using the presence of the group, he empha-

sized creative interaction and the significance of the social and relational field to the therapeutic process.

In gestalt therapy, the objective is to generate awareness and insight so that clients become aware of what they are doing, and how they are doing it, and are guided to explore new possibilities for change through enactment. For Perls, the principles of isomorphism and field theory were embodied in the living out of past experiences and memories in the here and now, as suggested by Rank (1958). This therapy often shows similarities to the acting of theatre, and the "play" may include a cast of characters – mothers, fathers, siblings, parts of self – explored and expressed through senses, emotions, imagination, and script, in which various parts come into enacted opposition and dialogue with one another. The encounter is ultimately mediated by a third force able to sense the whole picture, or *gestalt*, and to bring the various parts into some kind of resolution.

The techniques of gestalt therapy include working with body awareness, dialogue, and the explication of experience through nonverbal forms of expression such as dance. Gestalt therapy stresses experimentation, process, and discovery over interpretation and end result. Perls used gestalt therapy enactment techniques such as role-play, movement, and dialogue as ways of working with charged situations and relationships. His idea was that whatever disturbs us from the past needs to be replayed in the present in order for us to feel it, understand its impact on our lives, and find relevant resolution to who we are now.

Through this "here and now" framework, Perls brought the client's attention to her body posture, tone of voice, gestures, and physical sensations. Enactments and dialogues would be developed as the way to make contact, respond to, and work with a situation or memory. Perls insisted that people stay in the present in order to experience themselves with more awareness and work on issues experientially rather than analytically.

For example, as a client recalls her relationship with her mother, she might begin to feel cold and shiver. In gestalt therapy, we might suggest that she stay with the shivering, develop it into a larger movement, and speak to her mother from this shivering experience. Or the shivering might take her into another feeling, such as fear of her mother. We might

then have her enact the scared daughter and the bullying mother using both movement and words.

In his personality model, Perls also explored the top dog/underdog dyad, the bully and the victim. The top dog part characteristically contains dominating, authoritarian qualities, and the underdog part contains weaker, helpless qualities. The gestalt therapy approach calls for confrontation and resolution between the two opposing top dog/underdog aspects. Perls (1973) used chair work techniques, where the client would play the two parts using words and gesture.

Perls' theory of personality included the concept of *ecological independence*, which viewed the human process as both internal and interpersonal. He proposed that boundaries are both the way that we differentiate ourselves and the way that we make contact with others. He used the metaphor of *mental metabolism* to describe the process by which we take in or "bite off" life experiences, including ideas, places, and relationships. He suggested that the healthy or unhealthy nature of our boundary either assists or interrupts our ability to digest and assimilate what we take in from the world around us. Disturbances in the boundary make contact and awareness difficult or distorted.

Perls defined the dynamic of disturbance of the contact boundary using five prototypes: *confluence*, or fusion with other; *retroflection*, or doing to self what you might want to do to others; *introjection*, or "swallowing whole," as in mimicking or organizing self around the "you should be"; *projection*, or confusing self with other or placing outside of self what is really your own experience; and *deflection*, or avoidance and turning aside. In working with the gestalt therapy techniques, the top dog/underdog dynamic as well as tendencies that might suggest these different characteristics of boundary disturbance become apparent and are worked through in dialogue and movement enactment.

Psychosynthesis

Psychosynthesis was developed by the Italian psychiatrist Roberto Assagioli (1888–1974), who was one of the pioneers of *transpersonal psychology*, which takes a step beyond humanistic psychology to address more

explicitly the spiritual dimension. The psychosynthesis model influenced the therapeutic orientation of my work during the mid-1980s. Drawing upon the traditions of psychoanalysis, Jungian psychology, existential psychology, Buddhism, yoga, and Christian esoteric practices, Assagioli expanded notions of the creative and spiritual aspects of self as unifying forces within the individual and within society.

Assagioli's early work as a psychiatrist took place in clinical settings where he researched and treated acute cases of psychosis. Assagioli (1965, 1974) described three concepts as central to his approach. The first is what he called the arousing and development of the will, the human capacity to harmonize conflicting drives and impulses toward creative and responsible action. The second is the transmutation and redirecting of biopsychic energies, particularly sexual, aggressive, and combative tendencies. The third is the awakening and releasing of the *superconscious* spiritual energies, which have a transformative impact on the personality. In a potent metaphor, Assagioli (1965) compared this release to the "intro-atomic energy latent in all matter" (p.8).

Assagioli's model describes various levels of self in terms of the flow of energy through realms of consciousness, from the unconscious to the subconscious, conscious, and into the superconscious. The restricted, interrupted, unbalanced flow of energy, or overinfusion of energy, into any of these realms was, according to Assagioli, the cause of psychological disturbance.

Assagioli's model for personality structure was defined by what he called the *core self*, the *subpersonalities*, the *superconscious*, and the *transpersonal self*. Assagioli suggested that the individual is a compilation of many parts (the subpersonalities), and that disease is a manifestation of the conflicts between these parts, the dominance of some over others, and the absence or lack of development of certain counterbalancing "healthy" parts.

Assagioli agreed with the concept that the whole person is known by encountering her parts, and that the parts must be brought into relationship with one another to achieve wholeness. Fragmentation occurs, from his point of view, as a result of an impact to the person. Such impacts create a splintering off from what he calls the *core self*. Depending on the nature and force of the impact, these parts of self, which he calls

subpersonalities, move away from or toward the center, and form isolated particles or constellations which hold various unconscious impulses, tendencies, and characteristics of the person.

By bringing awareness to and dialoguing with each part as well as creating dialogues between the parts, certain parts can be strengthened, the dominance of others can be weakened or dissolve, and new, healthy parts can be developed. Integration occurs through this process of awareness and dialogue. This model of personality included the possibility of many more "characters" at work within the person than the bully and victim of gestalt therapy. It also recognized the importance of working with the higher realms of consciousness. For Assagioli (1965), this process of bringing to consciousness, using the creative will in embodied action and synthesizing or reharmonizing conflicted parts, not only regenerates the intrinsic wholeness of the person but also leads to the door of what he called the Great Mystery.

Assagioli developed a method of creative dialogue and enactment, the evocation of sensory perception, and expressiveness to clarify and free clients from their identification with the subpersonalities and to integrate these parts around a central unifying sense of self. The use of many art mediums to develop awareness and engage in dialogue and enactment in psychosynthesis is far broader than in gestalt therapy. In fact, use of the arts in therapy are intimately interwoven in psychosynthesis.

Assagioli's extensive use of the creative arts in therapy included movement, visualization and active imagination, role-playing, creative writing, and the use of music and smells to evoke psychoemotional responses. This was based on creative and imaginative explorations of sense response, image, dream, symbols, and subpersonalities as reflections of the realms of consciousness and the parts of the life "story." The therapist was called a *guide*, acting as a collaborative explorer with the client, taking a more active role in the early stages of therapy, then slowly shifting to the role of witness in order to foster self-motivated inner growth as therapy progressed.

The survey of the schools of psychology I have covered in this chapter shows the evolution toward a synthesis that reunites art and psychother-

apy. In the remaining chapters of Part Two, we will see this synthesis expand to embrace an even larger role for the body and movement.

Somatic Psychology

In a way, my body is like the body of the earth, which with its mountains, valleys, river beds and uneven topography tells the story of its history and creation as surely as my body expresses the trials and creative changes that I have experienced throughout my lifetime.

Ken Dychtwald (1977, p.19)

Body-oriented approaches

The reinstatement of the body in psychological thinking and theories of personality was instigated by Wilhelm Reich (1960), the founder of somatic psychology. Rather than looking at the body from a "mechanistic" point of view, and rather than seeing its parts and functions as separate occurrences, Reich began an inquiry into the body as a powerful reflection of psychic processes and cosmic energy. Reich explored the interruption and free flow of energy manifesting in the body not only as a reflection of psychic processes but as an integral aspect of returning to health by freeing up the energy of consciousness.

Reich's (1960) holistic view of the body held that the entire history of the person was contained within the physical structure and organismic functioning. Reich proposed that the traumatic events of life cause muscular contractions in the organism that restrict the flow of what he called *orgone energy,* the primordial cosmic energy basic to all life. This freezing mechanism Reich called *character armoring,* and he developed a method to liberate the biophysical emotions it contained.

A contemporary of Freud, Reich developed *orgasm theory*, which placed the issue of sexual instincts and function in an altogether different and broader light, having to do with the restriction and release of psychospiritual essential energy. Reich's theories span the fields of biophysics, psychology, ethics, social functioning, and mysticism as they attempt to understand the very nature of what he called "the living man."

Reich's meticulous articulation of theories and techniques oriented to the emotional and mental life of the physical body instigated and inspired the field of somatic psychology and heavily influenced the body-oriented therapies of Alexander Lowen (born 1910) and John Pierrakos (1921–2001) (bioenergetics); Moshe Feldenkrais (1904–1984) (awareness through movement); Ida Rolf (1896–1979) (structural integration); Charlotte Selver (born 1901) (sensory awareness); and Randolph Stone (1889–1981) (polarity therapy).

Developments in the field of somatic-based psychology establish a contemporary therapeutic framework for combining verbal/intellectual, physical, and psychoemotional means to help us explore and resolve conflicts. In a challenge to the concept of body/mind split, somatic-oriented practitioners view psychological change as intrinsically related to the life of the body.

A number of significant body-oriented therapies emerged out of Reich's groundbreaking work, including that of some of his students, including John Pierrakos and Alexander Lowen (1975), who developed *bioenergetics*. In this lineage, though forging a different track, was Moshe Feldenkrais (1972, 1985) who began emphasizing what he called "awareness through movement" in the 1940s. Feldenkrais (1972, 1985) developed an approach called *structural integration* that focused on the relationship between the physical body and the emotional, mental, and behavioral makeup of the individual. His postulate, simply stated, is that there is a direct and ongoing correspondence between the way an individual functions and matures on all three levels: physical, emotional, and mental.

For Feldenkrais, the building of a healthy and sustainable self-image is intimately linked to the entire nervous system and, through the nervous system, to muscular and skeletal action and the motor cortex of the brain. Feldenkrais pointed out that it is far easier to be aware of our voluntary

muscles, just as it is easier to be aware of what we already know and to recapitulate familiar patterns. So, too, it is easier to maintain faulty posture even though it causes distress to the entire organism, just as it is "easier" to repeat familiar emotional responses whether or not they lead us to better conditions. By working at the level of the involuntary physical functions, and bringing awareness to the unknown or blind spots, we can change old patterns.

Feldenkrais illustrated this principle at work by directing our attention to the function of breathing, spontaneous and compulsive action, faulty and correct posture, and the body–mind connection. He offered a broad theory of the living human being, including such far-reaching topics as love, motivation, behavior, education, physiology, and social order. He explored the workings of the nervous system, the energy of the organs, posture, muscular tension, and the principles of alignment and action in movement. This investigation of the habitual patterns of the body, he demonstrated, helped to facilitate change.

Feldenkrais created a map proposing that emotions and beliefs manifested in specific kinds of tensions located in particular body parts. For Feldenkrais, the body served as a metaphor for the entire life experience, not only as a source of felt phenomena, but also as living action in motion. Reading the body map and changing the patterned body structure would, Feldenkrais believed, result in a different way of experiencing, moving, and acting in the individual's life.

The cross-pollination among fields that exploded during the latter part of the twentieth century meant that the work of Reich, Feldenkrais, and other pioneers in psychology and body-oriented therapy would have a profound effect on those involved in the artistic arena, particularly dancers, as we will see in the following chapter.

Dance

All that I know when I dance, I want to know in my life when I'm
not dancing.

Pernille Overo, Tamalpa Institute Student

To understand the importance of dance in the development of
movement-based expressive arts therapy, it is helpful to look again at the
larger historical context. In tribal cultures, dance has provided a means
for establishing and conveying the relationship between the mundane
and the spiritual, for integrating the individual and community, for
reflecting and enhancing the connection between the human and natural
world, and, through enacted myth in ritual, for marking important events
and meeting challenges.

In post-tribal cultures, dance turned toward representation and enter-
tainment. As examples of the deterministic, Victorian worldview, the
classical forms of dance, such as ballet, were pragmatic; in them, the
dancer mimics formalized steps to represent a fixed and formal interpre-
tation of "reality."

The emergence of modern dance at the beginning of the twentieth
century radicalized the art form and led to a series of new approaches to
dance and movement which deconstructed the classical orientation. Just
as the progression we have traced in the field of psychology revised our
understanding of the separation between body and mind and empha-
sized the importance of full human expressiveness, at the turn of the
century new approaches to dance followed a similar evolution.

At the heart of these revolutionary developments lay a far-reaching
inquiry into the relevance of dance/movement as a powerful means of

creative self-expression and as a form of psychotherapy. Pioneers of this "movement" began to articulate how dance can be used to work with the body and mind, and explored connections between expressive movement and psychological content in the service of fostering authentic expressiveness. Teachers of dance looked at movement as a form of embodied learning.

Anthropologists brought attention to the cultural significance of myth and ritual expressed in dance. Early innovators in this new thinking were François Delsarte (1811–1871) and Sir James George Frazer (1854–1941). Delsarte was a French opera singer who lost his voice and turned his interest in the theatre to the observation of unconscious movement, researching and developing a system of naturally expressive gestures for actors to replace the superficiality of theatrical gesture. With the publication of his book *The Golden Bough* in 1890, Frazer introduced an anthropological perspective of dance, citing his research on the role of ritual dance in primitive cultures, which inspired a renewal of myth, magic, and spirituality in modern dance (Frazer 1922; Levy 1988).

Influenced by these early innovations, the first modern dancers included Mary Wigman (1886–1973), Isadora Duncan (1878–1927), Martha Graham (1894–1991), and Ruth Saint-Denis (1877–1968), who focused on the idea and experience of the "freely dancing body" through the expression of emotion connected with myth, ritual, and spirituality. Artists became interested in using dance performance to evoke and challenge the audience emotionally. Dancers began to explore how movement could reveal the unconscious, interpret behavior, and facilitate change. Mary Wigman's work in Germany, known as *expressionistic performance*, aimed at paring dance down to its most essential movements and to the intense expression of emotion. Isadora Duncan and Martha Graham turned to classical Greek theatre to find naturally emotive movement that connected with archetypes and myths. Ruth Saint-Denis explored ideas and myths from eastern cultures and esoteric teachings. All were attempting to return dance to the exploration of both personal feelings and universal themes (Jahner 2001).

Early twentieth-century teachers such as Rudolph Laban (1879–1958), Margaret H'Doubler (1889–1982), Mabel Ellsworth Todd (1891–1969), and Irmgard Bartenieff (1900–1981) developed

methods for using movement and dance as an educational process. These pioneers articulated movement/dance as an art and science, examining the relationships between structural, functional, and emotive movement. They saw movement/dance as a creative learning process through which the mover could understand herself and her world as well as express herself. As much as focusing on the aesthetics of the dance, these educators emphasized the inner life, emotions, sensations, and development of the person expressed in movement and dance.

Margaret H'Doubler (1925, 1940) was a truly revolutionary thinker who broadened our thinking of dance beyond the scope of physical education, recreation, or a form of entertainment to be witnessed. A teacher at the University of Wisconsin, H'Doubler (1925) based her innovative philosophy on what she called a "search into the real nature of dance," which she believed would reveal the "aesthetic capacities of man and the real worth of his expressing himself through creative activity" (p.7). Her writings on dance as an individual and social path for depth learning, creative expression of emotional life, and development of the soul are quite inspiring and remarkable. H'Doubler was not a dancer herself but a teacher of dance, working with children and young university students, mentoring many, including Anna Halprin (born 1920), who later would herself pioneer new approaches in dance performance, dance education, and dance therapy.

Rudolph Laban (1960) developed a system for analyzing and notating movement based on four factors, *space, weight, time,* and *flow,* which became a theoretical model used by many dance therapists. He provided one of the first models of movement analysis, including a professional language that dance therapists could use in describing their work with clients. His protégé, Warren Lamb (1965), added the concept of *shaping,* which describes where the body forms itself in space. He defined shape in terms of three factors: its flow determined by changes between body parts towards or away from each other; its direction being the paths that movement makes in space; and shaping, which is the adaptation or molding of movement. The *effort/shape* model developed by Laban and Lamb became a common framework in the field of dance therapy.

Irmgard Bartenieff integrated effort/shape into her work as a physical therapist and went on to develop her own approach to body-movement education, focusing on the connection between structural, functional, and expressive movement. She perceived body movement as a complex, integrated whole which reflects the mover's ability to integrate body feeling and emotional feeling, as well as the mover's relationship to environment and others.

The evolution of dance/movement therapy

The challenge to the dominant concept of the function of dance led to the evolution of dance/movement therapy. Influenced by the changes taking place in early twentieth-century intellectual culture, this new field drew from and paralleled the psychological theories of Adler (seeing the aggressive drive as a positive force toward independence and self-reliance), Jung (incorporating active imagination, symbol, myth, and the value of the unconscious), Reich (psychosomatic expression), Perls (nonverbal enactment), May, Rogers, and Maslow (creative motivation and human potential), and J. L. Moreno (1889–1974) (who developed *psychodrama*, incorporating group interaction and dramatic dialogues). All stressed the powerful relationship between psyche and soma, emphasizing the positive and creative aspects of the unconscious and the imagination.

Dance therapy joined the widening field of nonverbal, nonanalytic, and nondiagnostic approaches to psychological health where the body–mind connection and creative enactment were central to the therapeutic process. Placing its total focus on the relation between the inner movement (sensation, feeling, image) and the outer movement expressed in dance, dance/movement therapy posits that movement reflects emotional states and can lead to psychological insight and behavioral changes.

Pioneers such as Marian Chace (1896–1970), Blanche Evan (1901–1982), Liljan Espenak (1905–1988), Mary Starks Whitehouse (1911–1979), and Trudi Schoop (1903–1999) were early innovators who began as modern dancers, choreographers, and performers and developed their work in hospital settings, as creative dance educators,

and then as dance/movement therapists. As these practitioners articu-
lated their theories and methods, the field grew, and they and their senior
students created university departments, led training workshops, and
took dance/movement therapy into private practice with clients.

Marian Chace articulated the therapeutic use of dance/movement
according to the following major classifications: body action, the devel-
opment of motility of the skeletal musculature, and recognition of body
parts, breathing patterns, and areas of tension which block emotional
expression (to allow a development of emotional responses which can
prepare the person for experiences of change); symbolism (the process of
using imagery, fantasy, and recollection in enactment); therapeutic
movement relationship (how the therapist or teacher perceives, reflects,
and responds to the client's or student's expression through her own
movement interactions, voice, and words); and group rhythmic relation-
ship (the facilitation and enhancement of group rhythmic action by
which chaotic or confused elements are organized into meaningful
dances).

Blanche Evan called her work "creative dance as therapy." Believing
that what cannot be expressed in words can be expressed through
movement and metaphor, Evan's early area of specialization was creative
dance with children (Levy 1988). She stressed that dance therapy should
not be limited to the mentally ill but should be brought to the wider pop-
ulation; that is, the "normally neurotic urban adult." Evan's methodology,
like that of Chace, was organized according to what she identified as the
primary therapeutic capacities of movement: functional change
(including postural work, coordination, organization of body parts, and
rhythmics) and improvisation-enactment (by which the individual is able
to experience the "physical equivalent of the psyche in the body through
action").

Evan's improvisation-enactments involved the use of projective tech-
niques such as fantasy and images (for instance, moving as if you are a
color or moving an imagined conflict); sensitization and mobilization of
potential body action as a means for broadening the person's repertoire
of expression; and in-depth or complex improvisation, where a structure
is created to explore a particular theme or problem.

Mary Starks Whitehouse (1999) worked primarily one on one with high-functioning adults. She first called her approach *movement in-depth* and later *authentic movement*. She remarked that a significant turning point was the day when she realized that rather than teaching dance, she was teaching people. More than theory or philosophy, the inner life of the mover was of primary interest to Whitehouse. For her, movement was a way of becoming conscious more than a way to "act out." She drew from Jungian psychoanalysis, emphasizing revelation of the unconscious through movement, and attending to sensation and images through nonmovement as much as through expressive movement. Like Jung, she believed that deep, inner directed movement can lead to an experience of the "transcendent."

For Whitehouse (1999), "the body is the personality on the physical level and movement is the personality made visible" (p.52). Her approach focuses on the significance of developing kinesthetic awareness in order to connect movement expression with emotion and subjective response. For Whitehouse, the therapeutic experience rested on the bridge between inner movement and outer movement authentically expressed. To get to this sort of movement experience, she believed that people would need to "sacrifice" all stylized, patterned ways of moving and thinking, and work at a very introverted level to become aware of deeper sensations and images.

Whitehouse also worked with *polarity*, which she believed was present in all things and formed a cornerstone of her approach. She believed that movement offered a powerful literal and metaphoric pathway for working with opposites. Drawing upon Jung's active imagination and his theories on individuation and the distinction of self as ego-centered and self as connection to the transpersonal, authentic movement's primary aim is to make the unconscious conscious.

One of Whitehouse's innovative contributions was in the realm of therapeutic intervention. She based her responses on feeding back to movers what she witnessed, or asking movers questions about where their movement was taking them, rather than interpreting or making a meaning of what she saw. She stressed the importance of talking in between movement improvisations to allow reflection on the movement experience.

Rather than mere catharsis, authentic movement encourages an internalized encounter through nonstylized natural movement, where the person often works with eyes closed and the witness "holds the space" simply by being there in a noninvasive, less action-oriented manner. Whitehouse's description of movement and change in her essay "The Tao of the Body" (1999) captures the esoteric quality of her thinking and approach.

Mary Whitehouse's senior students, Janet Adler and Joan Chodorow, continued to develop and expand on her original work in their theoretical and philosophical contributions to the authentic movement approach (Pallaro 1999).[1]

Trudi Schoop made a unique contribution to the field by integrating her experience onstage as a mime and by introducing the important concept of externalizing conflict. Like Whitehouse, Schoop believed that people are pulled by opposite forces. Schoop believed that movement/dance offered a way to free up repressed and conflicting emotions. Schoop used improvisation and performance, guiding her clients to exaggerate the expression of emotion in posture and movement and to enact the extremes and various parts of themselves like a cast of characters. She used her great sense of drama and humor, creating an atmosphere of safety, free play, and creative distancing. She believed that once people were able to connect with their own finite reality through this kind of creative confrontation and working through, dance would also provide a way to connect with the larger, infinite universal life energy.

While dance/movement therapy proposes its own set of principles, theories, and models, there are many parallels with the practice of movement-based expressive arts therapy which I describe in this book. Both approaches draw from principles intrinsic to the art and science of the body and movement, and the relationship of the body and movement to psyche. Movement-based expressive arts therapy works quite actively to bring "inner" sensation, feeling, and image into "outer" action by employing the full range of the creative arts: movement/dance, drama, voice, painting, poetry and other forms of writing, ritual, and performance. This approach also focuses on the creative process as a psychological mirror, and suggests its own particular interactive dialogue between

witness and mover, and individual and group, as well as working with themes and metaphors in a particular way.

Postmodern dance

Anna Halprin (born 1920) is often called the first postmodern dancer, and she was a chief pioneer of dance as a healing art. As a student at Wisconsin University, Halprin studied with the dance educator Margaret H'Doubler, who served as her mentor. Deeply influenced by Moshe Feldenkrais and Fritz Perls, by the aesthetic philosophies of the Bauhaus School and the ideas of such teachers as John Dewey and Rudolph Arnheim, as well as by the design work of her husband Lawrence Halprin, Anna Halprin became a pivotal figure in the West Coast avant-garde.

A dancer, performance artist, and teacher, Halprin developed a unique and revolutionary approach to dance as a healing art while at the same time the originators of dance therapy were developing the new field. In the spirit of her studies with H'Doubler, Halprin explored the body in its most organic states of natural movement. She drew from the science of the body and of movement as well as from the aesthetic perspective for her approach to movement. Like Whitehouse, she has insisted that she practices an approach rather than a method, reflecting her commitment to breaking down the conventional understandings of dance in favor of focusing on creativity itself as a generative process. Her work revolves around nonstylized movement connected with kinesthetic awareness and the inner images or story of the dancer.

In her early years, Halprin took her dancers out of the studio and off the stage and put them into the environment of the natural landscape and the city landscape. She collaborated with artists from diverse disciplines, developing one of the first intermodal approaches. Looking for the most relevant thematic material, she focused on the issues and themes of the times and culture in which she lived. Her performance work turned to myth and ritual, but the myths she crafted were myths of the present times.

Challenging the traditional proscenium theatre that had defined performance space and separated artists and audience, Halprin allowed her

dance pieces to spill off the stage into the auditorium, theatre lobby, and street. Just as she had broken through the boundaries of stylized dance, the naked and clothed body, the studio and everyday landscape, the racial and cultural divide, and the lines that separated artists and art mediums from one another, Halprin also turned her performance pieces toward audience participation. She worked primarily with untrained dancers and with people from diverse cultural-ethnic backgrounds, as well as with musicians, painters, lighting designers, actors, and psychologists.

Over time, Halprin's focus shifted from performance work to workshops and teaching. When Halprin was diagnosed with cancer in 1971, her focus shifted toward explorations of dance for personal healing as well as community rituals aimed at healing social challenges. From the early 1950s, Halprin's work paralleled the alternative developments of the original dance therapists and the artists of the radical avant-garde. In the next chapter, we will turn our attention to the contextual roots of modernism, postmodernism, and the avant-garde, and the emergence of expressive arts therapy out of this fertile ground.

Note

1 Fran Levy's (1988) book *Dance Movement Therapy: A Healing Art* provided valuable reference material for this section on the history of dance/movement therapy.

Modernism, Postmodernism, and the Avant-Garde

Everything is in flux.

Heraclitus

Once again, it is important to understand the larger historical context so we can see how modernism and postmodernism fertilized the growth of expressive arts therapy. The modern era saw a movement away from the Enlightenment, the Age of Reason. Eighteenth-century thinkers hoped to free humanity of its suffering by dispelling myths and superstitions in the name of progress. Values were centered on science, logic, and the mechanistic viewpoint.

Thinkers of the modern age challenged the authoritarian-based power structures of the eighteenth century, during which the gods of church, state, and science predominated. When Nietzsche declared that "God is dead," challenging Christian morality, he was speaking of the corrupt and élitist power structures that had ruled in the name of progress; he believed these power structures had robbed the "populace" of their expressiveness, creativity, and sensuality. He foresaw the void left as a result of the dissolution of guiding myths and traditions.

The modernists asked: If truth was not to be found in the order proclaimed by the church, the state, and science, then where was it to be found? With the breakdown of institutional authority, what kind of center might offer inspiration, hope, and shared values?

The modernists attempted to fill the void with new presentations of myths that would impart essential values in the midst of chaos,

impending nihilism, and anarchy. Modern artists looked for what might hold value in a world lacking a clearly defined moral center. In the first half of the twentieth century, there was an explosion of new trends in the arts; the call was for "everything new."

Renouncing convention, artists and writers such as Pablo Picasso, Jackson Pollock, James Joyce, and T. S. Eliot experimented with paint, image, and words, breaking things down to basics, exploring the "inner truth" beyond appearances. What became important was light (the Impressionists), line and shape (Paul Klee and Wassily Kandinsky, along with Picasso), paint as color, texture, and movement (Pollock). The surrealists worked with the principle of nonlinear juxtapositions and dreamlike images presented as "another reality," often bordering on the nightmarish or otherworldly. Surrealist technique strove to work unconsciously from the unconscious, using "automatic expression," nonintentionality, attempting just to "let it happen," or flow. Shaun McNiff (1992) describes surrealism as calling for "the participation of the entire society in the dissolution of separations between art and life" and suggests that surrealism was a particular precursor to the way painting is approached in some expressive arts therapies (p.50).

Writers and poets began playing with words as free association and "stream of consciousness" (T. S. Eliot, Virginia Woolf, and James Joyce). Ancient myths were re-presented in contemporary story line (D. H. Lawrence, W. B. Yeats, James Joyce). The composer John Cage experimented with random sound and silence. The artist Marcel Duchamp defined art as that which the artist points at. New concepts of aesthetics arose which proposed art for its own sake.

Aesthetics in architecture, most notably represented by the Bauhaus School, decried frivolous, ornamental styles in favor of the beauty of essentials; functionalism emerged, emphasizing light, simple lines, and the new materials – steel, glass, concrete, and wood. In this new aesthetic, form was to follow function; the question became how could design facilitate and reflect an experience of the "pure" nature of things.

Nature returned to center stage with the design of urban parks and suburban homes oriented to the outdoor landscape. Decks and terraces provided the transitional space between indoor and outdoor living. If human beings could no longer live in nature, then the new architecture

would bring nature back to humanity. The work of Frank Lloyd Wright placed organic design at the forefront of architecture, stressing naturalism over decorative style. The asymmetrical forms of nature reflected in constructed dwellings attempted to return people to organic living.

Thinkers such as John Dewey and Rudolph Arnheim began to look at aesthetics from incredibly wide interdisciplinary viewpoints, going beyond what was relevant to artists alone. For instance, Arnheim (1972) described the core belief of the twentieth-century art teacher as a radical departure, arguing that art is not the privilege of the few but a natural activity of every human being; that a genuine culture depends less on the rare geniuses than on the creative life of the average citizen; and that art is an indispensable tool in dealing with the tasks of being.

The new aesthetics looked at the relationship between sensory experience, meaning, and new interpretations of beauty unbounded by formal ideas. In other words, how does it actually feel, and how is the imagination evoked? These new thinkers redefined art as serving a much greater purpose than mere decoration and entertainment; instead, they saw art as intimately connected with the core needs of human life. Applications to psychology, education, philosophy, and the broadest societal concerns formed a new philosophy of aesthetics. This was particularly important since much of modern art, with its emphasis on the personal, subjective experience, was essentially self-absorbed, thereby intensifying the lines between the middle and lower classes and the élite.

Postmodernism marked an explosion of new trends and styles in the arts. The demand of the postmodern world was to integrate and live with differences. Postmodern thinkers and artists immersed themselves in the everyday happenings and ordinary things of their culture, and then tried to reflect them back. During the 1960s, artists of the avant-garde movement took Marcel Duchamp's earlier declaration (defining art as that which the artist points at) even further into explorations of "ordinary life" activities.

The art event was called a *happening*, where artwork took place outside the studio, theatre, and gallery, placing the making and performing of art right in the midst of daily life. Members of the audience were the passers-by, and art materials were whatever you brought with you or found. In this way, artists themselves became the medium in interaction

with the material provided by the most mundane and common objects of life.

Avant-garde performance art focused on process, on whatever emerged in the moment of artistic encounter. Improvisation was about throwing oneself into the unknown and working with the element of the totally unexpected and accidental. Avant-garde artists attempted to break down the conventional lines between artist and audience, artwork and the everyday. Just as art was whatever the artist pointed at, the audience was whoever was passing through the chosen landscape of the artist. This was a way of bringing art "into the street" and fully engaging the unsuspecting community in artistic experiences.

The avant-garde movement spawned a series of works, including experimental music, theatre, dance, and painting. All of the elements of art making were thrown up into the air and landed in totally unexpected ways. Artists began experiments in mixed media and multimedia creations and events. Dancers worked with musicians, poets, actors, and painters in total collaboration.

Allan Kaprow (born 1927), who coined the term *happenings* in collaboration with Halprin's Dancers' Workshop Company, went out into the streets of San Francisco, using the downtown financial district as a stage set. Dancers moved amidst pedestrians in business suits with briefcases, mothers taking their children for an outing, and shoppers, running, walking in slow motion, directing traffic, crawling over cars, standing still in a held posture next to a stop sign, or intentionally imitating and improvising with the movements of a passer-by.

Postmodernism deconstructs the concept of one dominating narrative in favor of popular stories and the play of opposites coming together in new and eclectic mixes. Harmony and balance, the postmodernist declares, are to be found in the disharmonious and dissonant beauty of different elements brought into relationship. Postmodern values are shaped in the meeting places between past and present, and in the co-existence of more than one meaning and experience. The concept of one center as a way of defining experience is seen as exclusionary and marginalizing. Attempts to fix an "only reality" are challenged in favor of the nonhierarchical free play of opposites, emphasizing how things are related rather than why they are related.

Interconnections

With these explorations and political and cultural responses to the idea of valuing the multidimensional and diverse aspects of the individual and group, the play of opposites and the interconnection of many parts came back into view. The connection between past and present and between individual and collective narratives, the significance of sensory perception, the value of difference and diversity, and the metaphoric significance of daily life happenings led to the acceptance of new approaches in therapy, education, group facilitation, and health care as well as in the arts. Concepts of interdependency, of many parts held by one web, brought environmentalism and spirituality back into the mainstream, and placed them in relationship to the arts, education, and science.

In education, nonlinear ways of learning through the development of sensory perception, artistic expression, and work with individualized learning differences were reflected in the early twentieth-century work of Marie Montessori (1870–1952) and Rudolf Steiner (1861–1925). Alternative schools for children sprang up in almost every community and expanded to include educational approaches for all ages.

Alternative (or complementary) medicine was rediscovered, and in many circles has been accepted as equal or even superior to the orthodoxy of the mechanistic western medical approach, with its focus on diagnosis and treatment of symptoms. This allowed for the return of ancient forms of medicine, such as acupuncture, and the more recent but forgotten forms, such as homeopathy and naturopathy, chiropractic medicine, and various forms of herbology. With the now widespread use of alternative medicine, the treatment of disease takes into account the whole person, physical, emotional, mental, and spiritual. This paradigm understands health as the freeing up of the natural energy of internal movement. Treatment brings the poisons to the surface and releases the blocks in energy to restore balance and harmony between all of the parts of the person.

The field of science, like the fields of art, psychology, education, and medicine, also demonstrated this shift away from the mechanistic view of the eighteenth century. Philosophers probed the nature of ultimate reality, psychologists probed the nature of personality, and artists probed

the nature of medium and expressiveness, while the new scientists probed the nature of matter.

Challenging the Newtonian view that reduced all phenomena to the motions of hard, indestructible atoms and the image of nature running like a machine, Einstein's (1961) theory of relativity (developed between 1905 and the late 1920s) led science back to a concept of nature's inherent harmony. Einstein's discovery described mass as a form of dynamic energy associated with activity and process. Particles, he discovered, are not static objects but are constantly involved in a movement toward (attraction) and away from (repulsion), like a dance between opposites.

Modern science has discovered that all matter is made up of the same energy, with movement at the core, governed by laws and principles regarding chaos and order, attraction and repulsion, inertia and change, and creativity that are present in all processes.

Patterns called fractals (Briggs 1992), captured in photographs of mathematical equations, plant life, and cellular structure, reveal a complex web of form and color which resemble pieces of art, establishing the probability of interconnections; this concept has changed the way scientists discern patterns at all levels (Jahner 2001).

Quantum physics describes the subatomic level of matter as a dance of particle and wave guided by the energetic force of chaos and order. Chaos theory (Briggs 1992; Briggs and Peat 1989) describes an intrinsic process of disequilibrium which generates chaotic activity and is followed by an inevitable process of self-organization. This could just as well describe any psychological or artistic process, where we find ourselves needing to work through the inevitable phases of fragmentation, dissolution, and despair, which, in the right environment, or with the necessary input, are followed by the inevitable process of reorganization and transformation (Prigogine 1996; Prigogine and Stengers 1984).

With physicists describing the planet and the universe in terms of energy, rhythm, movement, creativity, and one universal consciousness which self-witnesses, the links between the laws of science and those of psychology, art, and spirituality discovered by the Greek philosophers and eastern mystics have been reestablished.

The period of experimentation and exploration in the 1960s and early 1970s saw artists, psychologists, educators, philosophers, and scientists beginning to gather together and cross over into interdisciplinary pursuits, increasing the breadth and depth of their discoveries. Since to some degree many had been unaware of the parallel discoveries in other fields, this second renaissance brought with it incredible innovation based on mixed media in the arts and a cross-pollination between fields and pioneering thinkers.

The emergence of expressive arts therapy

In the mid-1970s, expressive arts therapy emerged as part of the movement from modernism to postmodernism. Building on the foundations of the phenomenological philosophers and psychologists, as well as on ancient, modern, and postmodern practice of the arts, the founders and contributors to this new field brought together the strains of European and American thought, experimentation, and innovation. However, expressive arts therapy is not simply a conglomeration or readjustment of previously articulated theories, nor is it a hodgepodge of various art practices. Rather, this "new school" places the western and eastern traditions and the ancient practice of the healing arts squarely within the context and culture of contemporary life.

Expressive arts therapy proposes a radical approach, joining art and psychology to facilitate embodied learning and expressiveness. Based on the use of intermodal arts, expressive arts therapy sees the relationship between imagination and sensory expressiveness as the pathway for drawing forth awareness, creativity, and change. The interplay between psychological and artistic processes is the ground from which disturbance and new options for insight, change, and health are explored.

Shaun McNiff (1981, 1992) and Paolo Knill (Knill, Barba and Fuchs 1995; in Levine and Levine 1999) at Lesley College in Cambridge, Massachusetts, developed the first academic department in expressive arts therapy education in 1974. At the same time, I was developing and teaching an approach to movement-based expressive arts therapy at the Tamalpa Institute in the San Francisco Bay Area, California (Halprin 1989, 1999). In the 1990s, Jack S. Weller at the California Institute of

Integral Studies (CIIS) in San Francisco, California, developed the second university program in expressive arts therapy, and the International Expressive Arts Therapy Association was established.

Paolo Knill is a seminal figure in the founding and development of expressive arts therapy as a recognized and respected field. In his early years Knill was a scientist as well as an accomplished musician. Also a member of the avante garde art movement, it is this multidimensional and experimental background that Knill brings to his approach as an artist, teacher and therapist.

For Knill it is the practice of the arts and the art works themselves which act as a change process. Rather than integrating art into psychotherapy, it is from an orientation which is centered in the arts that Knill articulates the philosophy, theory and praxis of expressive arts therapy. In his book, *Minstrels of Soul*, and in numerous articles, some of which appear in the Poesis Journals, many of Knill's main theories are presented. Rather than a superficial rephrasing of his important concepts, I would refer the interested reader directly to Knill's own writings. I will, however, mention briefly just a few of his key formulations.

Looking at the work of the musician and educator Wolfgang Roscher during the 1950s, Knill discusses the significance of what he calls the "new polyaesthetics" to the intermodal techniques of expressive arts therapy. A significant model developed by Knill and central to his thinking is *crystallization theory*, which pertains to the ways in which an art medium can facilitate psychic material in coming into "optimal clarity, precision of feeling and thought" (p.30). Relating to polyaesthetics, he proposes a model that describes each art medium in terms of a *communication modality*, which facilitates crystallization. The *intermodal transfer*, a phrase coined by Knill, is the shift from one art medium to another, according to what will enhance the focusing process, emotional clarity and the imaginative range. As explained by Knill, the intermodal transfer facilitates crystallization through the development and the clarification of the psychic material (images, feelings and meanings).

Knill also speaks about the art process as a way of *decentering* in order to "see" the material and the life experience in a new light, in other words, to generate new resources and solutions. He uses the phrase "an alternative experience of worlding" to describe the process that I believe is at the

root of arts in therapy. For Knill this phrase describes the process by which the arts engage and expand a "range of play" not available in everyday life or in the more conventional ways of relating to our narratives of distress.

A great visionary committed to the growth of this field and to the evolving and collaborative nature of the work itself, Knill spearheaded the founding of a network of expressive arts therapy training institutes around the world. Yearly Symposiums were started in Europe and North America where students could join in master classes and in a festival of the arts to experience a variety of approaches and to learn about the field. In founding the European Graduate School in 1995, Knill established an international campus where teachers and students from affiliated institutes and universities around the world gather each summer for intensive studies and collaboration.

Applications of expressive arts therapy span a range of settings, including one-on-one therapy, workshops, classes, training groups, artist laboratories, clinics, schools, hospitals, and the workplace, where it serves to facilitate collective creativity, communication skills, and problem solving. The style and specialization of the expressive arts therapist, teacher, or facilitator vary tremendously, and client populations range from children and teenagers through adults. Each practitioner usually has a particular specialization based on training in one of the arts, while she incorporates many of the arts. For instance, some practitioners might emphasize music, while others highlight poetry, theatre, painting, or movement/dance, as the approach in this book does.

Far from being a closed and fixed system, the field of expressive arts therapy continues to evolve and mature in response to the nature of the work itself, to the surrounding culture, and to the compelling issues and needs of society and the ongoing collaborations between its practitioners and colleagues in related fields.

New paradigms

The new paradigms of the twentieth and twenty-first centuries attempt to reframe our understanding of the complexities of life in the postmodern age – including the necessity to move with chaos and diversity, the certain

birth of new order, and the constant movement of consciousness in all things. We are returning to the principles and laws by which people and communities lived in the most ancient of times. Yet we are making this full circle in new ways, on new ground, with new and more complex challenges. In the fields of psychology, philosophy, art, education, medicine, and science, these new paradigms are pointing us toward a more embodied life, one in which art, science, psychology, and spirituality are no longer divorced or kept separate but rather are reconnected through shared metaphors and universal principles and ideas.

During the twentieth century, we witnessed a remarkable expansion of shared knowledge, an explosion of available information, and a high level of exchange and cross-pollination. Although in some cases, there is the risk of losing the depth and integrity of a particular system, the synthesis and cross-fertilization signal the need for a very different way of thinking. In developing our creative intelligence, we must understand it not from Descartes' point of view ("I think, therefore I am"), which equates our entire identity with the one-dimensional mind. We must, instead, understand creative intelligence as belonging to the whole organism and to the many dimensions of mind in the process of becoming conscious.

We have not yet embodied the image and the reality of the web of interdependency, nor have we responded to the global imperative. In this quest for wholeness, it is fitting to bring together all of the knowledge which has been discovered and rediscovered in the search for our true human nature. The modern world, driven by the industrial revolution, generated mass production; the postmodern world has generated mass information, consumption, and an influx of ever-changing styles and trends.

Postmodernism opened our perspective as a culture to a view of reality that challenged mechanistic and dualistic thinking – a fixed center and moral system determined by a hierarchy based on good or bad, have or have not, body or spirit. Ownership of the body, imagination, and spirit by church and state has been challenged. Difference, diversity, and multileveled interpretation of experience have been given renewed value. However, for all of its significant breakthroughs, the postmodern world has not yet fully addressed the loss of soul in our culture. As James

Hillman (1975) suggested in his radical challenge in *Revisioning Psychology*, a century of psychotherapy has not enlightened us.

Body and imagination continue to be used primarily for the sake of creating commodities to be sold in the marketplace. Mainstream art is oriented toward easily consumed entertainment, feeding off our materialistic desires and fears. When faced with conflict and difference, we are not so different from people of the Middle Ages whose strategies were based on conquering and destroying. We now possess a vast array of tools, information, and access to the global community, but this has not resulted in an equal amount of shared knowledge or resources.

How will we respond to the ever-increasing demands and threats of a highly accelerated and fragmented world in the twenty-first century? What comes after postmodernism? Will the living of an embodied life with consciousness at its center serve as the next cultural prototype?

Reclamation of soul in our culture requires that we free body and imagination from the grip of consumerism, that we base our commitment to aesthetics not only on the outer beauty of the things we own or want but on matters of the inner world beyond appearances. Must it be one or the other? Is it necessary to forsake the material world in order to find soul? If so, then as a global body we are certainly lost. Or can we benefit from the modern and postmodern phases of our development and live from that threshold where inner and outer worlds meet, where darkness and light, suffering and freedom, are understood and lived in their proper relationship? For it is in the luminous space where each reflects the other that soul and spirit are to be found.

Plato's expression *techne tou biou,* meaning "the craft of life," suggests to us that we need more than an increased capacity to "do life," whereby we become identified with and by the things we have. Rather, we need to enhance our capacity to *be* in life, with, as the humanists believe, our innate capacity for awareness and creativity leading us toward a meaningful existence. This view of life as a craft challenges us to think of the living of life as an art form in itself, requiring the development of sensitivity, tools, skills, attention, and presence.

The ability to live fully and expressively in the present, to develop a mature relationship with the past and to "dance with" the pull of opposite forces within and around us, is essential to the art and craft of life. For this

we need practices which strengthen our commitment to learning and to change, what Alfred Adler, Rollo May, and Roberto Assagioli called *creative courage* and *will*.

Our endeavor now is to find ways to honor the sacred traditions and myths of our tribal ancestors, for they represent our roots, our earliest search for meaning. It is also our task to travel past our ancestors in the conscious awakening and creative expression of the self in our world today. Such an awakening must include our inherent human need and passion for creative expression, for it is in creativity that we will find our impulses toward life and growth.

The need for a connection to the whole of creation gave form to the cultural expressions of ancient communities and sages. In our personal and collective growth, we need to continue to evolve creative forms to manifest our most basic human needs and potentials. The practice of movement-based expressive arts therapy, which we will explore in detail in Part Three, provides tools and guidelines to help facilitate this transformation. Through the act of enlivening and manifesting the creative self, all our different parts begin to find good relationships with one another. What we are able to embody in ourselves, we are able to bring into our relationships with others and into the world. Remember Kabir's poem which began our review, "I laugh when I hear that the fish in the water is thirsty..." – our thirst for soul will not be quenched by traveling abroad, but by traveling inward, and, when we find ourselves, we will rediscover the world.

PART THREE

The Practice

CHAPTER 8

Creativity, Art, and Therapy

Creativity should be explored as representing the highest degree of emotional health, as the expression of normal people in the act of actualizing themselves.

Rollo May (1976, p.38)

When we speak of art and creativity, the connection is presupposed and immediately understood. But we will be considering a less obvious relationship. In expanding our notions of artistic and creative processes beyond the purview of the professional artist, we are proposing a therapy that is powerful by virtue of its foundation in the creative process. We know what creativity and art have to do with each other, but what do creativity and art have to do with therapy?

Seen from the widest view, the process of therapy includes all of the ways people become conscious of themselves and are able to change. The therapeutic process requires what we might call a descent or a going inward, a temporary suspension of our linear thinking and day-to-day living. Such an in-depth encounter, though not easily entered into, allows us to explore our pathos and reclaim the parts of us which have been lost. Our tendency is to stay with the familiar and shy away from true soul searching. In the Sufi tradition, there is a figure called Nasrudin, the clown as teacher. By way of example, consider this Nasrudin teaching story:

A friend walking home one evening finds Nasrudin crawling around on his hands and knees under a street lamp. "What are you doing?" his friend asks. "I'm looking for my keys," says Nasrudin. "Let me help you," replies his friend. "Where do you think you lost them?" "Oh, I lost them somewhere down the road," Nasrudin answers. "But then why are you looking here?" asks his friend in astonishment. "Because," answers Nasrudin, "this is where the light is."

This deceptively silly story actually speaks to a challenge not easily met. If we are to dare to leave familiar ground and challenge our accustomed patterns, we need tools that will help us connect with our creative energy. Illuminating and transforming metaphors become essential. The creative art process generates an energy much like that of light, so that as we travel into dark places we are able to break through into new experiences of reality and new ways of being. As we consider this, we will look at the metaphoric relevance of creativity, art making, and artwork to the thera-peutic process and, in fact, to any process whose aim is the development of consciousness and self-actualization.

Creativity as life force

At the core of the life force is the presence of a constant moving and creating energy. Intrinsic to this "dance of life" are all of the variations of energy moving – flowing, fragmented, gentle, forceful, expanding, con-tracting, dense, light, dissipating, and regathering. Out of this generative process, all life forms emerge and manifest in the natural world and in human consciousness and action. The creative play of the life force lies in the flux between creation and death, harmony and conflict, like elements and opposite elements forming in relationship to one another.

Observing the presence of this creative play in the natural world can be inspiring, renewing, and beautiful. Think of your favorite setting in nature. You might take a walk to this environment to refresh your spirit. Each time you visit this place, if you are really paying attention with all of your senses, you will notice that some things have grown and others have not, some things have died away and some have been changed by the influence of other elements. Temperature changes affect the feel and

appearance of the landscape. Night and day revolve in a never-ending cycle.

It is a great challenge to apply this principle to the landscape of the psyche – and embody it. What is fascinating and inspiring to observe and appreciate in nature often seems problematic in our personal lives. When we observe the ocean "acting" on the land, we do not say, "Damn that ocean for turning rock into sand." Yet we make these kinds of value judgments about almost every situation in our lives. We actively resist what could be a very creative interaction between the ocean and the rocks in the landscape of our lives, and so we never have much of a sandy beach where we can collect shells or lie comfortably in the sun.

Creativity connects us to the natural process that exists in all things on the biological, emotional, mental, and spiritual planes. Tapping into the energy of this foundational life force constantly moving in us and around us, we can reconnect with the innate human impulse for creation and evolution. We can develop the capacity to tolerate tension and let go of static and constricting forms that block the healthy and creative flow of life energy, the very flow that makes change possible.

As these basic impulses and capacities in us are awakened and strengthened, so is our innate intelligence, which allows us to apprehend creative relationships between what often seem like contradictory pulls. For instance, a client who is afraid of love but who has drawn the painting of a woman in love gives herself over to all kinds of art dialogues between the two impulses in herself with total commitment, great abandon, and immense delight.

When we are immersed creatively, we feel a sense of passionate aliveness, engaging our total and committed participation in life. We feel encouraged to take risks, to "put ourselves out there," to explore and consider all of our "stuff" as grist for learning. Our process, and all of its content, becomes interesting, illuminating, and productive. When we are tuned into the "creative flow," we experience a freedom of our energy and expression, and an unusually heightened sense of awareness.

Such infusions of creative energy often connect us to the larger Self, or what we might call the divine, and the direct experience of unity. When we return to daily life and whatever challenges we identify with, the experience of being connected with this creative life force allows us to

bring back with it fresh perspectives and knowledge. In fact, freeing up this creative energy frees up our whole way of being.

The unconscious and imagination

On the level of psychology, the creative process connects us with the unconscious, opening us up to the impressions of the psyche that lie out of reach during our ordinary daily routines. Working in a "nonlinear" way, which creative process engenders, brings forth content from the unconscious – images, memories, sensations, and sources of knowledge or ideas that we do not get at directly through analytic thinking or the censoring mind.

Returning to Rollo May's proposal that we should explore creativity as "representing the highest degree of emotional health," I would add that the absence of creativity inhibits our well-being. We can see that, without creativity, we lose access to the richness of the unconscious. Mirroring western society's long history of fearing and resisting the mystery of the nonrational, intuitive qualities of the imagination, our educational, religious, family, and social training cuts off the link between creativity and the unconscious very early in our lives. Instead, the social imperative values goal over process, and linear thinking over imagination. Activities that cultivate and provide an outlet for imagination are relegated to the backseat, seen as "extracurricular pursuits" or "hobbies."

Lack of creative dialogue with the unconscious robs us of the opportunity to use the vast amount of energy and resource material of our inner life for conscious understanding and expression. The pathway between imagination and unconscious made possible by the creative process is, therefore, as significant for all human beings as it is for the declared artist.

Another way to think about creativity's importance to psychic balance is through metaphor. Imagine that creativity keeps the water of the psyche moving. If the water gets dammed up or goes unused, it loses its capacity to flow freely, and then its vital energy gets stagnant and swampy. Over time, the unused water sinks deeper underground, into the unconscious. When artists work, they draw on this underground water through the creative act.

When we are making art or involved in any kind of creative endeavor, accessing the unconscious is something like stumbling across the meaningful material that wants to emerge into the light – to be seen, felt, listened to, and given form. The creative process is circular, meandering, sometimes rather fragmented. It is not goal oriented; it is not focused on outcome. Like the unconscious, creativity functions as an underground reservoir which flows beneath the obvious and apparent everyday level of things. In opening up the creative channel, we are restoring access to the unconscious and to the interior world of the intuitive self, allowing our thinking mind to flow freely, to meander, and to stumble upon the material that most wants to emerge.

The unconscious and imagination are intimate partners in such a creative process. However, the unconscious acts on its own as the container filled with potentially rich ingredients. If we think of the creative life force as our basic fuel, the imagination provides us with the material needed for the creative expression of the unconscious. Artists are known to cultivate and work from this rich dialogue between the unconscious and imagination expressed in the creative act.

Imagination is the meeting ground where old and new come together – what was, what is, and what could be. The imagination, as Ellen Levine (Levine and Levine 1999) puts it, "takes us beyond and behind the everyday" and toward the "active transformation of experience" (pp.259–260). Imbued with both receptive and active qualities, imagination holds images for us to reflect on as they emerge, percolate, and come together. Unlike fantasy, imagination in its active orientation includes embodiment, the impulse by which we feel the necessity and drive "to make visible." John Dewey (1934) described it as a *faculty* which brings together diverse images, feelings, and senses for the creation of new forms of unity.

Together, the unconscious and imagination form a bridge between our inner life and vision and our outer expression in the world. If the unconscious is the holder of past impressions, then it needs imagination to enter the exterior world. Through the imagination, we penetrate the interior world and shape its contents into meaningful and visible forms. Indeed, it is imagination that allows us to live as creative beings in the world.

Creativity as process

As we engage the unconscious and imagination in creative processes, we experience ourselves as active participants in life, explorers with the power to reshape our responses to our life stories rather than victims of our circumstances. Whereas creative energy as life force simply exists and moves, we must generate and learn the creative process as activity.

In a therapeutic sense, the creative process mobilizes volition and cultivates our ability to respond. Looking at creativity in the context of therapy, choice making activates volition as the client is called upon to pay attention to what is happening, to determine focus, to shape her material, and to modulate her expression and action according to changing conditions. "Response-ability" is developed and exercised in each moment that these choices are made and expressed in action. In these "creation moments," sensation, feeling, image, and "story" come into view, first as separate parts and eventually as an ordered constellation of elements where each is seen in relation to the whole.

The "actor" (or client) must develop the ability to feel where and how to shift her focus of expression according to which element or impulse is most compelling. The person becomes aware of what is happening in herself, then chooses what and how to attend to it, and through the creative act forms a whole picture of her experience. The ability to respond by making creative choices is developed through the exercise of this dialogue between internal sensory experience and perception and outward expression. In this sense, creative process in therapy serves as a metaphor which allows us to work on the development of creative will ("I choose") and responsibility ("I act" with awareness: "response-ability").

Blocks in the creative process as metaphor

Blocks in the creative process indicate a loss of contact with this vital life energy, an imbalance in the ability to respond through acts of volition, and a cutting off from imagination. This blocked energy turns into feelings of depression, anxiety, or anger and becomes attached to such reactions as collapse or deflation when we are faced with new or unknown possibilities, narrowing of vision to see what the options are,

CREATIVITY, ART, AND THERAPY 89

constriction in the ability to explore all available resources, and holding
back from fully engaging with the process.

Here we have delineated four very clear movements: *collapse, narrow,
constrict*, and *hold back* – each one a metaphoric signal to help identify the
nature of the creative block and its corresponding connection to the
larger life experience. When the creative block appears in the form of one
of these feelings, sensations, or movement tones, we can reinvigorate the
imagination by thinking metaphorically. For instance, we can ask: In
what situations or relationships in my life have I experienced the same
kind of blocking quality or reaction? Some quick examples using our
postural signals will give our imagination a clear picture and sense of this
concept of the creative process as metaphor.

- *Collapse*: I start a project and quickly give up. I recall a similar
 reaction and feeling when my marriage fell apart, and I
 couldn't create a new life direction for myself. I can't do it.

- *Narrow*: I rush while I create a product. I want to get it done
 as quickly as possible. I always struggled with mathematics as
 a child. I just wanted the right answer. There is either the
 right way or the wrong way.

- *Constrict*: I want to be brilliant, but I often feel overwhelmed
 by others. I get resentful of others who are very expressive.
 My sister was an extrovert; she took up a lot of space in the
 family. I was more introverted and didn't feel acknowledged.

- *Hold Back*: I don't really think that I am smart or talented
 enough. If I do create something, then I will have to show it.
 I'll have to put myself out there to be seen and judged. I used
 to be terrified of meeting new people. I worried that everyone
 would find out that I didn't know as much as they did.

How we work creatively and how we get blocked reflect our personality
and our life scenarios. Working from the viewpoint of creative process
becomes an approach for exploration in therapy. We focus on process
rather than on outcome – on revelation through the moment-by-moment
felt experience. The challenge of engaging with painful experiences,
revisiting our history, dropping patterned defenses, and meeting our

shadow stuff takes place within this context of creative exploration. Such an approach goes beyond an analytic, problem-oriented focus into the realm of the imagination, where experience is explored metaphorically through the arts.

Art as process and as artifact

One of the best ways to engage the creative process, the unconscious, and the imagination is through art making. Looking at the process of making art as we have looked at the creative process, we find psychological principles and messages from the psyche at work. The process of making art and the artifact itself are both the means and the messages through which we encounter ourselves.

Art making in therapy is about experimentation, exploration, and play. It is about working with sensory experience and then working with what arises. The material we are working on speaks for itself in the poetic language of feeling and imagination. It meanders and unfolds in a mysterious and spontaneous way rather than according to formula or protocol.

Just as any creative process does, the artistic process invites and also demands that we explore, experiment, take risks, and remain open to whatever emerges. Art making, like therapy, insists that we reconsider our "ordinary" ways of thinking, acting, and being. In art making as in therapy, we are attempting to reshape our perceptions of ourselves, to find truth and meaning. You might say we are searching to reinvent ourselves and our relationship with the world. Such a search will take us through cycles where we encounter our limitations as well as our ability to break through. A central consideration and metaphor in this kind of therapeutic process becomes how we are able to tolerate, work with, and trust these forces in ourselves.

In therapy, we shine the light on all of the ways our thoughts, emotions, and life experiences restrict us. If therapy is really to change us, we must enter willingly into an unflinching search for greater freedom from our disabling tendencies and wounds. In movement-based expressive arts therapy, we encounter, work with, and break through our psychic restrictions through the creative process of movement and art expression.

Working with the material of the art medium, as much as working with the material of personality, psyche, and situation, demands that we grapple with how to make our experience visible in the form of the art piece. Does it stay connected with authentic sensation and emotion? Do the important images and parts of the story come alive? Maybe something entirely unexpected appears. Is the unexpected, or the "mistake," welcomed, given validity, and worked with in the moment? Or does our effort to "get it right" and to match the art piece up with our preconceived ideas take precedence?

Our encounters with the material of each art medium put us into confrontations with our mind-sets and with the censor subpersonality, with the ways we hold back and limit ourselves. All of the familiar insecurities, fears, and tendencies to overcompensate come up: Is it good enough? Does it "say" what we had in mind? Does it answer the question? What kind of impression will we make? We fear that we cannot do it. We are not talented enough; we do not have the training. In other words, it is too much or not enough, we are too much or not enough, or they are too much or not enough.

In painting, we must come to terms with the material – with canvas, paint, color, found objects. What colors do we choose? How does the paint land on the surface? Is our inner image coming through? In movement/dance, we must deal with tempo, force, and how we move through space. When we are working with the body in creative movement, there is an internal mediating process constantly taking place between sensation, feeling, and image, between the various body parts, and between tension and relaxation. How do we deal with this flux? Which impulse do we follow? How can we best articulate our movement so that it reflects our inner experience?

Grappling with the medium itself, choice making, and our mental and emotional responses to this unfolding expressive process place us in a metaphoric encounter with the whole question of our being, as all of our past conditioning comes into play. During this process, we also find that the "style" of our art making reflects a similar style to the way we go about daily life and the way we work on issues in therapy. For instance, do we "stay with it" when the going gets rough? Do we jump ahead to try to get to a finished product? Do we walk away when it does not look the way

we want it to? Do we judge, compare, make many false starts, rush through, hold back? What "inner voices" are running us?

The art mediums in therapy become the concrete materials we play and struggle with, put together, take apart, and reassemble as we encounter the patterned ways of being which run through our lives. Breakthrough moments happen when we emerge into free expression and feel that we have found the right form. Everything feels right, it flows, and we create the "just right" expression, or a new way of being makes itself known to us; the authentic feeling or the insight arrives. The breakthrough seems to require a pre-life, a waiting, a struggle with, and then a letting go or turning away from the absorption momentarily.

Getting to a breakthrough experience usually requires qualities which most of us have trouble with in daily life: letting go of our attachment to outcome, tolerating chaos, staying with it, suspending right–wrong judgments, paying more attention to the inner feel than the outer appearance, and cultivating the qualities of acceptance and patience, of practice and discipline.

Expanding on Freud's metaphor of therapy as an archaeological excavation, we see that the art formed is like a therapeutic totem, an artifact found from the dig into the soil of our life. We find recurring motifs in images, movements, and themes when we look at the art itself. These recurring motifs are like the threads of a tapestry that resonate with the weaving and unfolding of our life narrative. This art as totem allows for experimentation and play, an acting out in present tense of what was, what is, and what could be in order to shape and reshape the connection to, and understanding of, the life story in new ways.

The creation of the dance, drawing, or poem becomes a symbolic act that affirms in us the basic life force – the impulse to create. We have something concrete to mark the encounter. It is, in a certain way, alive, imbued with imagination and the creative energy used to form it. It remains in space and time, connecting us to new images and reflections that we are ready to embody or work more on. Art becomes the medium for the therapeutic encounter and the metaphor for emotions and life themes. In its metaphoric role, the art provides a kind of distancing – the art holds it for us or says it for us – and we can enter into dialogue with it.

Aesthetic experience

In addition to the psychological metaphors of art making and the artwork itself, another key principle for making the art process deeply therapeutic is the aesthetic response. The aesthetic experience is based on sensory perception, on how we perceive the world, and on our understanding of the body as a sensing, feeling, and imagining whole. We have all had aesthetic experiences. We see a scene in a movie or hear a poem that moves us to tears or laughter. The fragrance of a flower brings up a nostalgic feeling, and perhaps a childhood memory of our grandmother's garden. A sculpture provokes a deep feeling of inspiration and insight.

Aesthetics speak to our sense of beauty independent of ornamental formulas and conventional prescriptions. A client is working on her self-image and her struggle to connect with her femininity. She has had a dream that she wants to explore. In the dream, she finds herself alone in a white landscape filled with snow. I ask her to imagine entering this landscape and to begin moving as if she is in it. She says that at first she thinks it will feel cold and empty, but that she finds it peaceful and pristine. She imagines lying in the snow and moves her arms up and down as if tracing patterns. This reminds her of the wings of a "snow angel." She says, "Beauty doesn't always look the way we think it should, and it isn't necessarily comfortable."

In the aesthetic response, soul is touched; imagination, emotion, and sensation are engaged. Whether working with material of painful or pleasurable content, the aesthetic experience leads the one expressing and the witness into creative and meaningful encounters. In the aesthetic experience, substance and form meet in such a way that we are emotionally and imaginally moved by the expression rendered.

Principles and theories of aesthetics suggest that it is through our sensory life – through taste, touch, sight, smell, sound – and through our kinesthetic sense that we experience the world. As the sensory experience is so deeply embedded in all of the arts, the aesthetic experience plays a particularly important role in the crossover between art and therapy. Our ability to respond aesthetically allows art to enter the realm of therapy. To facilitate this crossover, we need to develop and refine our aesthetic capacity. Just as a musician needs to keep the strings of the violin properly tuned in order to create resonating music, so our body, mind, and spirit

need to be tuned to keep the channels of our senses, emotions, and imagination fully open.

When art expression and felt experience truly meet, or when an individual's art fully reflects some important part of her psyche and story, she herself is moved and changed by it. When the channels are open for the aesthetic response, just as when they are opened for the free flow of creative expression, art provokes, reveals, and educates; this can be profoundly healing.

In developing the maps and methods of practice based on an aesthetic approach, we investigate both the nature of an experience and the form of expression through which it unfolds. We find ourselves engaged in an ongoing process of inquiry. Since our focus is on the transformation of experience into creative expression and possibilities for change, there are key questions for us to consider:

- What is the material that wants to be worked with? How is it presenting itself?

- How do we become aware of that material? What and where are the blocks?

- What are the available resources?

- How might the art be used in helping the inner experience find its external shape and meaning?

In working with the arts therapeutically, we must be careful not to place the emphasis on how something should look according to formal ideas regarding order, beauty, or unification. Nor should we place our attention on outcomes. When we do so, we risk increasing the separations between the inner life of the person (substance) and the matter being shaped through the art medium (form). In fact, we can understand such separations as a deadening of the spirit of the art medium itself, a disassociation of heart from matter. Rudolph Arnheim (1972) referred to this as art reflective of "insignificant living."

For the moment, let us return to the world of art for an example. Watching a skilled dancer with expert technique does not necessarily inspire us, or cause us to reflect on anything that is particularly relevant. But watching a dancer who is able to express true emotion and bring

relevant images to life through her movement may leave us feeling inspired and exhilarated. When heart and matter come together, form conveys experience in a way that brings us into an immediate and alive relationship with our inner world and with the world around us. In the field of expressive arts therapy, Paolo Knill (Knill *et al.* 1995) coined the phrase "low skill, high sensitivity." This phrase points to the importance of the capacity for aesthetic response over the development of technique and skill for their own sakes.

To come to feel, know, and understand a thing through creative expression requires a joining of substance with form. This joining process should reflect the burning questions, challenges, and potentialities that are deeply rooted in our lives. John Dewey (1934) spoke of the arts as the "ordering of raw material" into forms that stay intimately connected with the "everyday events, doings and sufferings that are universally recognized to constitute experience" (p.106).

In the joining ligaments between creativity, art, and therapy, we find the themes, struggles, and myths that run throughout our lives. The creative process, the process of making art, and the artifact itself are all medium, metaphor, and message in therapy. Our work links the inner experience of sensation, feeling, and imagination with outward expression as we play with the dynamics of restriction, breakthrough, and free flow – and discover the attending narratives.

Creativity, art, and therapy metaphors

Let us retrace the steps of our discussion on the metaphoric connections between life energy, creative process, art, and therapy through a series of five examples:

1. Identifying with the energy of the life force in nature.

2. Aligning artistic expression with the unconscious and the imagination.

3. Uncovering a psychological metaphor in the creative process.

4. Experiencing restriction, breakthrough, and free flow as we work with the medium of an art form.

5. Encountering the message of an artifact.

In each example, we will get a sense of how the aesthetic response can be developed so that inner experience finds its full expression in outward form.

1. Mirroring the energy of the life force in nature

I often take groups of students into the natural environment to catalyze new ways of experiencing the self. The intention is to relate to the natural elements and particular places in the environment, attuning to essential qualities by identifying and interacting with natural objects. The following is a design for a series of activities to generate a "play with nature images."

EXPERIENTIAL GROUNDING

Spend some time exploring the following elements: tree, rock, and water. First, just observe each element. Notice color, shape, other organic things attached to it, the dead and alive aspects of it, the way other elements are acting on it. Second, move as if you are that tree, rock, and water. Third, move into physical contact with the tree, rock, and water. Fourth, explore the environment around you and move into contact with other people using the qualities of tree, rock, and water.

Create a drawing or poetic writing in response to the natural environment as you have experienced it. Now reflect on these questions:

- What is each element "saying" to you?
- What kind of energy does each element activate in you?
- How did you interact with others using these qualities in nature?
- How would you like to apply what you experienced to your life?

By being in and interacting with nature as a poetic act, the creative force of nature as a metaphor shapes us as if we are a piece of art, or we might experience nature as a work of art which moves us aesthetically. This kind of altering experience can reconnect us to our own naturally creative energy.

Figure 8.1 Tree dance photo

2. Aligning artistic expression with the unconscious and the imagination

A client begins her therapy session with the statement "I'm afraid to start this session." I suggest she find a place in the room where she could start simply by moving. She goes to a wall and curls up against it. After a few minutes, she begins a very small movement, extending her legs slightly so that her feet inch along the wall.

I ask her if she is aware of what her feet are doing, and she says no. I describe what I see and suggest that she continue by repeating and developing this movement of legs extending and feet inching. Her movement becomes intensified as does her encounter with the wall. After giving her time to explore the wall with her legs and feet, I suggest that she "use" her legs and feet to find her way through space, leaving the wall and returning to it whenever she wants to.

She expands out into space, then returns to the corner; she uses the wall for support to leave the corner a number of times. She creates a number of different dances with the wall, with the corner, and along the floor. Finally, she makes her way into the center of the room. I suggest that she explore standing up, feeling with her feet and legs the solidity of the floor underneath her. She does so while speaking of her fear to be in the world without any protection and support.

We take time so that she can explore finding a feeling of support in her legs and feet while standing, and then we add mobilizing her arms and hands in movement to act as protectors. We complete the session with my suggestion that she imagine the corner in herself, the wall in herself, the floor in herself, the protector in herself, and that she hold a spoken dialogue with these parts.

Bringing awareness to the client's unconscious expression and guiding her to make conscious choices by using her imagination in movement and spoken dialogue allows her to develop her aesthetic responses so that she is informed and changed by what is revealed.

3. Uncovering a psychological metaphor in the creative process

In a workshop, participants are asked to make a drawing in response to the question "What is up for you that you would like to explore?" One student starts to draw, then stops and crumples her drawing up into a

tight ball. She begins to draw again, then stops and tears up the second drawing. I suggest that she stay with starting to draw and then stopping and crumpling or tearing up as many sheets of paper as she wants to. Then I suggest that she create an "installation piece" with all of her torn and crumpled sheets of paper.

Each workshop participant then shares a spoken word and movement exploration of her drawing with the group. When it is the turn of the participant described, she moves, immersing herself in the bits of torn paper and throwing them through space. As she speaks, the exploration of the crumpled and torn sheets of paper reveals a long-held-back anger and desire to confront her partner forcefully and "tear apart" a relationship that is not working.

Here we are reminded that the process is often more important than the product. If the finished drawing had been viewed, in itself, as the goal to be achieved, the metaphor and message of the process would have been lost.

4. Experiencing restriction, breakthrough, and free flow as we work with the medium of an art form

A client is working with the image of a bird in flight. She remains stationary on the floor with little arm motility. We might speak to the seeming incongruence or opposition between the image and its outward expression. The client's lack of movement might demonstrate a separation between the substance of the experience being worked with and its outward expression in form, indicating a possible block in her ability to respond aesthetically to her material. Or it might indicate that there is more to this bird image and the restriction in moving it than simply "OK, it must fly." We do not assume that either the image of the bird or the lack of ability to generate flying-like movements must change. We want to explore the restriction, discover how the breakthrough will emerge, and observe what will arise in the free flow.

There are two steps to follow. First would be to work directly with the apparent opposition. For instance, there might be a part that wants to fly and a part that does not. Or maybe something else needs to happen before flight. What is it? The next step would be to focus on facilitating a joining of the movement response with the inner image by coaching the

mover to use her legs to explore leaving the ground and her arms to explore wing-like arm movements. Perhaps the mover is unaware that her images and actions do not really match up, another kind of metaphor. As the "matching up" starts, there may be a certain creative suspense. Will she actually find a way to leap, to fly? What will it take?

As the client attempts to bring the image of the bird in flight to life, she is moved by the struggle to find the movement as much as by the emergence of the dance of the bird. Together, the elements of the exploration become an important life–art metaphor, allowing her to work through the stages of restriction, breakthrough, and free flow.

5. Encountering the message of an artifact

I have asked a group of students to bring a series of "self-portrait" drawings to session, created over a series of weeks. As one student brings her drawings in front of the group, I ask her to focus in on the image she most wants to attend to. She chooses one of her self-portraits. I ask her a series of questions about the image. She describes the drawing as the "self I would like to be – a powerful, compassionate, wise teacher." I suggest that she imagine the self in the drawing speaking to her. What would it say? The drawing says, "I am your future. I am who you might be at the end of your training."

I suggest that this student find a place in the room to put her drawing that reflects where she feels she is now in relation to the drawing and its story. She sets the stage by creating a line of pillows, which leads from her place in the group circle all the way to the door of the studio. She opens the door and places her self-portrait drawing on the doorstep between the studio and the outside. I ask her to tell us about the environment she has created. She talks about the tension she has felt in thinking that she needs to "be there" and "be that" before she is actually ready. She does a dance in which she explores the space in the room, moving from where she is now in the center of the room to where she wants to be at the doorway.

Then, she creates a circle between the place in the group where she is sitting and the drawing of her powerful self at the doorway. She collects something from each of her fellow students – scarves, pens, water bottles,

notebooks – and makes a circle of group belongings as a centerpiece around her.

She shares the message of her drawing in her closing statement to the group. She says that she realizes she has been so busy trying to be brilliant and perfect that she has been missing the opportunity to learn, to not know, to make mistakes, and to be on an equal footing with her peers. Speaking as if from the voice of her painting she says, "I am your future. Enjoy what's happening now; you will get to me."

CHAPTER 9

Maps and Methods
of the Practice

Whatever theoretical model may be adopted, do not believe it is the
whole. The whole can only be the person, the one teaching and the
one moving in an atmosphere of mutual trust.

Mary Starks Whitehouse (1999, p.77)

The interweaving in practice of creativity, art, and therapy requires that
we propose a series of working models to help us understand how
substance (experience) and form (expression) can be joined. The princi-
ples, tools, and models of this practice of movement-based expressive arts
therapy provide a structure in which we bring the unconscious and imagi-
nation into dialogue; aesthetically tune the body, emotions, and mind;
and explore inner life and personal narratives through the metaphors of
making art and in the messages of the art itself.

Keeping to our idea that inner experience finds meaningful outward
expression and fitting metaphors through aesthetic shaping, each map
and model presents an attempt to frame these links. The intention of
movement-based expressive arts therapy is to assist people in developing
awareness, creativity, and embodied expression; to facilitate an in-depth
exploration of personal myth, pathos, and potential; and to catalyze
breakthroughs into new ways of being.

The maps and methods of this practice help to establish a way of
thinking and exploring that sustains focus, immersion, and presence with
what is happening in the moment. The proposed maps and methods
suggest ways to follow and understand what unfolds and what is possible.

The practitioner must learn how to work in a highly intuitive and imaginative way while remaining grounded in certain objective frameworks, using methods that support the embodied experience and the aesthetic response.

This approach holds the embodied experience preeminent as a source of learning and change. Here we view the embodied experience as centered in the body, the container of our entire life experience, and as centered in movement, the expression of our biology, personality, and soul. The theories and methods which inform movement-based expressive arts therapy need to provide guidance in our facilitating the expressive interplay between body, feeling, and imagination, which is necessary for a true embodied experience. In addition, we need a framework for developing the aesthetic capacity and the metaphoric relationship between the art and therapy process.

We will begin by looking at the theories, methods, and techniques that establish our basic understanding of the physical, emotional, mental, and spiritual body. Then we will take a "beginner's mind" look at how to observe and decipher the language of the expressively moving body so we can work with specific connections between movement, metaphor, and narrative.

Improvisation will serve as our next model for looking at a wider view of free play, in which there is minimal structuring. The role of "aesthetic witnessing" describes a feedback attitude fitting to this work. A guiding model for the functional phases of therapy suggests how we might catalyze and follow the flow of emotional energy and insight. A working "intermodal" model relevant to the three primary art mediums of this work – movement/dance, drawing, and poetic writing – will complete our backdrop.

William James (1977) advised us to see life as a scientist and to live it as an artist; our application of these theoretical models to living flesh and bone demands that we play both parts. The challenge for the practitioner, whether working on her own, with others, or in the role of guide, is to refrain from imposing formulas and agendas. At its best, the purpose of a good structure, like skeleton to muscle and muscle to bone, is to allow for greater stability and flexibility, expanding our ability to respond to chal-

lenges and opportunities of the moment with spontaneity, intelligence, and imagination.

The three levels of awareness and response

First, we will take a closer look at how we work with the body and movement. When we speak of "the body," we are not only talking about the physical level of the body but also about the emotional, mental, and spiritual levels. Although each level holds and gives us access to our experience in a particular way, we also understand these levels of body in their unity. Just as each art medium opens, reveals and reflects aspects of ourselves back to us, we also see different reflections of ourselves by separating our physical, emotional, and mental responses. We ask:

- What is happening in the physical body (sensation, body posture, body parts, gesture, and movement)?

- What is happening in the emotional body (feelings)?

- What is happening in the mental body (images, memories, associations)?

- And how are they related (are they in accordance or in opposition)?

We refer to this basic map as the "three levels of awareness and response." Remember that line in the children's song: "The hip bone's connected to the thigh bone; the thigh bone's connected to the leg bone…"? The three levels of awareness and response have the same kind of lyric; each is separate from the others, and they are all connected.

The methods of our practice focus on enlivening the relationships between the physical, emotional, and mental levels based on the following key principles:

1. From the ground of physical responses and expression, emotional and mental impressions emerge.

2. When any level is isolated from or in opposition to another level, intrapsychic and interpersonal conflict results.

3. As each level is tuned and aligned with the others, higher degrees of awareness, creativity, and expression are possible.

4. The more creative the interplay between the three levels of body, emotions, and mind, the more authentic, mindful, and integrated we become.

5. As our ground of being reflects these qualities, we are more open to transcendent or spiritual energy.

In developing the expressive body from the point of view of the three levels – physical, emotional, and mental – we are working experientially and metaphorically with our past and with the ways our life experiences live in us at unconscious as well as conscious levels. We explore recognizing and working through restricting somatic and emotional patterns that keep us attached to conditions of the past. Such attachment leads to a kind of inertia and loss of creative momentum. Shaking loose from these entanglements frees us to embody the capacity to be more fully and expressively present in the moment.

We work with the principle that when the first three levels are well integrated enough, the body becomes like a channel that allows us to access higher levels of consciousness. In the three levels of awareness and response map, we refer only to the first three levels in their expressive capacity. We understand the fourth level as being beyond words. Therefore, we say that in the arts, the spiritual level is represented symbolically, in painting, song, dance, and ritual; these art forms act as metaphor, reminder, and aid in cultivating our spiritual awareness.

In this way, we can see how movement-based expressive arts therapy supports mystical practices, spirit, and the spiritual experience (the fourth level). In working with creativity, we are opening to the essential impulse toward life, to new perceptions and possibilities, and to learning how the mind can go beyond attachment to a particular circumstance. We recapitulate the folding and unfolding of the cosmos, creating, deconstructing, and recreating again; in this way, we come closer to the larger "universal mind."

Again, the three levels of awareness and response are:

1. *Physical*: Sensory sensations, breath, body posture, body parts.

2. *Emotional*: Feelings, such as anxiety, joy, calm, excitement, anger, sorrow.

3. *Mental*: Thinking processes, such as planning, remembering, worrying, imagining, and fantasizing.

Following different directions

Because we want to work in a totally embodied way, we activate and include our physical, emotional, and mental levels of awareness and response in all of our explorations. We follow several different directions.

ASCENDING AND DESCENDING

Since the physical level is our ground base, first we notice and work with sensation, body posture, breath, or a particular place in the body or a body part. Then we track "upward" to the emotional level, noticing and working with feeling responses that are evoked. Then we pay attention to and work with images and thoughts on the mental level, activating the imagination. Or we start at the mental level, with an image, memory, or theme, explore the emotions connected to it, and then complete the cycle by reconnecting or grounding in the physical body through focusing on breath, sensation, posture, or a body part.

LOOPING

We start with whatever level the person chooses or is presenting. We focus on any level, one at a time, and then switch from one to the other in any order. For instance, we start with a feeling, shift to an image, explore the physical sensation or posture, go back to the image, explore the feelings that are being evoked, and so forth.

INTERPLAY

We work with the connections and the transitions between the physical, emotional, and mental impressions and responses. We focus on what the levels are evoking, and how they are working off one another, and in relation to one another. We might shift back and forth, or we might engage all three levels at once around a shared image, theme, emotion, or sensation.

1. Focusing on each level

Mental level

Emotional level

Physical level

2. Descending
*from mental
to emotional
to physical*

3. Looping
through the
levels

Ascending
*from physical
to emotional
to mental*

Figure 9.1 Three levels of awareness and response

We want to get equally comfortable with focusing on each level, one at a time, with ascending and descending, with looping, and with focusing on the interplay, so that we can respond to whatever is most needed in the moment. Sometimes this might mean following whatever is happening, and other times it might mean redirecting or challenging what is

happening. We can ascend, descend, loop, and interplay over the course of a session or a number of sessions, or within an hour-long exploration.

Using the three levels of awareness and response map

Let us take a closer look at what can happen when we use this map as a framework. In drawing attention to the relationships between physical, emotional, and mental responses, we establish a frame of reference for identifying our material. When we go deeply into the body and expressive movement as a reflective way of working with emotions, thoughts, and imagination, we expand our embodied inquiries. As emotions surface, we return to body sensation, posture, gesture, and movement as the language through which feelings are fully expressed and clarified. All of our mental impressions and responses connect our physical and emotional responses to the particular conditions, both past and present, in our lives. Turning the mind toward imaginative musing provides the story line for exploration and opens the thinking process to totally new perceptions.

We can evoke and explore each of the three levels of awareness one at a time or in various combinations, depending on what is called for. We can also devote time to developing and exploring at one level in order to discover where the individual is weak, cut off, or predominantly expressive. When we have established this frame of reference, we can direct the work toward the interplay between the three levels by using an art medium that is particularly suited to each level and to strengthening the connections between them. I will discuss this further when we look at the intermodal arts model later in this chapter.

For each individual, the three levels of awareness and response function somewhat differently. Different people have different degrees of sensitivity and range, and often favor one level over another; some favor the physical level, while others are more attuned to feelings, and still others are able to call upon very active imaginations.

Drawing upon each person's area of strength, this map guides us to build our awareness and ability to respond from our less-favored, or underdeveloped, level. Many family and social influences affect our ability to express ourselves physically, emotionally, and mentally. Personal and collective belief systems inhibit our expression on each level

in unique ways and in ways that reveal typical commonalities. Our range of movement, for example, is determined and limited in part by the beliefs that have shaped us.

As we work creatively on each of the three levels, we begin to identify personal strengths and weaknesses, as well as habitual patterns and blocks. The person may discover that skills she possesses on one level can begin to be transferred to another, more inhibited, level. We can effectively employ the levels that are most creatively developed in a particular individual to build a bridge into the less familiar terrain. For instance, one person may be a well-developed dancer and find it difficult to express her feelings – reflecting a dominant mode of expression on the physical level, and a less-developed mode on the emotional level. Movement can cover up feelings as much as it can reveal feelings. Another person may feel self-conscious when asked to engage in dramatic movement expression and feel more comfortable with verbal or written expression.

The dancer may focus first on connecting with her feelings more deeply by using fewer movements, slowing her movement down, or moving with her eyes closed, which gives more time for feelings and images to arise. The person who is more comfortable talking about her experience – predominant mode of expression on the mental level – might first write a story and then use that story as a dance/movement score, invoking the physical level. Our approach suggests increasing the range and flexibility between physical, emotional, and mental levels of expression. In making these transfers between levels, the individual can begin to focus on exploring responses at the less familiar or undeveloped level by using the less familiar art medium.

In doing so, areas of expression the person has avoided make themselves known. Cut-off levels of self-expression are often hidden keys to a more fully liberated sense of self. They provide a rich opportunity for exploring the blocked or inhibited areas of our expression. Often such blocks give us valuable information to explore, and tell us something about how we are blocked in other areas. When someone encounters a difficulty, it is often valuable to choose one of the levels of awareness where she feels resourceful, as a way to facilitate a breakthrough. When a successful breakthrough has occurred, she can examine how the energy got blocked, or what the block was about, from a new perspective.

Any given outlet of response has no more and no less value than another. What is important is the heightened awareness that enlivens the experience of creativity and engenders an experience of what is possible. This gives us the opportunity to work on expanding our ability to express ourselves creatively, which has a direct impact on our sense of integrity and on our feeling of excitement for life. With practice, we are able to work at higher degrees of awareness accompanied by a wider range of expressiveness. This is a bit like learning to play a musical instrument. First we learn to play scales, and eventually we learn to play Mozart, finally becoming masters at it if we stick with the practice.

The phrase *levels of awareness* implies a built-in sense of an ascending order. We continually refer back to physical responses and physical expression as the ground from which emotions and mental responses emerge. Movement both engenders feelings and expresses feelings. The interplay between movement and feeling evokes mental images and thought associations, and the interplay between movement and images evokes feelings. As we become more highly attuned to each level, and increase our strength and flexibility at each level, a circular relationship and open flow of energy between the levels begins to develop.

We might call this a gestalt experience – when all three levels are working together, or are in synthesis, and we feel authentic, vibrant, and present. Fritz Perls used to say to participants of his workshops, "Get out of your head and come to your senses!" By this, he meant, rather than analyzing your experience, feel it and enact it as a way of knowing. We rarely listen to our body, which, like a treasure chest, is full of our life experiences, contained in a deep and accurate way. The three levels of awareness and response remind us to return to the physical level as the ground our emotions and thoughts both come from and return to, to listen more carefully, and to make a different kind of sense of things. The role of the teacher or therapist in movement-based expressive arts therapy is immensely important, since we need a skillful witness to guide us and reflect back to us both what is happening and what is possible.

Exploring and tracking movement

Now we will explore the various components that point us toward seeing and developing the functional as well as the aesthetic qualities of movement itself. I will discuss what I consider to be the most elementary and introductory aspects, the ABCs, involved in deciphering a rather complex and rich language.

We can break our study down in three ways. First, we need a vocabulary to help us see and understand movement in relation to possible physical and psychological messages. Second, we need a vocabulary to help us link movement to emotional states, to images, and to the myth that is being expressed. Finally, we need resources to help us expand the range of movement play.

There is much to observe and sense as we "watch" movement, in ourselves or in others. We pay attention to the relation between high and low muscle tone. We look for the presence and degree of tension and relaxation, contraction and release. We notice the flow of breath in relation to the movement. We carefully follow the body parts in motion. We notice which parts of the body are engaged in movement activity and which are not, where in the body the initiation of movement occurs, and how other parts of the body follow through or respond by supporting or resisting. We look at posture and how the musculoskeletal system determines idiosyncratic patterns of movement. We work with gesture as well as with gross motor movement and cycles of movement. As we decipher the medium and messages of expressive movement, we work both with what is there and what is missing.

Using a very basic model, we can observe, understand, and develop movement according to the elements of *space, time, force,* and *shape.* The use of space is seen by observing how a person is choosing to articulate her movement in relationship to her immediate environment, including the area immediately around the body as well as the entire geography of the room. We might notice whether the person is using large or small movements, or moving on the periphery, on diagonals, or in the center of the room. We notice the organization of time through speed or tempo, and through the acceleration and descent of tension in the movement. We observe, for instance, whether the movement is fast, slow, or changing

tempos, sustained or jerky, and whether the mover is able to make transitional shifts between qualities.

Force manifests as the varying degrees of energy or momentum that the person gives to her movement, and relates to how the body responds to the pull of gravity. Is the movement light or forceful? Is enough momentum applied to complete a movement action? As Laban (1960) and Bartenieff (1963) have suggested, we see shape in the form of the movement, in how the body adapts to and moves in space – the quality of shape might be *circular, angular, direct,* and *indirect.*

We can also talk about shape in terms of posture and from the point of view of how tension is held in the body and in the movement. The basic postural qualities can be described as *collapsed, contracted, extended, hyperextended,* or *centered.* Each of these postures affects the way a person articulates her movement, and determines the movement range that she can access. These postural and movement qualities also have correspondences in feeling responses and mental states and attitudes.

Usually we focus on how movement is developed around one of these elements at a time: *use of space, shape, force, posture, articulation of body parts,* or degrees of *restriction* and *flow.* However, each has a bearing on the others; while we might focus on one element at a time, we also shift our focus to all the relevant elements that have an impact on the movement as well as to the relationships between the elements.

In noting repetitive, idiosyncratic, or restricted movements, in which the use of space, time, force, and shape remains the same, we might assume that resources are limited and that other restricting patterns exist. What we do not do, however, is match up particular qualities with an interpretation. Rather, we draw attention to the quality of movement – to how the mover is using space, time, force, and shape, or posture, or gesture – and give input that mirrors, adds to, intensifies, or supports the person. As we observe and speak to the movement, we understand that we are observing and speaking to the feelings, images, and narratives that lie within.

Just as the individual mover expresses psychological processes, feelings, and images in her use of space, time, force, and shape, so partners or a group moving together express similar dimensions. As we observe

these movement interactions, the relational or group myth is revealed and can be worked with.

The interplay between, and joining together of, a number of movement cycles connected with images or feelings that together express various components of an experience, or story, we will call a *dance*. To find these components and explore their interplay, we work with a set of four specific phases. By *repeating*, *developing*, *switching*, and *shifting*, we generate a way of exploring and organizing our material

Once a movement begins, *repeating* it brings awareness, attention, and clarity to the action. The mover identifies what she is doing, feels it, and notices any accompanying images.

Developing an identified movement introduces elements that expand, deepen, and change both the movement and the mover's experience. The mover grows her resources and her ability to follow through by "actively listening" to where the movement wants to take her; by responding to the ongoing and growing movement response, she works with the flow of feelings and images that are evoked.

Switching introduces awareness of different elements, which can be explored in relationship to each other, including opposition and contrast as well as like or related parts. Like the phase of developing, switching emphasizes variation and mediation.

Shifting introduces the action of dropping elements, emphasizing and mediating between opposite forces, focusing on transitions, and exploring the connections between various elements. Shifting increases the capacity of the mover to choose between a variety of possible qualities so she can expand the repertoire of the exploration, to emphasize confrontation, release, or change.

Developing an interplay and an exploratory cycle of repeating, developing, switching, and shifting prevents the mover from staying attached to isolated movements and from getting stuck in one way of exploring between movements. As a whole picture of moving is born, "the dance of…" emerges.

Movements with the potential to be quite interesting, challenging, and significant to the mover are often interrupted or dropped before their message is fully explored. By repeating, developing, switching, and

shifting, we are practicing *movement ecology*. In this way, we can get the most out of the medium and its messages. This is how it might look:

- *Repeat*: Stay with one gesture, movement, or movement phase. Notice the shape of the movement, the force, and the space you are using. Keep doing it until you become very clear with it and find one repeatable cycle of movement.

- *Develop*: Apply different speeds to the movement. Give different degrees of force to different parts of the movement. Take it through space in different ways. Use different tempos. Make it bigger, smaller. Engage different body parts with it. Keep at it until you have gone as far as you can with it. Drop or change some parts of it, and add new elements. Follow through with each movement.

- *Switch*: Go back and forth between two different qualities in the movement, heavy and light, moving very small and moving expansively, moving while holding the breath and releasing the breath. Make your switches slowly, quickly.

- *Shift*: As you use different qualities, or shift your focus from space to force or from one image to another, explore the movement transitions that lead you from one element to another, paying attention to the "in-between movements."

We can use this cycle of repeat, develop, switch, and shift as many times as relevant, and in any combination, to heighten and expand the dialogues between movement, images, and feelings. Significantly, with this kind of model, the mover develops her own ability to self-witness, generate her own creativity, and make her own choices. This model is also very effective for tracking and coaching.

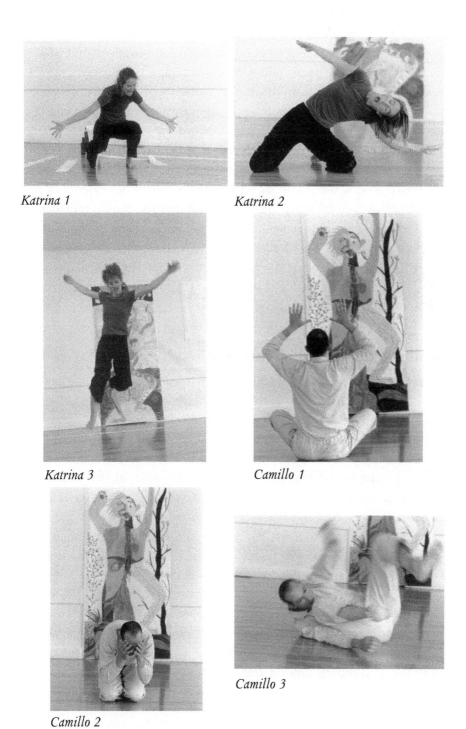

Katrina 1

Katrina 2

Katrina 3

Camillo 1

Camillo 2

Camillo 3

Figure 9.2 The Cycle of Repeat, Develop, Switch, Shift

Coaching movement

The teacher or partner as witness uses these considerations in observing and giving feedback about what is present in the movement and what is absent or underdeveloped. The witness coaching the movement mirrors back what she notices using words or movements, giving resources which will intensify the mover's experience of her own movement, and adding new tools for enlarging the possibilities and for allowing feelings and images to become congruent with action.

Coaching is a way to bring more awareness to what is being expressed so that the mover can confront the attending material of her narrative through the movement itself. Through the careful articulation and development of movement, feelings are released and changes occur through a repatterning of the movement expression. *When movement changes, so does psyche.* New movements bring us into new physical states and to fresh images that act as symbols in the forming of a new experience.

Aesthetic responses and interventions

The witness plays a vital and collaborative role in the therapeutic experience. Whether co-learner, teacher, or therapist, simply by the act of paying attention, the witness creates a *holding environment* in which the mover feels seen and cared for. The eyes of the witness bring intensity to the unfolding process, while when a person is working alone all of the intensity must be self-generated. Unlike having an audience, where the concern is on delivery, impact, and the performance as a presented piece of work, the relationship between enactor and witness requires unconditional acceptance and trust in entering the unknown together. The witness holds the symbolic quality of partner and guide, the one who is fully present yet able to observe from the outside.

The witness brings her ability to see, hear, sense, and imagine as the basis for her aesthetic responses and interventions. The witness focuses on the aspect of the person's narrative that is arising as well as on how the material is being shaped expressively. The witness organizes her interventions or feedback around five intentions: to acknowledge what is

there, to deepen the experience, to expand the means of expression, to develop new resources, and to suggest possibilities for change.

The witness first pays attention to what is being presented. Once she has a feel for both what is being expressed and how, her interaction with the enactor aims at drawing the person's attention more vividly to the material. In this sense, the witness follows and tracks by seeing, sensing, empathetically feeling, and imagining rather than by directing, interpreting, or analyzing.

There are a number of ways for the witness to intervene. One is by "coaching," as in the more active role of therapist. Another is by giving aesthetic feedback. For our purposes, I will briefly describe some of the ingredients for giving aesthetic feedback. Continuing to pay attention to what she sees and hears, the witness allows herself to be inspired by the expression or artwork of the other. Working with aesthetic feedback through the medium of an artwork itself involves responses that originate in the sensory experience and imagination of the witness, such as an empathetic tightening felt in the chest, or the image of a clenched fist that "wants" to strike out.

The witness may relay the aesthetic response in a number of different ways. The witness might dance the other person's drawing, respond to an exploration with a gesture, or offer a further development of the movement play, suggesting what might happen next. The witness might give back an improvised spoken poem or song.

The witness's aesthetic responses may mirror, add to, intensify, or blend with what the enactor has already shared. The witness's feedback could also involve the introduction of a completely new, contrasting, or missing element that redirects the exploration. Now enactor and witness (fellow students, client and therapist, student and teacher) are mutually engaged in the experience of exploring and shaping the material.

In this collaborative process, the witness may arrive at the richness of her own emotions, images, and insights, which she can give back to the other, opening up places of feeling and possibility, trust and creative exchange, which enhance the material and the working relationship. By giving back a dance or a poem, for instance, the witness gifts the enactor with the richness of her own inner life, which also speaks of how she is moved by the work of the other.

The witness typically employs sentences that begin with "I see," "I feel," and "I imagine" for verbal feedback, to keep the shared perspective grounded in physical, emotional, and imaginal responses. The witness reflects back what is happening by speaking of what she sees or notices. She enters into the emotional realm by probing for what the enactor is feeling as well as sharing her own feeling responses. She gives back images and stories rather than analytical thoughts, judgments, or advice. This flow enlarges the aesthetic realm of interaction, placing interventions in the field of creative play. In giving feedback in this way, the witness may open up an unseen or underdeveloped part that the enactor is then able to see, feel, and appreciate herself.

The witness asks questions which serve as prompts to keep the enactor engaged in the exploration or artwork:

- If the drawing could speak, or if your movement could speak, what do you imagine it would say?

- What image would help you break free?

- What movement would take you to the feeling you are expressing?

- How could you get up off the floor in a relaxed way?

- If you could add something to the drawing, or to the dance you've done, what would it be?

- What do you notice as you switch back and forth between the very slow and the very fast tempo of your movement?

The witness understands that she herself is engaging in a creative art process whether she is giving aesthetic feedback, working verbally from the I see/I feel/I imagine attitude, or coaching a movement exploration.

Improvisation

In working with the arts therapeutically, we view the individual as having innate capacities for creativity and awareness. However, we also understand that these capacities need to be released, strengthened, and given outlets for embodied expression. One way we go about this is by using the principles of the artistic process exemplified in improvisation, which

Stephen Nachmanovitch (1990) calls the "master key" to creativity. As we look further into the principles of improvisation, we will continue to think about the interweave between creativity, art, and therapy.

Improvisation is play. In this context, I am speaking of the serious play that occurs when we are right in the moment relating to what is happening and to whatever is available in our immediate environment. This might include the concrete objects in our external environment, such as paper and paint, musical instruments, toys, other people, trees, chairs, and so on. It also includes the sensations, emotions, ideas, and fantasies of the moment, which are present in our internal environment. Improvisation demands our moment-by-moment responses. When we improvise, our attention is anchored firmly in the "here and now".

In improvisation, everything is workable. There are no judgments about what is good or bad, and there are no mistakes. Everything, whether it arises on the level of soma or psyche, is used as material to create with. We are not looking to get rid of, fix, cling to, or analyze anything as that would impede spontaneity and go against the true nature of improvisation. In improvisation, we call to the unconscious and allow it to come forward without censorship. In fact, improvisation allows the unconscious and conscious to meet each other in the creative process. As we develop improvisational skills, the "mutual education" between the two unfolds (Chodorow 1991, 1997). At its best, improvisation is like a full-bodied theatre of free association in which things get revealed on many levels without preconceived intention or attachment to outcome.

Children at play are great improvisers. Many adults, however, have lost this most intrinsic and basic form of creative expression. In this vein, psychiatrist Donald Winnicott (1971) put forth the significance of play in psychological healing when he stated that it is in playing that the individual child or adult is able to be creative and use the whole personality, and that it is in being creative that the individual discovers the self. In this sense, we understand improvisation not as a frivolous and insignificant activity but as a rich and sometimes challenging exercise of our creative muscles.

Improvising itself can bring up a number of obstacles and fears for people. Learning how to play again in this way brings tremendous opportunities to free up the areas in us which have become blocked, and

release the stuff that is stored behind these stuck places so that we can work with it.

The serious play of improvisation activates a number of key elements:

1. Committing fully to what we are doing.

2. Staying open.

3. Responding to whatever comes up.

4. Working with what attracts us.

5. Paying attention to relevant details.

6. Developing whatever arises so that things get fully expressed.

7. Repeating things until they become clear so that we know what it is we are doing.

8. Staying with something because it is interesting or until it is finished.

9. Shifting from one thing to another to increase diversity and create transitions.

10. Switching between disparate and contrasting elements as a way to work with opposition.

11. Dropping things that are not working or that are finished so that there is space for something new.

12. Maximizing the use of all of the available resources.

These points suggest how improvisation stretches our limitations and tones our creative capacities. Developing the ability to be spontaneous, to focus on what is happening in the moment, to immerse in the material at hand, and to respond with the senses, emotions, and imagination are all key to improvisation.

Further, improvisation is a kind of play that demands we cultivate a willingness to be challenged and to open up around internal and external limitations. When we improvise, we agree to be surprised and to work with change as a constant element. Improvisation in the realm of creativity teaches us about letting go of attachment to the way things are or should be. As a result, we have an opportunity to cultivate an attitude of

independence, which arises when we remain detached from specific intentions or outcome and instead stay present with and responsive to whatever occurs.

Returning to our notions about aesthetics, improvisation as play gives us a stage upon which to explore the relationship between experience and imagination. In cultivating the ability to improvise as an artist, or as a child, we develop and exercise the aesthetic response. We may encounter the "performance demons" (anxieties, stage fright, fear of failure, etc.) on the improvisational stage, and what better way to meet them than to play them, or to play with them? Inviting the uncensored and the nonsense takes us a bit further away from the controlling mind and emotions, and frees us from certain limitations about what is allowed, or what we ourselves might allow.

The what and how of this form of free play reveals interesting patterns and tendencies which might otherwise remain disguised or simply talked about rather than enacted. Play, too, suggests an attitude that anything is possible and anything goes, a permission to get into things or, from the witness point of view, to see things revealed and reflect them back to the improviser.

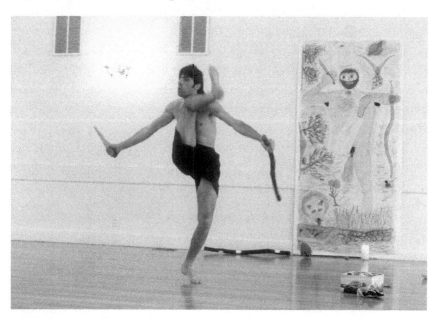

Figure 9.3 Improvisation 1

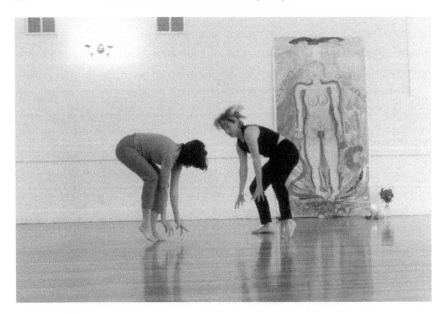

Figure 9.4 Improvisation 2

The five-part process

Our next model, the five-part process, which I will describe according to its five separate and overlapping phases, provides a way of witnessing, exploring, organizing, and guiding the work.[1] The five phases are *identification, confrontation, release, change,* and *growth.* Each phase evokes and facilitates certain important steps in the therapeutic encounter. Guiding according to this model helps to stabilize the learning that can occur between creative-expressive enactment and the life issues that the client is working on.

While the three levels of awareness and response map provides a model for following our internal sense, the five-part process offers a model for tracking and facilitating how that internal experience is expressed in the exterior world.

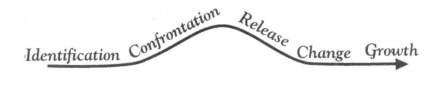

Figure 9.5 Five-part process

Therapy, like any learning process and like any creative process, depends on an interactive flow between the individual and the environment. The expressive arts environment, as much as being a place for creative encounter and enactment, must also supply appropriate elements for learning so that integration can take place (Piaget 1972). As a learning model, the five-part process helps to create an educational environment which supplies the individual with the elements she needs to become aware of, express, and organize her life experiences, to make both symbolic and actual changes which lead to growth.

By making the therapeutic models apparent and accessible, it becomes a creative resource for the person or the group as much as for the therapist and teacher. By sharing this map, we entrust people with the responsibility for their explorations, learning process, and growth. As the humanist psychologist Carl Rogers (1951) pointed out, it is essential that this focal point reside within the individual rather than in some external criteria such as the psychotherapist or teacher as authority or savior. As the facilitator works with this map, she also teaches the client and student how to use it, so that it can provide a shared vocabulary and the therapy can become a collaborative dialogue.

The five phases of this model are contained within the very experience of working with the expressive art mediums as a therapeutic process. As an example of how each phase overlaps with the others, we might use drawing as the medium to identify what is happening, or what we want to work with. When we identify by drawing, we are also confronting the image we create. There is a release in the kinesthetic act of drawing, and there is both confrontation and release in the feelings or associations that come up as we draw. As we draw, the image evolves and changes, or we change it, and shifts occur as what has been an internalized idea, image, or feeling comes to exist in a visible way on paper.

In a written description such as this, the five-part process may appear linear, as if we must follow one step after the other in an orderly fashion. In fact, quite a bit of flow, fragmentation, disorganization, and reorganization unfold along the pathway of this five-part process. In a therapeutic process which follows these five phases, there might be quite a bit of looping back and forth between the phases. In a very real sense, the seed of each phase is present within all of the others.

New layers of material get uncovered by focusing on each phase one at a time, as well as by moving back and forth between the phases. Keeping the differentiation between each phase flexible allows for us to replay, rework, and deepen the process. The five-part process map provides markers and an overview, a way of describing, tracking, and facilitating the five primary phases of therapy.

Identification

Identification is the phase of the therapeutic work in which the person focuses in on and names an issue. The issue might be found in a theme, an image, an emotional response, or a situation to be worked on. Identification might occur in locating a predominant sensation; noticing a repetitive movement, gesture, or posture; recalling a dream; or looking at a drawing.

The identifying phase shifts awareness from "the everyday" to more in-depth awareness so that exploration can begin. Identification brings attention to the inner experience and to the material to be worked with, establishing a reference point around which movement, dialogue, and change can occur, what Eugene Gendlin (1978) referred to as *focusing*, which allows us to discover the existential meaning of experience.

To identify is to respond to the questions: What is most compelling for you? What do you want to work on? Identification does not just take place at the beginning of a session. It continues throughout a class or session. To identify, we might ask the question: If the movement, drawing, or body part could speak, what would it say?

Finding, clarifying, or reclarifying a central image, concern, or new option is itself a significant aspect of any session. Drawings can serve to help identify an image to explore, providing symbols as well as qualities of shape, color, and texture as keys leading into dialogue, movement, or role-play.

Whenever identification occurs, it elicits more awareness and strengthens the creative will and the collaboration between client and therapist, ingredients which are essential to the phases of change and growth. Without it, the therapeutic exploration can become aimless and haphazard, or dependent on the facilitator as the source for interpretation and advice.

Confrontation

Here "confrontation" does not mean to resist or fight with but rather to meet and to encounter what is present. The client (or student) faces her identified material and fully immerses in it through expressive enactment. In the identification phase, we bring something into focus; in the confrontation phase, we explore it. Once we have identified a theme or focal point, confrontation is the act of metaphorically or symbolically becoming it or going into it.

Movement explorations, vocalization, and spoken dialogue are the mediums for expressive confrontation. During this phase, the witness might point out any discordance she notices between feelings, images, thoughts, and their expression in movement in order to intensify the confrontation. Movements or postures might be exaggerated and intensified, and switching between opposite parts might be introduced.

While the client/student commits all of her attention to the exploration, the therapist/teacher helps her in working with the images, feelings, and life associations that are triggered. The guide may suggest a variety of enactment possibilities and art modalities to facilitate the encounter and the movement back and forth between the phases.

Release

Full expression on all three levels (physical, emotional, and mental) during the confrontation phase facilitates a release of held impulses – neuromuscular tension, emotions, unexpressed images, and memories. With release, the energy and the dynamic attached to a particular circumstance shift, and an opening emerges in which new impulses can arise.

Sometimes, by virtue of the confrontation itself, release happens naturally. This can be pointed out and developed. Movement, sound, and guided dialogue can also facilitate release. The particular form of the release relates to the energetic quality of the enactment and the content that has been explored. Release might come in the form of tears, anger, or any kind of letting go, or a shift in imagery, movement, or the "story" being told.

When the enactor has an emotional release, she experiences an accompanying release in muscle tone, posture, and breath. With the

emotional and physical release, she also experiences a release on the mental level, as thoughts and images shift. Subtle signs demonstrate that a release is taking place. Other signals of release might include a shift in body states, tone of voice, or facial expression, in the use of space or force and how feelings are being expressed, or in the feelings themselves.

This is an important and challenging phase. When a person is not able to move into release, we look for the block or impasse. Both are valuable phenomena, and we want to explore them when they appear. Several things may have occurred in the phases of identification and confrontation. It may be that not all of the compelling aspects of the issue have yet been identified and confronted, that key elements were overlooked or not enacted fully, or that an unused art medium might open up a new pathway. So we return to identification and confrontation and move through the cycle again.

Often, actively giving over to the conscious expression of an impasse leads to a breakthrough. We go into it creatively; we sing the impasse, dance the impasse, or paint it. Blocks are not "bad"; in fact, they provide important thematic material for exploration. Whatever is unfinished becomes apparent in working with movement, drawing, and dialogue as therapeutic enactment.

Watching the body and the movement, and listening to the voice, is essential, since physical expression is a very honest and accurate indicator of what has been confronted and released and what requires more attention. The body does not lie and invariably identifies what is present as well as what is missing.

Returning to the identification and confrontation phases usually occurs several times within a session, and certainly happens many times throughout the course of therapy before a complete and lasting release occurs. This is natural, and every small or partial release can be appreciated and supported as having great value and an important impact on the person.

Change

Change is movement from one place to another, a shift from one state to another state. More specifically, in therapy it means that an old impulse has been expressed and released and a new impulse has emerged. It is

important that any new changes be explored and enacted in movement, not just identified and talked about; in this way, the nervous system is given a direct message to encourage the whole body in the expression of the new state. The muscular and anatomical structures as well as the psyche and imagination need to be realigned around this positive imprint. Some form of documentation, such as creating a poem, a letter, or a drawing, helps to affirm, make concrete, and record changes that have occurred.

One strong and congruent body experience with any new imprint of release and change serves as a repatterning model for what is possible and for further encounter work. Simple acts – assuming a different body posture, repeating a new sentence or movement, practicing a tone of voice or facial expression, or drawing the change image – serve as symbols for deeper and more complex changes that have been discovered and that the person wants to bring into her life.

Growth

The phase of growth is connected with the ability to apply what has been learned in the previous four phases to everyday life experiences. We cannot assume that the transition from change to growth will happen immediately or will be easy. A cathartic experience or insight may prove difficult to sustain and embody on a daily basis. Growth depends on the ability of the individual to ground such insights and changes in the soil of her ongoing life interaction, and this typically takes time and practice.

If we discover an inability to live out the changes discovered in therapy, we identify this as the relevant theme or issue to explore next. Once again, we might consider an examination of what was missing or incomplete in the explorations of the previous phases.

Degrees of change and growth are commensurate with the ability to adapt to the ongoing processes of separation and integration, or tension and relaxation, which exist in all aspects of life. The practice and repetition of moving through confrontation, release, and change builds up the muscles which allow us to tolerate, adapt to, and trust the cyclical nature of things, including the life of our own psyche.

Where is true life?

Alone

Holding it in my abdomen

Oppressor, Victim

I see you, you see me

Part of it all

Leaving the familiar road. What next?

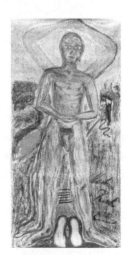

I stand with it all

Figure 9.6 These paintings by a client demonstrate a progressive movement through the five-part process

Growth is, in fact, an accumulation of change moments. In nature, a plant must assimilate the nutrients from the environment in order to grow; so, too, must the individual work on her ability to absorb the nutrients that are generated in the therapeutic exploration in order to grow and blossom. Growth occurs over time. Just as in tending a garden, patience and attention are required.

Both the three levels of awareness and response and the five-part process maps foster life–art dialogues and help us build bridges between the creative art exploration and our lives outside the art-making studio or therapy room. We identify life issues and struggles as themes to encounter consciously through expressive arts explorations. Thus, rather than approaching material as problems to be solved or eliminated, we approach material instead as valuable resources for a creative process and a therapy which is centered in the body and imagination.

The psychokinetic imagery process: an intermodal arts model

> There is a vitality, a life force, an energy, a quickening, that is translated through you into action and because there is only one of you in all time, this expression is unique. And if you block it, it will never exist through any other medium, and will be lost.
>
> *Martha Graham (in De Mille 1951)*

The psychokinetic imagery process is our intermodal arts model. Participants move, draw, and dialogue. Inspired by her collaborations with visual artists, in the late 1960s Anna Halprin (1995) began to have her dancers draw in class. Experimenting with the relationship between dance and drawing for healing, she came up with what, at that time, was a unique method. She named it the *psychokinetic visualization process*. Later, as others developed and expanded the process, the term was changed to *psychokinetic imagery* to clarify that this is not merely a visualization process but rather an active and expressive engagement with sensations, images, and narratives. This intermodal arts model is now central to almost all of the expressive arts therapy approaches and is used in a variety of different ways by many expressive arts therapists and teachers.

I think of the model as an expressive arts chorus. We use it every time we practice the work. Although it appears to be rather simple, it takes us to extraordinarily deep places in ourselves and in our art.

Figure 9.7 Psychokinetic imagery model

What we are doing with the psychokinetic imagery model touches on a complex network of pathways. Working with the interplay between the kinesthetic body, visualized images, and the felt experience, the psychokinetic imagery process lets us bypass our preconceptions and allows resources from the unconscious to surface. The movements, symbols, and images that arise out of the psychokinetic imagery process are much like dreams which occur in an awakened state, spilling into the dance or onto the paper, conveying information not normally apparent to us. This gives us material to work with which we do not always have access to through ordinary therapeutic or artistic means.

By interrelating each of these mediums in systematic and repetitive ways, we are constantly recreating and strengthening the interplay between body, emotion, and imagination. Each medium speaks with a

particular resonance to our physical, emotional, and mental levels of being. This resonance can be understood and used to engage our sensory motor responses in particular ways. Movement and dance correlate with our visual, auditory, and kinesthetic senses, and resonate deeply with body sensations and feelings.

Writing, whether poetry or prose, connects us to imagination, memory, and thought, and involves our auditory and visual senses. Drawing engages our visual sense, and, when connected with movement and imagination, resonates with body, emotions, and mind (Knill *et al.* 1995). Although we focus on each of the art mediums one at a time, we also shift back and forth from one to the other so that we are constantly working with the interplay between the mediums and between the psychic and sensory motor material that arises. As we work in the psychokinetic imagery process, transferring between the three art mediums, we are working with our entire psychic and sensory motor selves.

These three mediums can be engaged in various orders. We might start with movement, follow with drawing, and finish with a written dialogue, or we might start with a drawing, follow with movement explorations, and finish with a poem. The psychokinetic imagery process is a total intermodal system in which each of these three forms of creative expression is engaged in relation to the others. What arises in movement informs and inspires what arises in the drawing, and both provide material shaped by the meaning we articulate through dialogue.

A variety of exchanges can take place between or with the drawing and the dance, as well as the ongoing dialogue that we are in with the body and movement. I have been particularly interested in developing the dialogue aspect of the process as a way for people to work aesthetically with movement and words in improvisation. After the words have been found in improvisation or through poetry, storytelling, and other forms of creative writing, movement explorations then grow into what I think of as spoken-dance pieces, in which experience and meaning mutually evolve and feed off each other.

We find words directly from our movement, giving equal emphasis to what I call the dialogue with the image and movement or dance. In this way, we encourage people to create scripts which add new layers of

aesthetic expression. Written and spoken dialogue gives meanings to the images of the drawing which stay true to the images themselves rather than coming from the more usual mind of analytic interpretation. The drawing offers a way to shape the mental image and "hold it" in a dynamic way, so that the image and its meaning can unfold and be revealed. Dialogues allow people to reflect further on the multilayered messages of the dance, the drawing, and the relationships between the two. Now the dance, drawing, and dialogue hold equal, interdependent importance, each playing a key and revealing role in the work.

In further developments of this model, we pose *reflective questions* for journal writing, a way to bring focus to life themes, patterns, and possibilities for change. Reflective questions keep our thinking exploratory and engaged with our actual felt experience. Journal writing becomes the palate upon which the writer reenters her experience to think creatively and "mindfully" about it, and to find or make a relationship between metaphoric and literal reality. In addition, we make connections between what happens in the studio and what happens in our lives outside the studio. Not only does this heighten our creativity and expand our field of expression, but as each medium relates to and informs the other, powerful insights are generated which shed light on the circumstances of our lives.

The mediums of movement, drawing, and dialogue serve one another in many interesting ways. When we dance, we have no concrete image of our experience, no documentation of what we did. The closest we can get is through the eyes of our witnesses and any feedback they might give us, unless we have been filmed, which only captures the most outward appearance of our experience. Our drawings capture or hold for us some aspect of the spirit of the dance.

Although movement leaves behind nothing concrete, the painting we do provides an artifact to mark, or remind us of, the existence of the dance. I often ask people to draw both before and after a movement exploration, so that the drawings are both something in and of themselves as well as a documentary of a journey. Sometimes the drawing might "say" how it wants to be moved or voiced; other times the movement might "say" what image wants to be drawn. Written dialogues with the dance and drawing act as a way of making meaning through language.

As I mentioned previously, we can use the three mediums in a variety of orders. I most often start with drawing or movement and end with some sort of written dialogue, which is used as the text for spoken poems, stories, or dramas. Somatic and kinesthetic development seems to have an effect on the capacity to visualize and to express imaginatively. Drawings change over time as images and feelings change, as insight evokes new images, and as the drawer develops an expanded sense of her own body and more experience developing her movement expression.

Working with movement in relation to a drawing, we have the mover explore key elements of the drawing. So we take apart, or "break down," the image. I use the phrase "become the image," meaning that the mover imagines herself as a color in the drawing, and imagines how the color in her drawing might move. Then she might choose a second color to "become" in movement. Switching back and forth between the movement of the two colors, perhaps discovering a third surprise element in the movement of switching itself, the dance of the colors begins to emerge.

Other key elements from the drawing to be explored might include textures, shapes, or symbols, or the paper itself. This is a way to get the mover away from an interpretive or pantomimic dance of the drawing and helps her get inside the image and explore with as few preconceived ideas as possible. In the movement exploration or enactment of the drawing, we ask: If the movement could speak, what would it say? If the drawing could speak, what would it say? These prompts facilitate a shift into dialogue and help to keep the words connected to the aesthetics of the experience as it unfolds. Often sentences discovered through the "voice" of the movement or drawing become the opening sentences for a poem or story.

Partner work can include trading drawings with others. We can take on our partner's drawn image and its attending emotions and associa-tions. In this exchange, we give each other a form of aesthetic feedback, reflecting back patterns, possibilities for change, and new ways of thinking. We might also dare to confront difficult images, having the distance we need to play with what is there. As we play with material, which does not specifically "belong" to us, we meet ourselves in an impro-visational, experimental, and flexible way, which is not so attached to our

concepts of "what it's about." This may offer us fresh energy and new resources which we can "take back" with us to our own material.

The bond forged between partners working in this way often includes the feeling of really being seen, understood, and empathized with. Sometimes a partner is able to read between the lines, and make visible through the creative intuition of enactment a part of the other person's story which has not yet been told.

When using the psychokinetic imagery process, it is important to encourage participants to accept whatever drawn images emerge without judging and without concern for their graphic or technical merit. For some, drawing may feel clumsy, embarrassing, and unsatisfying at first; for others, the movement or the poetic dialogue may prove most challenging. For instance, people often report that their drawings do not capture the essence of what they are seeing in their mind's eye. The untrained painter, with the mind of a beginner, might be more likely to "let things come through" rather than painting about what is already known, or from a preconceived outcome. In the same way, trained dancers often find it a challenge to get beyond patterned movement to emotion and to the creativity of spoken words that are connected to emotion.

I had quite a struggle with drawing myself, and I share this with participants as a way of giving encouragement and saying, "Stay with it." After some years of using the medium of drawing in workshops and trainings, I wanted to use the process to work on a recurring personal theme. I noticed that whenever I made a drawing, I felt so ashamed of how it looked to me that I would tear it up before anyone could see it. My first drawings did not come close to expressing the richness of my inner images and feelings. I decided to go on a drawing retreat by myself. My intention was to confront my inhibitions about drawing and to attempt to resist the urge to destroy my drawings or throw them away. "Just be with it" was my mantra.

I drew all day and night. On the second day in retreat, I began to notice a dramatic change in the nature of my drawings and in my actual experience of drawing. I noticed how the very experience of drawing began to affect my emotions, which changed from fear and inhibition into creative exhilaration. The connections between my personal theme

and the inhibitions and fear I felt about drawing became evident to me, and I engaged in dialogues with myself and various other figures who were characters in my "you can't draw – that's not good enough" story. Essential to this change was a willingness on my part to keep committing to the art process, to stay in contact with all of my feelings as I drew, and to observe my judgments and impatience rather than interrupting my thoughts, feelings, or the artwork.

A number of key things occurred. I became very engaged and excited by the creative act of drawing itself. In other words, drawing became at least as interesting to me as the "problem" or theme I was working with. Shifting into an art medium that was unfamiliar and undeveloped put me into a confrontation with myself and opened up an incredible amount of blocked energy. I got to look at some core beliefs and fears that were triggered, and I was deeply touched by the artwork and the messages that the drawings revealed.

When we are working on a drawing, we are also working on something in our lives. When we are moving, we are moving something in our lives. Drawn images and dances as explorations of a theme or issue become resources for therapy or problem solving. Also, and most importantly, the act of drawing and dancing as process engages the senses, emotions, thoughts, and imagination, taking us into a direct experience of ourselves and a productive confrontation with whatever is evoked.

Exercises

In this section, I present the three levels of awareness and response and the five-part process in practice sessions.

The three levels of awareness and response exercises

The purpose of these exercises is to:

- heighten your awareness of the three levels of experience and expression – your physical body, your feelings, and your thoughts or images

- explore how each of these levels affects and relates to the other levels while exploring a particular theme

- "listen" to the story that each level wants to tell
- open up the pathways between each level so that more creative energy and interplay is available.

EXERCISE 1: BREATH AND MOVEMENT

This exercise provides a warm-up, invoking the physical level.

Start in a sitting position, and focus on your breath. Place your hands on your chest so that your awareness of your breath and the movement of your inhalation and exhalation is intensified. When you are ready, move your hands to your belly as you continue to feel the sensation and movement of your breath. With each inhalation and exhalation, let your movement response grow. Develop and explore whatever movements arise as you follow your breath.

Begin to move through space. You may feel like adding sound. Stay with the focus of your breath, letting it be the sensory experience which leads your movement and leads you through space. Build on any other physical sensations which arise. Add the sound of your breath, letting it become the music which accompanies your movement. Begin to shape a "breath dance." While you continue to maintain your focus and connection with your physical sensations, let your movement also respond to or be colored by any feelings or images which are evoked.

Consider these reflective questions, which you can respond to in spoken word or in journal writing:

- If your breath had a voice, what would it say?
- If the physical sensations you have become aware of could talk to you, what would they tell you?

EXERCISE 2: THREE-LEVEL DRAWINGS

The purpose of this exercise is to see or listen to yourself very carefully on each level – the physical, the emotional, and the mental. You will create three small self-portrait drawings on three separate pieces of paper.

The first drawing is a drawing in which you focus on the physical image of yourself. Pay close attention to how your body feels and what your image of your body is.

The second drawing is a drawing in which you focus on an image of your emotional self. Pay close attention to what emotions you are most in touch with.

The third drawing is a drawing in which you focus on a mental image of yourself. What mental state are you in?

On the back of each drawing, write some words or sentences; these might be like titles of the drawings, or they might be like statements from the drawn images.

Respond to each of your drawings in movement, one at a time. How does each image want to move, or what are its movement qualities? I recommend about five minutes of movement for each drawing.

Choose one of the three drawings that you most want to focus on, and develop it further. Add to the drawing, and do some journal writing in which you reflect on the drawing you choose. Does it reflect the physical, emotional, or mental level? What does this choice mean to you?

Engage in written dialogues between yourself and one of your drawings, between two of your drawings, or between all three.

EXERCISE 3: SELF-PORTRAIT DRAWING

Create a self-portrait drawing in which you use the three smaller drawings from the prior exercise as preparation resources or small studies. Set aside more time for this drawing. Use your whole body image as the "outline." When you are finished with your drawing, write a dialogue or a story.

Explore the self-portrait in movement, or create the dance of your self-portrait drawing.

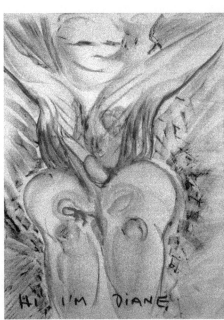

Hi, I'm Diane

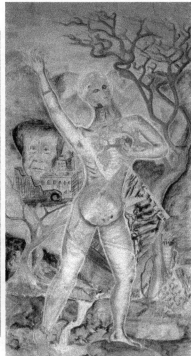

Embodied all

Figure 9.8 The development of the self-image as well as the relationship with the medium of drawing itself took place over six months

You may find that repeating Exercises 2 and 3 in their entirety on a seasonal basis, or at important juncture points in your life, will prove very revealing and supportive. I often think of this as "housecleaning," or remodeling and updating my image of myself. The images you draw hold powerful information about where you are in your process and what needs your attention.

The three level drawings followed by the self-portrait drawing also provide wonderful material to work with in groups.

Additional indications for teaching setting

In a group setting, the facilitator is the timekeeper. The group divides into partners. One person holds up each of her drawings and watches as her partner explores each image in movement. The facilitator calls out when it is time for the partners to begin, when it is time to finish moving one drawing, and when it is time to switch to the next drawing. All of the partnerships are working at the same time, with each witness keeping her focus only on her partner.

Each partner holds up her drawings, one at a time. The other partner responds to and enacts each drawing in movement. When one cycle of drawings is complete, the partners switch roles; the mover becomes the observer, holding up her own drawings, and the observer becomes the mover, enacting the drawings of her partner.

People enjoy this exchange of drawings, as it gives them the chance to be removed from their own material and see how someone else works with it aesthetically. The observer may feel that her partner's movement enactment is a reflection of her own experience, she may see possibilities that she had not considered, or she may see her partner get at something that she herself has not been able to express.

Most often, the individual has a set of preconceived ideas of what the drawing means in relation to her life script. Such fixed ideas limit her spontaneous and creative ability to respond freely in the moment. Images and movements, in this regard, can become static and fixed, supporting the old patterns rather than encouraging new possibilities. Partner exchanges are one way to break through these limitations. The partner who is exploring an image which does not "belong" to her is also breaking through into the improvisational play which becomes possible when we are not so attached to what we think the story is. So the partner brings a fresh and open attitude to the enactment that is free of an emotional and mental script. This can inspire the observer to consider new forms of expression, and it can also carry over into the partner's enactment of her own drawings.

Once we really learn how to improvise, to work with what we do know as well as to stay open to the surprise of the moment, to let the movement and the image really direct us, we can take this skill back to our encounters with our own stories.

For the partner exchanges to be most effective in opening up this improvisational field of play, the writings on the drawings and any verbal sharing about the drawings should not occur until after the movement explorations are complete. This way, the mover does not try to act out her partner's story.

When the movement cycles of both partners are finished, give the partners time to talk with each other. Some questions to ask might include:

- What interested you as you watched your partner move each of your drawings?

- What feelings or imaginings were elicited for you?

- What did you see in your partner's movement that was a surprise?

Later these same partners can reconvene to share their writings and their final self-portrait drawings, and to continue their dialogues with each other. This creates continuity between partners who act as witnesses for each other. The collaboration of the partnership itself moves through the cycle of the three levels – from physical to emotional to mental. First the partners make contact through movement, then they share the feelings the drawings and movement evoked, and finally they share their story line as expressed in the written dialogues.

The five-part process exercise

In the next section, I will present an exercise in which each activity pertains to one of the parts of the five-part process. These are examples of any number of ways we can work with this map.

IDENTIFICATION

Choose a concern, issue, or theme that you would like to work on. It could be connected with a relationship, a situation at work, a physical challenge you are experiencing, or a question that you are struggling with.

Create a drawing in response, playing with whatever literal or nonliteral images unfold as you draw.

Title your drawing, and write the title on your paper.

In your journal, explore or respond to what has come up in whatever writing style suits you: poetry, dialogue, storytelling, letter writing.

CONFRONTATION AND ENACTMENT

Now, put your drawing against a wall where you can see it. Confront it face to face.

Begin to move the images that you have drawn. Enact the drawing with your movement as if you *are* the drawing or are entering into a dialogue with the drawing. Move each color, shape, or symbol. Use your voice, making any sounds or using words that are evoked as your movements connect with your feelings.

Stay with this process for as long as you need, until you feel you have completely experienced and expressed your drawing in movement.

RELEASE

Find a movement or movement phrase (two or three repeatable cycles of movement) which gives you the feeling of breaking through. It may be something like stomping, hitting, tearing, pushing, swinging, jumping, or reaching. It might be soft swings, gentle holdings, or stroking movements. Just go with what comes up. Breakthrough movements often involve a certain degree of force and muscle tone that give an authentic feeling of moving into something new. Be sure you are using the space around you, above you, and below you. Continue with your break-through movement phrase until you experience a physical release. Use words and sounds.

CHANGE

Let your release movements lead you naturally into a movement which feels new in relation to your identified issue. If nothing occurs to you, make something up. If you could have the new movement of your choice, what would it be? Then explore it. Imagine what your new movement would say if it had a voice, using just a sentence or two. Repeat your sentences and movement together.

Lie down with your eyes closed for a period of reflective quiet time. Be open and pay attention to the sensations in your body, your feelings, and any images that appear.

Whenever you are ready, open your eyes and sit up. Make a second, new drawing of the original issue you chose to focus on, reflecting how you feel now. Your second drawing will reveal any emerging changes.

Take a few minutes to move the second drawing in order to affirm and imprint the new image in your psychosomatic awareness.

GROWTH

Do some journal writing in a style that flows with your creative impulses, such as poem, story, dialogue, or free association. Some general suggestions include: a dialogue between your first and second drawings, a letter to a person in your life who is associated with your issue, or a dialogue with a body part or between two body parts which were highlighted in your movement. Write a letter to yourself in which you give yourself specific examples of how you would like to apply what you have experienced in this exercise in your life – with your body, in a relationship, at work, and so on.

Journal writing acts as a conductor for making meaning of this experience and for envisioning how you might want to apply any insights evoked during your exploration to specific life situations. Your writing will help you apply your intuitive experience and determine the steps you want to take toward growth.

This entire exercise can be oriented around any theme, burning question, specific conflict situation, longing, or dream.

The exercises in this chapter provide a beginning point. In the next chapter, we will deepen the process by exploring metaphors for the various parts of the body.

Note

1. Anna Halprin (1995) began to use the term *five stages of healing* to describe a model she began using in 1972. The term *five-part process*, the definitions of each of the five parts, the overall description of the model, and the commentary on its use in tracking movement, in working with drawn images, and in therapy reflect my own development and design (Halprin 1989).

The shadow wants to speak

Confronting

Letting it come up and letting go

Figure 9.9 Confront, Release and Change Images

Body Part Metaphors

> For every thought supported by feeling there is a muscle change.
> Primary muscle patterns being the biological heritage of man, man's
> whole body records his emotional thinking.
>
> *Mabel Ellsworth Todd (1937, p.1)*

In this chapter, I will lay out a map describing a way of identifying and
exploring the anatomical and physiological functions of each body part
in relationship to corresponding metaphorical themes. I will provide
examples that demonstrate how to use this map in working with the body
parts. First I would like to give an overview so that you can begin to
understand how I go from *function* to *association* to *metaphoric theme*, and
from there to setting up *movement situations* in which this map is applied.

This particular method of working with the body parts is based on
bridging the literal and metaphoric aspects of the body. In working with
the body and movement, with their very clear, literal reality, we consider
how the functional aspects of the body and particular movements evoke
certain attending emotions, images, and associations. This makes for a
powerful metaphoric interplay between the actual and imaginal worlds.
In this phase of the work, the body parts, their corresponding
movements, and their thematic associations are used as keys to the parts,
or chapters, of our self and our life story. In this way, the body parts play a
similar function to the symbols or scenes in a dream.

In considering the literal viewpoint, we investigate aspects of the
body such as anatomical structure and physiological functions. Looking
at the movement of a body part, we explore the movements which are
initiated by or belong to the particular repertoire of each body part. For

instance, legs and feet: crawl, stand, walk, run, skip, leap; pelvis: rotates, thrusts forward and backward, swings side-to-side; arms and hands: reach, hold, punch, grasp, stroke. In considering the metaphoric viewpoint, we investigate images, feelings, and archetypal as well as personal associations which correspond to certain parts of the body and to the movements which belong to that body part.

There are several ideas to consider when working with this relationship between the actual and the metaphoric body. One is that the emotional and mental responses and the "events" of life associated with these imprints are stored within the different parts of the body. This storing at a physical level most often occurs without our conscious awareness. The unconscious housing of emotions, thoughts, and images – and the particular situations with which they are associated – may have taken on a negative or restricting quality, which blocks positive, though dormant, possibilities from emerging.

We have discussed how creative movement reveals the ways in which our bodies store negative and positive imprints and how we often establish our sense of alignment around old emotional scripts and continue to organize ourselves around old traumas, patterns, beliefs, and postures. This is mirrored in physical structure and in the functioning of each body part. We can see in our bodies, in our posture, in our gestures, and in the ways we move where we are stuck, how we are holding, and the quality of our longing or our joy. We can watch how the body parts are engaged in movement and know something of the inner story that is being expressed.

Thinking of the body as a family made up of separate yet interrelated members, we know that each part has an impact on the whole and that each part can help us to understand the whole. When a family is in conflict, it is important to listen to each member separately as well as listening to how they communicate with one another so that we can really hear and understand. Or we use the image of the body as a house, with each body part offering a way inside.

We begin by exploring each body part separately and one at a time, to provide depth. Although our larger purpose is to find relationships between the body parts and to reintegrate the body as a "unity," we first identify and explore the "script" associated with each body part. We want

to discover what is creating disintegration or conflict, as well as what kinds of creative dialogues can happen within each body part and between different combinations of body parts. We use each body part and the body parts in relation to one another as metaphoric keys into archetypal and personal themes. Over time, an authentic reintegration of all our parts occurs, reflecting our embodied discoveries and insights.

For the purpose of this study, we divide the body into the following general parts and areas: head and face; neck, throat, and jaw; spine; ribcage; shoulder girdle; arms and hands; abdomen; pelvis; and legs and feet. We identify corresponding functions, associations, and themes with each of these different parts of the body; these link the individual's experience with commonly held human responses, which I refer to as "archetypal themes." These archetypal themes are related to the biological, physiological, and functional aspects of each body part. In this way, the different body parts can be approached as archetypes for the collective human experience.

Let us look at how we travel from body part to the corresponding movement repertoire, feeling responses, images, and theme. There are a number of angles of approach that we might take. We engage the physical body by finding movement activities which are oriented to the particular function and range of each body part. For instance, the physical function and movements that belong to the repertoire of the legs and feet more than any other part of the body include crawling, standing, tiptoeing, kicking, and walking. So we might explore this range of movement possibilities.

As we go from a body part into the exploration of its particular movement repertoire, we remember that movement evokes images and feelings; when the body moves, the emotional and mental levels are engaged, allowing us to work with the three levels of awareness and response – physical, emotional, and mental. When crawling, I might feel like a baby. When standing, I might imagine the effort I have expended in my life. When I tiptoe, I might remember the times in my life when I have been cautious and afraid. When kicking, perhaps I am experiencing and releasing some stored-up anger; I experience strength in my leg muscles as I get in touch with my power and ability to mobilize. Explorations

based on the particular movement repertoire of each body part invite the metaphoric themes of that body part to emerge.

Another angle is to narrow down the repertoire by identifying a specific movement to explore. Following our example for legs and feet, we could choose walking as the given movement. Then we might add resources related to space (backward, forward, sideways, in circles, into the corners), time (which in the language of movement is speed – fast or slow), and force (sharp, fluid, heavy, light). So we combine walking with walking quickly and slowly or changing directions. Walking backward or forward, quickly or slowly, in circles or straight lines will evoke different feelings and images that add new layers of meaning to the metaphor of walking.

Another way to work with body part, movement, and metaphor, again using the example of legs and feet, is to begin with an open exploration of whatever movements occur as you lead with your feet and legs. Then the mover chooses one or more particularly evocative movements and explores the chosen movements by repeating, developing, shifting, or switching and making transitions. As we zoom in on the movement resources particularly meaningful to each mover, the personal experience around an associated image, feeling, or life theme will deepen, and the metaphoric "dance of the body part" is created.

For instance, after exploring a variety of different movement situations leading with my legs and feet, I might choose to develop walking as my primary movement. Improvising, I walk slowly into a corner, then turn and walk quickly out of the corner. I repeat this over and over until I am out of steam and fall to the floor. When I have caught my breath, I begin to crawl around the room. I imagine myself as a tiger; I am hunting, a bit dangerous. I feel unafraid and free. I make sounds and have fun with it. Later I might tell the story of the slow walk, the quick walk out of the corner, the collapse, and the emergence of the tiger. This act of creative storytelling is for the sake of the story I weave in the moment and also acts as the fable or myth speaking to that part of my life which my feet and legs dance revealed to me.

The psychokinetic imagery model also applies to our work with the body part metaphors. We might begin with a drawing of the legs, explore movement enactments of the drawn image, and write a story from the

"voice" of the legs, or the point of view of the legs. This is another way of centering our expressive work around the metaphoric qualities of the body parts to encourage the life stories to emerge. Ongoing movement explorations of any body part result in new images and drawings, because as we work with movement in this way emotions are released and changes occur.

The following section delineates the different body parts, and a variety of functions, associations, and themes that relate to each one. The description of the functions of the body parts is fairly objective, while the associations and themes are more subjective, bound by cultural norms and expectations. As a result, they cannot pertain to everyone; as facilitators, we must remain alert to the information we receive from people about their individual associations and life themes.

Now let us look at this map, which includes each body part, its primary function, its associations and possible metaphors, and finally an example of a theme from which to create movement explorations, drawings, poetic writings, and reflective questions. In the exercises, you will find that I take these different approaches into the movement itself.

We will start from the top of the body and work our way down.

The head and face

Functions

The head and face form the control center of the body and act as a highly intense sensory receptor or processor. The brain selects sensory input to be retained, gathering input from the external environment and determining how it will be used. The head and particularly the eyes establish a sense of equilibrium through space perception. The face translates sensory sensations: sight, sound, taste, touch, and kinesthetic perception.

Associations

The head as the sensory selector is associated with the ability to make choices based on what is recorded. We think and process cognitively; we fantasize, dream, and imagine with our head, which includes our brain, skull, and perceptive organs such as the eyes, ears, and nose. We decipher and decode all internal and external stimuli through this body part. The

survival instinct and self-defense are based on our ability to translate this input accurately and respond to it.

We express our thinking responses or make them visible with our face. The head and face act as a social mask, making visible how we choose to present ourselves to the world. The head as a thinking part is associated with how we integrate our thoughts and intellect with sensations, feelings, and memory. The relationship between linear or conditioned thinking and creative, intuitive thinking often comes into view. This body part might be associated with issues such as reconciling heavy, hardworking, or serious qualities with light and playful qualities. The head, then, is associated metaphorically with our internal feeling and thinking processes and with how we are expressing these internal processes externally.

Themes

For each body part, there are numerous themes that can take people into their *life narratives*. With the head and face, one of the themes we play with is "mask and unmask."

Head and face warm-up exercise

This warm-up exercise allows you to explore whatever arises. Let your head drop forward, and then slowly lift your head up again. Repeat this progression three or more times.

Balance your head upright in relation to your spine. Take a few moments to explore this balancing of your head on top of your spine and notice the micromovements, shifting your head slightly as if playing with a globe on top of a stick.

Slowly turn your head from side to side. Experiment with your range of side-to-side movement as you turn your head. Play with different speeds.

Now begin to rotate your head in circles, dropping your head down toward your chest and then rotating it in a full circle to one side, dropping it backward, then lifting your head to the other side and dropping it down toward your chest again. Complete this full circle three times leading to the left and three times leading to the right.

Move through space, letting your head initiate your movements. Explore any combination of movements from the warm-up repertoire. Work with space, time, and force as you develop your movement play. Let your head be the leader and let the rest of your body respond in any way that comes up for you.

Standing in place, drop your head down toward the floor and slowly lift your head up again. Stop randomly at different points along the way and let the movement and posture suggest a facial expression. You will notice that different positions and movements of the head evoke different feelings and fantasies. Once your facial expressions are warmed up, continue leading up and down and through space with your head as you add and explore various facial expressions suggested by the movement.

Do some free-form writing in your journal about what these movement warm-ups evoked in relation to your head.

Head and face exercise: mask and unmask

Make a drawing of your head and face (including facial expression) as if you are wearing a mask that represents one of your most familiar social roles.

Make a second drawing of what you imagine is behind this mask – as if you are unmasked.

Title each of your drawings, and write the title on each drawing.

Take five minutes to enact your mask drawing in movement and with sounds or words. Take another five minutes to enact your "unmask" drawing.

Find the relationship of the two in movement as you switch back and forth from one to the other.

We work on the mental level of awareness and response through creative writing. In this way, we shape meaning with a script, a story, a dialogue, or a poem.

Write a dialogue or a poem between your mask drawing and your "unmask" drawing.

Consider these reflective questions, which you can respond to in spoken word or in journal writing:

- How does your mask feel and how does your "unmask" feel?
- What is the worldview of each?
- Are there ways in which they are in conflict with each other?
- What does each one want and need from the other?

Recall situations when you have worn the mask and when you have worn the "unmask." Write some thoughts about what you imagine it would be like if you wore your mask or your unmask in your family, with friends, at work.

The neck, throat, and jaw

Functions

The neck connects the head with the shoulders and the rest of the body. It holds the head upright, and allows the head to turn from side to side, rotate, and drop forward or backward. The throat holds our vocal cords and upper esophagus, and is in charge of verbal and vocal communication, swallowing, coughing, and spitting up. The jaw is responsible for chewing and the function of speech.

Associations

The neck, throat, and jaw work together, creating a sense of connection or disconnection between the head and the rest of the body, between the inner experience and external expression. These body parts are associated with communication. In this capacity, they act as the conductors of our inner impulses, thoughts, and feelings to the outer environment and to other people. We use the throat to voice our personal identity, to speak up and speak out. The jaw engages with our intake of food by biting off what we have the capacity to chew.

Psychosomatic symptoms or postural qualities may signify difficulties to communicate inner feelings, especially feelings which the individual thinks may not meet with approval; an overload of responsibilities (biting off more than we can chew); or the feeling of having to swallow unwanted impressions from the outside.

Themes

A possible theme for working with the neck, throat, and jaw is "giving voice to…"

Neck, throat, and jaw exercise: giving voice to…

Start by making a drawing of your neck, throat, and your head with a focus on your jaw and mouth.

Use the drawing as if it is a graphic score for vocalizations. Respond to any of the elements in the drawing, including color or symbol, zooming in on the neck, the jaw, or the mouth one at a time. Explore the images or the different parts of the drawing in sound, spoken word, or singing. If working in a group, choirs of other participants can vocalize while the person to whom the drawing belongs listens. Others can vocalize the drawing while the person to whom it belongs moves with eyes closed to the sounds. If working on your own, you can experiment with moving to your own sounds.

Following the sounding of the drawing, write a story from "the voice" of these body parts.

The spine

Functions

The first evolutionary locomotor development in infancy is the ability of the infant to turn from her back onto her front. On her back, an infant is more vulnerable and passive, less able to censor sensory input such as tickling, stroking, or the visual impact of a parent's facial expressions and vocal sounds. When she is able to move from lying on her back to lie on her front, she begins to be able to lift her head up, look around, and to some degree receive or shield more.

The spinal column contains and protects the central nervous system, thus making a wide range of movement possible. The spinal column is also the hub or communication center, with fibers which send messages throughout the body.

Associations

The back portion of the body may be associated with the unknown or less familiar aspects of the self – the shadow side. What we do not want to look at or what we do not want to have seen may be stored metaphorically behind our view and out of the way. In addition, a sense of things or people we cannot see comes at us from behind. The spine connects with the shoulder girdle, ribcage, and pelvic girdle in a special weight-bearing collaboration, which allows flexibility and range of movement between these large body parts. The spine holds us up and plays a central part in forming our body posture.

Themes

Possible themes to work on which explore the spine include "What is my posture in life?"

Spine warm-up exercise: movement exploration

Choose a piece of music to provide a background rhythm for a movement cycle to heighten awareness and improvisational responses centered around the spine. The music should not include lyrics that might superimpose a story or particular emotional qualities. Something with a fairly steady beat is recommended.

From a standing position, slowly drop the head forward and let the upper torso, arm, and hands follow until you are hanging toward the floor, with knees slightly bent.

Pause for a moment, and then begin to rise up slowly until you reach standing again. As you rise toward standing, tilt your pelvis slightly under so as not to create an arch in the back. Engage the muscles in the thighs to support you as you slowly lift your torso and "unfold" the spine as if stacking one vertebra on top of the next. The shoulders and head are the last parts you lift upright.

Let your arms and hands dangle gently at your sides. As you stand upright again, become aware of the body posture that you most naturally seem to drop into.

Notice how your head and neck come to rest atop your spine. Notice the shape and position of your shoulder girdle and the placement of your

arms and hands at your side in relation to your chest and shoulders. Notice the position of your pelvis at the base of your spine. Notice the direction of your legs, turned inward or outward, thighs together or apart, and so on.

Repeat this dropping and lifting movement cycle several times; each time you return to standing, exaggerate some aspect of your posture that you notice.

With each exaggeration of your posture, speak a sentence out loud as if letting the posture itself make a statement. For example: "I'm tired of holding you up," or "I can handle anything."

When you have found a posture that strikes you as closely related to one of your primary "postures in life," continue to hold its slightly or greatly exaggerated shape and begin to play with it in movement and spoken word improvisation.

Let the posture and its movement and voice develop into a kind of character or caricature that inhabits the stage that you are improvising on. If you are doing this with others, you might begin to interact with one another, play off one another, and use the geography of the room as your stage set. An entire theatre of body posture characters can be developed.

Once you have established one posture in this way, create an opposite body posture and retrace the previous steps. Find its anatomy. Practice by standing in place, dropping the head and upper torso forward until you are hanging over toward the floor, then slowly unfolding the spine until you are standing upright again.

Shape your body stance into the opposite posture, working as a sculptor might with clay, shaping head and neck, spine, position of pelvis, placement of legs and feet, position of arms and hands, chest, and so on.

Explore the movement repertoire of this posture, and find some key sentences for its script. Then switch back and forth between these two postures, movement qualities, and repertoire of words, playing a kind of duet between the two.

Now find a third posture, which you imagine as a new posture you would most like to cultivate in your life now, and retrace the previous steps: finding the anatomy of the third posture, practicing it by standing, dropping forward, and slowly unfolding into an upright stance again.

Develop a repertoire of movement out of this posture; explore the rhythms it most likes to move to, the way it moves through space, and its corresponding words.

When the movement and word explorations of all three postures are complete, go to your drawing pad.

Create three sketches on the same sheet of paper of each of the postures you explored, a kind of series of self-portrait studies.

Jot down a few key sentences under each image, or write a short story which follows the three postures. In your writing, focus on each posture and note the various specific associations to your life circumstance that each posture suggests.

In your everyday life, take a moment out to "tune into" your spine and notice what "life posture" you are in. Try improvising with the possibilities by mobilizing your spine in different ways.

The ribcage

Functions

The ribcage houses and protects the heart and lungs and connects the chest cavity with the shoulder girdle. The lungs regulate and process the inhalation and exhalation of air. The heart filters the blood and pumps oxygenated blood throughout the body. The ribcage serves as a storehouse of vital energy-making nutrients from the blood and air. As the home for these two most vital organs, the ribcage protects a large part of our life-support system.

Associations

A cage that holds the heart, the ribcage is a body part that can evoke deep and vulnerable feelings. It often holds unexpressed feelings of love and longing regrets around needs that have not been met or are unfulfilled. The ribcage is a place in the body where we can feel and sense the rhythm of the breath. In cooperation with the arms, the ribcage allows open and closed movement and the possibility to choose when and how we want to open and close.

Themes

Possible themes include taking in (inhalation), letting out (exhalation), and "open and closed."

Ribcage exercise: open and closed movement explorations

Begin with a warm-up in which you bring your awareness to the physical sensation of your ribcage and lungs.

Close your eyes. Deepen and expand how you breathe with each inhalation and exhalation. Notice how your breath moves your ribcage in and out, up and down. Feel your ribcage, imagining your bones and muscles expanding and collapsing with each breath. When you are ready, begin to develop expressive movement in which your ribcage initiates opening and closing movement and leads you through space. Take it slowly; speed it up, then slow it down again. Explore small movements, large movements, and mid-range movements.

Add your arms and hands to intensify and develop your movement. Stay with the image, shape, and quality of opening, closing, open-extended, closed-collapsed, or contracted movements.

As you continue playing with the movements, add sounds or words as images and feelings arise. As any movements, sounds, or words become particularly evocative, stay with these resources and explore where they take you. Use the space as a symbolic resource in your movement play.

Keep shifting back and forth between open and closed movements, working with the sounds and words that belong with open movements and the sounds and words that belong with closed movements. Explore movement in open space and in closed space, and work with shifts in speed and rhythm that intensify both.

In ending your exploration, find a cycle of movement that might also include sounds and words with both open and closed movements in the cycle.

Repeat this cycle a few times so that it becomes clear for you. Following this short repetition, find the posture or gesture and the sentence or sound that feels most right in ending.

If you are working in a group, you might have people pair up as partners in a phase of their movement explorations, to play with open and

closed movements in duets as a metaphor for opening and closing in relation to others. In ending, you might have people partner to show their repetitive open and closed cycle and to share their final gesture and sentence.

Some reflective questions to consider include:

- What do you want to open to in your life?
- How will you do this?
- What do you want to close to, or what do you want to make closure with?
- How will you do this?

Here are three possible approaches for ending with a drawing of the ribcage:

1. Draw your ribcage as you image this body part now.

2. Draw the ribcage closed and the ribcage opened.

3. Draw the ribcage in response to any of the reflective questions.

The shoulder girdle

Functions

The shoulder girdle is akin to the pelvic girdle in its ability to perform a weight-bearing function. It augments the arms by acting as a weight-bearing yoke. In this way, it is like the hidden strength behind the arms, freeing the arms to manipulate, express, and protect. It connects the arms with the ribcage, providing strength and stability for lifting, carrying, pushing, and holding.

Associations

Associations with the shoulder girdle include carrying weight, shouldering responsibilities, protecting the ribcage, and helping the arms extend outward. Easily recognizable shoulder postures reveal frozen attitudes and emotions. Bowed shoulders may indicate a feeling of carrying too much responsibility. Drawn-back shoulders may convey held anger or a

need for self-assertion. Raised shoulders may be an expression of frozen fear. Squared-off shoulders may be holding an attitude which says, "I can do it!" or "I need to prove myself." Caved-in or dropped shoulders may hold feelings associated with low self-esteem. Held-back shoulders tend to hold defensive attitudes or an overinflated sense of self. If the shoulder girdle is misplaced, this affects expression in the arms. When the shoulder girdle is balanced and aligned, it conveys the qualities of courage, strength, and relaxed self-assurance.

Themes

A theme you can explore with the shoulders might be "carrying the weight of the world."

Shoulder girdle exercise: exploration in drawing

First draw a "blown up" image of your shoulders as you imagine and feel them now.

Give voice to the drawing. If the shoulder image could speak, what would it say? Write a few sentences.

Shoulder girdle exercise: exploration in movement

Create movements, leading with your shoulders. Look at your shoulder drawing and respond to the image. Close your eyes and play with the sensations, feelings, and images that spontaneously arise.

Following your movement play, imagine that your shoulders have a voice. What are they saying? Write a few sentences.

Shoulder girdle exercise: working with objects

Choose three different props – one you imagine is symbolically connected with something you have carried in the past, another which is connected with something you are currently carrying, and the third connected with something you would like to carry in the future.

Play with all three objects. Explore different ways of carrying and setting down each of your three objects. When you feel complete with

this exploration, create an installation piece out of the three objects. You may add other things to the installation.

Draw a sketch of your installation piece as a way of keeping the image. Write a poem or story that gives the narration for this piece of artwork.

The arms and hands

Functions

The arms and hands reach, hold, grab, punch, push away, manipulate objects, feed, write, and so on.

Associations

Associations with the arms and hands include the need and ability to make things, to destroy and rebuild, to hold on and to let go. With the hands and arms, we express our impulses to give and take. The arms protect the ribcage that houses the heart and lungs. The arms extend out from the shoulders and ribcage and can "act" as extendors of the heart, communicating feelings. They can express rage through hitting and punching, and have the ability to push away what is threatening.

We often enact our feelings of love, caring, and tenderness with our arms and hands. We most often use our arms and hands to connect with others. Arms and hands are the most socially accepted way to make contact in most cultures. Arms and hands reach out to express longing and desire.

Themes

A theme with which to explore the arms and hands might be "What am I holding and what am I longing for?"

Arms and hands exercise: exploration in drawing

Create a "blown up" image of your arms and hands as you imagine and feel them now. If your image could speak, what would it say? Write a few sentences.

Arms and hands exercise: exploration in movement

Improvise with different ways and qualities of reaching and holding. As you explore reaching and holding, the movements of your hands and fingers may lead into other movements, such as grasping, stroking, pulling, pushing, and punching. Find the combination of movements that feels particularly evocative and meaningful for you. Create and develop a repetition of movements that becomes your particular arms and hands dance. Add sounds and words.

Following your movement play, and using some of the sentences that came out of your movement improvisation, imagine your arms and hands have a voice. What do they have to say? Write a few sentences.

Next, explore how your shoulders, arms, and hands want to move together. Create an image of your shoulders, arms, and hands connected and on one sheet of paper.

Interweaving the images that arose in your drawings, movement improvisations, and writings create the story that your shoulders, arms, and hands want to tell together. Express it in drawing, writing, and movement.

The abdomen
Functions

The abdomen is the most unprotected area of the body as it has no bony structure to shield it. The abdominal area receives and refines food. It is the part of the body responsible for digestion, for assimilation, and for storing extra fatty reserves to produce more energy when the body needs it. In the female body, the abdomen provides extra room for growth during pregnancy. The muscles that move the pelvis are in the abdomen. Our intestinal tract winds through the abdominal cavity, dealing with digestion, assimilation, and elimination.

Associations

The abdomen is associated with gut feelings and the ability to digest. Conflicts associated with the belly have to do with holding down feelings, and with an inability to process and assimilate impressions

received from the outer environment. Our ability to eliminate, or how we eliminate, is connected with the abdomen. In eastern traditions, the belly is considered the center of the body, and the place from which a state of balance emanates. The abdomen acts as a transit area between the upper and lower portions of the body.

Themes

A possible theme to explore for the abdomen would be "contacting and expressing my gut feelings" or "holding and releasing."

Abdomen exercise: movement exploration

Begin by placing your hands on your belly. You can do this sitting in a chair or lying down. As you breathe deeply, connect with the sensation of your breath as your belly lifts and drops. Let the abdominal and intercostal muscles remain soft, and be sure not to force or hold your breath.

Gently rub your abdominal cavity with your fingers and the palms of your hands. Notice places of holding and any tension zones. Be aware of any sensorial connection between your abdomen, chest, and throat.

Let the sound of your breath become audible, and let any other sounds emerge.

Do a drawing of your abdomen. Spend ten minutes or more exploring the image in movement, leading from the abdomen whenever possible. You will probably want to engage other body parts as helpers and responders, since the abdomen is not usually an initiator of a wide range of external movement.

Write a dialogue with your abdomen. You might dialogue with parts of the drawing, as if from the point of view of your drawing speaking with someone in your life. Or you can write a dialogue between the abdomen and another part of your body.

In your journal, reflect on any of the following reflective questions:

- What have I had difficulty digesting in my life?
- What life experiences have I assimilated that have had a nourishing impact on me?

- What negative experiences have I been able to eliminate?

- Are there "leftovers" that I would like to digest, assimilate, or eliminate?

Do some movement and sound explorations in response to any of the images or situations that come up in your journal writing.

Put your favorite music on and do a belly dance!

Find a time to rest, relax, reflect, and play, and choose a specific activity away from your everyday life that seems to you "just the right medicine" in relation to the material that came up for you in exploring your abdomen. This will help you digest, assimilate, and eliminate.

After you have completed your writings, movement, and sound explorations, do a second drawing, perhaps following your ritualized "time out." Title the drawing.

Although the abdomen does not have a wide range of active movement, internally there is quite a bit going on in this body part. The drawings and extensive writing help us to get at the wealth of stored-up material reflected in the associated themes of this body part. The essential and constant internal movement of the organs and functions of the abdominal region have a huge impact on our health and well-being on a daily basis. The metaphoric correspondences of digestion, assimilation, and elimination are significant in relation to the health not only of the physical body but also of the psyche.

The pelvis

Functions

The pelvis is the foundation upon which the upper body rests, supporting locomotor movement. The coccyx bone, like a prehistoric tail, shifts our center of gravity toward the earth. The pelvis houses the sexual and reproductive organs, as well as the rectum and urinary tract through which waste materials are released. The pelvis also shelters the womb and birth canal, the testes and penis, and is, for every human being, the place of gestation and passageway into the world.

Associations

Associations with the pelvis include sexuality, procreation, birth, the reproductive instinct, containment, and expression of the life force. The pelvis is associated with feelings about repressing, releasing, and opening to pleasure and excitement in sensual and sexual expression.

Themes

Possible themes for working with the pelvis are inhibition, play, and passion. Due to the particularly personal associations with the pelvis, in general it is best for each person to identify her own theme.

Pelvis exercise

Choose your own order in working with movement, drawing, and dialogue. You can also shift back and forth between the mediums.

Take some time to tune into your pelvis physically. Explore whatever sensations and movements occur for you. Notice the sensations, images, feelings, and associations that arise.

Experiment with movement as you lie on the floor, as you stand, and as you move through space. As images, feelings, or "attitudes" come up, keep exploring them. "Stay with them" by bringing them into your movement.

Choose a few movements which feel particularly interesting for you and begin to repeat them or take some more time with them, creating a kind of dance of the pelvis. Find a particular "ending movement," and from that movement give your pelvis a "voice" in the form of a spoken sentence or two.

Create a pelvis drawing or a series of drawings inspired by your pelvis dance. One choice could be to explore a drawing further in more movement.

As part of your journal writing, include open associations on your pelvis and attending life associations. A possible framework could be remembering the past, paying attention to the present, and visioning the future. This framework could also work for another three-part dance exploration.

Example of pelvis work

The following is an excerpt of a student's response to the exercise, in which she used a gestalt dialogue. In her movement exploration, she discovered a relationship between her head and her pelvis. In drawing her mask, she identified what she called a controlling, masculine identity. In her "unmask" drawing, she identified what she called a feminine identity which she associated with her pelvis. Through movement and written dialogues between the two body parts, a conflict emerged and a resolution was imagined. She wrote:

HEAD: OK, I'm feeling a lot of pain and very shaky all over. What's happening down there?

PELVIS: Hello! I'm glad you're contacting me. This pain has been so locked up inside me. I want to let go. I need your support. I want more balance between us. Don't deny me, head. I want to be free.

HEAD: What can I do? I'm feeling very nervous about this. God knows what you'll do if I let go. I don't like the idea of you being in charge.

PELVIS: Oh come on. I want you to feel my pain. Listen to me. It's safe. Stop trying to be in control of me all the time.

HEAD: I'm sweating and shaky. I feel very insecure. I don't know about this.

PELVIS: Of course. This is very scary for you. But, come on. Trust me. I promise not to take anything away from you that you're not ready to let go of.

HEAD: What is your pain? I feel so lightheaded! I need some understanding before I can let go.

PELVIS: Sometimes I hate being a woman. You think boys are best. You try so hard to be like them. I want to be who I am as a woman, I want to enjoy my woman's body.

HEAD: I want to, I want to feel whole. Really, I can't figure this out. You could get me in trouble.

PELVIS: We're beyond that now, that's old stuff. Stop thinking so much. Just rock yourself. Hold yourself. I know you're afraid, I

promise it's OK. I am a woman. I am strong and beautiful. Stop trying to hide from me. Listen to me. Relax, breathe, feel me.

HEAD: Tell me about being a woman. What do I need to do to blossom into you?

PELVIS: Get into your love of beautiful things, your love of the feminine. It's time to let go of your old hardship story. You have proven your bravery and your competency. You've done well on your own. Love the fact that you are a mother. Laugh, sing, dance, flow. Be gentle. Play more!

HEAD: That doesn't sound so bad. OK. Thank you!

The legs and feet

Functions

The feet and legs stand and execute locomotor movements, including stepping, walking, running, jumping, turning, stepping up and down, moving toward and away from, changing direction, stopping.

Associations

Possible associations for the legs and feet include moving out into the world; finding your place or stance; being able to leave and return, to stop and start; having a sense of direction and connection; making changes in direction; moving toward goals; and feeling connected to the ground and balanced. Conflict experiences associated with the legs and feet include a difficulty in mobility, an inability to stand up for or remain firm around needs, feeling ungrounded, losing and regaining a sense of balance, and difficulty making changes in life direction.

Themes

A possible theme to explore with the feet and legs is "taking a stand."

Legs and feet exercise: drawing and movement

In preparation for drawing, close your eyes for a few minutes and focus on your legs and feet. Take a few minutes to imagine how your legs and feet

have been throughout your life. What activities, situations, and images do you associate with your legs and feet? As you begin to draw, let your impulses take over and direct you. Your drawing may be literal or figurative. It may be simple or detailed. Let the image of legs and feet as it unfolds on the paper lead you.

When the drawing is finished, tape it up on a wall. Relate to the drawing as you would a musical score, with your movement as the way for you to play the piece. Dance the drawing by responding to its elements: shapes, colors, textures, and symbols. Lead your movement with your legs and feet.

Using your movements as resources to explore and respond to the drawing, move in and through the space around you. As feelings, thoughts, and images are evoked, let these responses determine and shape your movements.

Create a second drawing of your legs and feet. By enacting a second drawing on the same body part in dance, you give your neuromuscular system a chance to embody a new imprint that might engender a greater degree of awareness and integration. You experience what we might call a recycling of impressions, which will affect your whole organism, expanding how you respond and think about your legs and feet and their associations in your life.

Look at your first and second drawings together. Give them each names or a sentence/title.

Do some journal writing to address the following issues:

- Identify the personal life themes associated with your legs and feet that you have recognized.

- What did your dance and drawing tell you about reshaping something in your life?

- What do you need to work on next?

Legs and feet exercise: writing

Write a dialogue between you and your feet and your legs.

Write a short story about your feet and legs starting from childhood and continuing to the present.

In your journal, consider the following reflective questions:

- What has thrown you off balance in your life?
- How have you felt connected to or disconnected from a sense of stability?
- What has your sense of your place in the world been like so far?
- What would you like to take a stand for in your life?

Keep your focus on the issues most personal to you. Recall any times, situations, or relationships when you felt unable to communicate or take action on behalf of yourself. Imagine that you are able to "take care of it" now. Write about this in your journal.

You can explore, embody, and answer these questions through movement activities:

- Explore balancing and losing your balance.
- Play with kicking.
- In a studio room, use the space to walk, run, leap, stomp, and stand firmly in a variety of combinations.
- Create a "taking a stand" dance in which you imagine people or situations from your life in the room.

Then write about what you've discovered in your journal.

Working with body part metaphors in a group setting

In group settings, any of the drawing or movement activities can be done in solo, with partners, or with the entire group working as a unit on one of the movement activities. As you can see from the above examples, you can move back and forth between moving, drawing, writing, and dialogue to learn more about your life themes. The expressive art modalities offer the opportunity to experience these themes outside the realm of the censoring mind, and the transitions back and forth between art modalities also helps to expand and clarify associations between body parts and life script.

You can also work with body part metaphors in a group setting. As a group warm-up, have the members participate in a brainstorming session.

On a blackboard, write the themes which students associate with the given body part. Certain sayings are succinct expressions of common themes. For instance, in the case of the legs and feet:

- He doesn't have a leg to stand on.
- Stand up for yourself!
- Stand on your own two feet!
- Take a stand! Don't run away from things.
- I feel weak in the knees.

After having each person do her drawing of the body part image, the facilitator may have the group divide up into partners. Each person will take a turn responding in movement to each of her partner's drawings. The reason we have another person enact the drawing rather than each enacting her own is to expand the perspective and free up the movement for both people. Each person has a script associated with each drawing and, in this case, with the body part in question. This script influences responses and can limit the range of exploration.

If I feel a certain way about the body part in question, or if I have pre-conceived ideas about my drawing, my ability to play shrinks to what I already know. I will tend to use my movement to act out something familiar, rather than discovering something new. People often become preoccupied with acting out a preconceived story that limits the range of expression or keeps repeating favorite movement patterns.

The person who is witnessing her drawing being moved has an opportunity to observe movement resources that she may not have dis-covered on her own, and which may offer new possibilities and surprises. Students often comment about how free they feel in working with someone else's drawing – free from the story, free from having to figure anything out, free from their strong and sometimes overwhelming emotional responses, and free to explore without attachment to any outcome.

The following are some directions for working with movement and drawing within the group context.

Group exercise: body part metaphors

Ask participants to join a partner without talking to each other about their drawings or body part.

One partner holds up her drawing. The other partner plays the active role. The active partner faces the drawing and becomes the mover, exploring the drawing in her own way.

As a group, the partners spread out in the space and work at the same time. Usually five minutes or so is enough.

Partners can talk briefly with each other before switching roles. Some questions that might emerge include:

- What did the mover get in touch with?

- How was it to see your drawing danced by your partner?

Then the partners switch roles and go through the same series of steps.

Complete the session with a group sharing and reflection period.

Summary

In considering the literal and metaphoric body, we have explored some of the corresponding functions, associations, and themes for each body part, which connect us to personal and archetypal experiences. It is important that the field of play stays open within this grounding framework, allowing and inviting each body to reveal and tell its own unique story. We want to stay in a searching attitude, letting our bodies and their metaphors guide us spontaneously, playfully, and courageously into old and new territory.

Remembering the psychokinetic imagery process – move, draw, dialogue – we incorporate these three art mediums to allow for and strengthen the interplay between the physical, emotional, and mental levels of expression. We want to provide a creative "play space" in which each individual can encounter and reflect on issues and themes in challenging and inspiring ways so that what she discovers and expresses in her art can be applied in all areas of life.

Our bodies hold our life story in both a literal and metaphoric sense. The body parts have symbolic resonances, which, like symbols in paintings or dreams, can assist us in working through issues. Through

them, we can come to know what was previously unknown to us. In these metaphoric encounters with body parts, we can confront, release, and change patterns in our ways of living. As we explore the interplay between movement, drawing, and dialogue, we also explore the connections and discordance between body, emotion, and mind.

In our explorations, we can begin with a movement experience or with a drawing. Beginning with movement provides a good warm-up for the focus of the session. When made conscious, movement expression brings a person firmly into the present moment. Drawing is a way to shape and make concrete our images. Making a drawing at the beginning and at the end of a class session helps us see what has changed, and helps us to image what we would like to change.

Journal writings and reflective questions help us make meaning from our metaphoric play. Creative writing connects our physical and emotional experiences to our mental processes in an imaginative way, and helps us think about things differently. It also provides solid grounding for cathartic experiences or insights that have been evoked as a result of the physical and emotional interaction. Writings can be in the form of dialogues, letters, stories, poems, or responses to reflective questions. Writing helps us shape the meaning of our experiences and embody our insights.

The map I have laid out here is a model that suggests a way of working and exploring the territory. The territory itself, however, is our primary interest – the actual experiences and insights that people have as they experiment with this way of working with the body parts as metaphor. We are challenged in this practice to stay present with what is happening and let go of any attachment to a particular outcome.

We want to stay open to the unexpected, the unfamiliar, and the unknown. We want to encourage each mover to discover her own repertoire of movement through each body part. We want to stay genuinely curious about the images and feelings that arise, whether or not they are on or off the "map." The reflective questions that each body part might suggest are very important in building the life–art bridge. We want to pose questions which do not presume a "right" answer, but rather ignite ongoing investigation. The beauty of this map, then, is that it stays open to the input of the mover as she explores.

Figure 10.1 Head 1

Figure 10.2 Head 2

Figure 10.3 Ribcage 1

Figure 10.4 Ribcage 2

Figure 10.5 Arms 1 *Figure 10.6 Arms 2*

Figure 10.7 Body back 1 *Figure 10.8 Body back 2*

Spine poem

You are my favorite and what I fear most
You don't forget, do you?
You don't forget trauma or pain or ecstasy,
the sexiness of it all
You have been holding so much,
how did I forget?
You are one of my best hiding places so many nooks and crannies
to place something valuable and leave it there for safekeeping, or for hiding,
now they seem to be the same
Michael is trapped there, lightning boy
so much pain, anger, missing in the memory of you.
somewhere I fear
that if I let that pain go, I let you go…
the memory of my best friend I had so much unfinished business with that I yearn
to attend to
and so I am.
in that same scary cervical space I hold other fears
the veils hang there, hiding who I am,
hiding from me and the world
so many fucking veils, I don't remember placing them all there.
that gauzy veil, hiding and somehow accessorizing a loss of voice
a fear to speak truth, to know what I want to say,
to formulate it and make it heard.
YELLING MY BRILLIANCE,
yes. what I have to say is brilliant
even when it doesn't come out right
It's the blocking of that flow of words that hurts,
that stops my inquisitive ponderings,
that bows down to expectation
what is allowed is to be seen and not heard
Heaven forbid I strike discord
and therefore disappoint the father, the mother
I want so much respect from
not unconditional –
but from what they have heard and listened come
through me.
I rip at the veils, try to shed them like snake skins.
skin, below skin, below skin
emerging. unfurling. stretching into who I am…
WHO AM I?
going in, in, into the fractals
only to feel them all open
together and separate at once and in millions of moments
with so much light and joy I cannot begin to speak it.
and that joy floats, weightless soothing colors cradled
softening and joining into deep pools
held within a bowl of creation
within a bowl of myself
an offering to myself.

Cameron Kincaid Richardson,
a student's work during training at the Tamalpa Institute 2001

Figure 10.9 Spine 1

Figure 10.10 Spine 2

Living Artfully
with the Wounded Self

I said to my soul, be still, and let the dark come upon you
Which shall be the darkness of God. As, in a theatre,
The lights are extinguished, for the scene to be changed
With a hollow rumble of wings, with a movement of dark-
 ness on darkness... (p. 27)

Wait without thought, for you are not ready for thought:
So the darkness shall be the light, and the stillness the
 dancing. (p. 28)

T. S. Eliot (1940, p. 71). Taken from 'East Coker III', from 'Four Quartets', in *Collected Poems 1909–1962*. Reprinted by permission of Faber and Faber Ltd.

Excerpts from 'East Coker' in FOUR QUARTETS, copyright 1940 by T.S. Eliot and renewed 1968 by Esme Valerie Eliot, reprinted by permission of Harcourt, Inc.

All of us, in one way or another, are left with the residue of an imperfect childhood. Some of us have suffered abuse and trauma, while others suffer from the mistakes of parents who simply were not able to nurture and reflect us in the ways we most needed. Alice Miller (1981), in her book *Drama of the Gifted Child*, gives a description of five primary needs that the child has for *respect, mirroring, echoing, understanding,* and *participation.* She goes on to discuss how parents are often unable to respond to these primary needs, using their children instead as the objects for projecting their own unfulfilled desires.

Accommodating parental needs results in what psychiatrist Donald Winnicott (1971) called the *false self.* Most of us have felt unseen in who we really are as separate from our parents' expectations. In order to bear

the feeling of separation essential to individuation, we first need the experience of unconditional closeness and regard, for it is through the eyes of the loving parent that the child first experiences herself and builds a relationship with the world around her.

Unfulfilled, we spend a good deal of our lives searching for ways to compensate for the places in us which have been abandoned or are lacking as a result of those unmet needs and introjected demands. Winnicott (1971) has described a true or authentic self in a state of noncommunication because it had to be protected against feelings of loss and rejection. Only when the part that contains all of the hidden memories and feelings of childhood is liberated can the self begin to articulate, grow, and develop its creativity. Therefore, it is crucial that the adult confront and reclaim whatever essential aspects were cut off in childhood.

Confronting the shadow

Jung described the *shadow* as that part of us which contains all the repressed and wounded recollections from childhood. The personal shadow from which no person can escape contains the collection of qualities and feelings that were not allowed – the negative emotions, the not-so-nice characteristics, the disorderly and chaotic, or any other aspect of our person that might jeopardize the well-constructed façade of the ego. Along with all of the "not allowed stuff," the undeveloped talents, gifts, and potential, as well as the ability to connect with and communicate our actual feelings and experiences, get inadvertently thrown into the bag as well.

It is difficult to look directly into dark and hidden terrain. Yet in the course of daily life, the echoes of the shadow are heard in the disturbances of physical illness, interpersonal conflict, and personal struggle. If we are willing to heed the advice of the priests of Delphi, "Know thyself," then the disowned and wounded parts of the self can actually lead us to the hidden treasures of who we are.

Most of us spend a good deal of time as adults attempting to reintegrate the split-off parts that make up our shadow. This shadow material affects our relationships and the life choices we make. It can be traced back to our family of origin, to the environments we have lived in, and to

the particular mechanisms or strategies that each of us developed in order to cope. These split-off parts become the threads that run through the story of our lives, resulting in certain kinds of life situations that present themselves over and over again.

As we begin to examine them closely, we find that there are repetitive patterns, challenges, and areas of sensitivity connected to these threads which we continue to confront throughout our lives. These repetitive patterns result in mechanistic responses that become roadblocks interfering with our ability to mature and live creatively. However, they can also serve as keys which open the way to self-awareness, understanding, and change. Our wounds, when worked with imaginatively and mindfully, can ultimately engender transformation in ourselves and lead to more meaningful relationships with others.

Themes associated with the wounded part of self are evoked when we work with the body and with movement. Deep memories and hurts arise as people open to their bodies. Focusing on body parts as metaphors for aspects of life narrative brings the person to the most compelling stories, some never before told or fully encountered. Winnicott (1971) proposed that it is through creative play, and the transitional space in which this play can take place, that the child or adult is able to discover, and recover, herself. In such play, the deepest currents of image, feeling, and meaning can be explored tangibly and in symbolic ways. Through expressive arts, we provide this essential play space so that fragmented parts can be recovered.

The therapist or teacher is a vital partner who witnesses and encourages the most internal experience being expressed through creative enactment. Having a witness and guide as a companion to see, hear, and validate our experience plays a crucial part in this healing process. Identifying with an adult part (whether that be the therapist, the teacher, or a part of our own self) that exists outside the context of the wounding situation allows the individual to respond in ways that were not previously available. The creative adult, like the "good enough parent" (Winnicott 1971), is able, in the present, to provide a safe environment for the child part to express itself.

The wounded self has, in the past, hidden itself as a means for defensive living. In the process, the body and feelings become armored

and paralyzed. Ellen Levine, in her clinical work with children, suggests that through art making people are able to use imagination toward "the active transformation of experience" and, in this context, the wounding experience (Levine and Levine 1999, p.260).

This transformation of experience can result in the release of destructive imprints, so that all the creative impulses, which flow from the body and its emotional scripts, become fully accessible and open to new life and new images. The energy trapped in negative emotions and events can find honest and constructive expression. The ability to mourn what was lost and to reflect as an adult on what can be changed in the present makes for an alive and healthy relationship with the material of the shadow. Energy previously given to upholding the false self is freed for the inevitable ongoing encounters with the wounded parts of the self.

An essential dialogue can take place between psychological suffering and imagination. James Hillman (1989) suggests that it is in the sense of affliction that psyche and soul are expressed. Pathos, he proposes, leads to the myth which will reveal what is within and behind the symptoms of disturbance. Following the disturbance as it mythologizes becomes a process of creative imagination in which metaphor and meaning are rewoven into the tapestry of the life narrative. Expressing places of suffering in creative symbolization can be a powerful way to discover the myth that is being lived and to turn away from the blocked, repetitive, and compulsive tendencies of personal history, posing meanings and possibilities for change and resolution. The dance, drawing, and poem can contain and express our suffering in ways which help us be with it and move on, finding a healthy way to reintegrate, or live differently with, our wounding experiences.

Looking beyond the specifics of the childhood experience, humanistic psychologist Abraham Maslow (1968) was interested in what he called *full humanness*. He defined stages of self-development, which he considered essential to releasing true human capacities or the true inner nature. In answer to the question "What makes people neurotic?" he proposed that it is a *disease of deficiency* not unlike that which occurs at the purely physical level. Just as a lack of vitamin B or vitamin C produces a physical illness, when the basic needs of the psyche are not satisfied, the absence produces an illness of the psyche, or neurosis.

Maslow (1968) described the basic needs as follows: for *life*, for *safety and security*, for *belongingness and affection*, for *respect and self-respect*, and for *self-actualization* (p.3). He suggested that these stages represent the progressive movement from survival needs to self-actualization needs and argued that when the first four levels of needs are not met, the fifth level of needs cannot emerge.

We organize ourselves around our wounding experiences, either through defensive armoring or through compensatory behavior, and this interferes with our ability to move from one developmental phase to the next. As we go about the business of living, the unmet and unexpressed needs of the wounded self are constantly affected or triggered by the external environment, by the people and events we encounter. This has a profound effect on our perception of the world, our relationships, and our physical and emotional expression.

Our wounded and fragmented parts hold static sets of beliefs, fears, attachments, negative emotions, behaviors, and patterns of movement. Out of these parts, we *introject* disturbance in ways that affect self-image, or we *project* conflicted and negative feelings onto other people and situations. We run the risk of becoming perpetual victims of our own internally held traumas, constantly seeing ourselves as victims of other people and the world. The wounded parts, left unattended, shape our life experiences. As Jungian psychologist John Giannini (1987) says, "No wonder most people want to stay in the 'light' of an extroverted, busy, workaholic consciousness. Most of us seek to avoid the dark shadow of our past which, nevertheless, continues to haunt us in every waking moment" (p.5).

Identifying this shadow that haunts us is a crucial step in the process of individuation and freeing ourselves from the conditions of the past. In working consciously with the experiences that have been wounding, it is possible to confront held fears and to unblock points of arrested development, so that the individual can be guided toward resolution and healing. Such a healing process reenergizes valuable creative forces in the psyche which have been cut off or misdirected.

In the rejoining of body and imagination with the myths of brokenness, we create an entryway into the shadow. Delving into this very vulnerable part requires tremendous courage and commitment on

the part of both client and guide. In working on her places of suffering, the individual must be empowered and respected wholeheartedly and on every level, thus endowing the reconstituted self with the qualities of autonomy, responsibility, safety, strength, and self-determination.

It is vital that the exploration of the wounded self is chosen intentionally, so that whatever territory is traversed and whatever images and feelings emerge truly contribute to the individuation of the person. Moving out of the character of the victim and dependency on outside figures of authority then becomes possible.

The myth of the wound becomes a story that stands on its own, like an artwork that allows for ongoing dialogue, creative interaction, and a reflective process. *Repeating* and *reliving* then become part of the aesthetic experience shaped by the growing consciousness of the person who in movement, painting, and poetry brings body, imagination, and feeling back to the hollow, helpless places. Embodied mythologizing acts as the glue which brings the broken pieces into relation with one another. The traces where joinings are made must remain visible as markings and reminders of the life lived just as it has been, for who would want to erase all signs of the struggle for a more authentic self? That struggle connects us with the larger myths of suffering, with our common humanity and spirit. The works of art serve as artifacts that remind us of the broken places, of the myth told, and of the journey toward healing.

The journey into the wounded parts of self can be compared to diving into the ocean of the unconscious to meet the dark side. The forces inhabiting the unconscious often take on destructive and disabling forms. When made conscious, these same forces may be freed to become, in their essential attributes, dynamically creative, motivating, and life-affirming, freeing us from wounds of the past. This work requires what can be imagined as a descent into darkness followed by a return into the light.

The journey of descent into darkness as a way to meet our "true self" is an age-old myth. It reminds us of the biblical story of Jonah, who boarded a ship in a desperate attempt to escape from the responsibilities of his life, symbolized by the call to leadership. In the midst of a storm, he was thrown overboard and taken into the jaws of the whale. Swallowed whole, Jonah underwent a period of self-reflection and self-confrontation

in the belly of the whale before being released onto the sandy shores to live the life he was meant to.

In many ways we, like Jonah, are unwilling to face our fears and confront how we draw back from the threshold of challenge and change. The unfolding of self requires an inevitable period of time in the belly of the whale. It also requires of us our innate creativity and wisdom. And for that we may need guidance, so that we can bring light to places of darkness and return to our lives changed and enlarged.

Working with the wound: an eight-act play

In *Timeas*, Plato speaks of the art of theatre and ritual as an essential ally in the recovery of wholeness. In this spirit, I borrow from the world of theatre, where the depths of human suffering and joy, from tragedy through comedy, are enacted as a way of revealing the human condition and pointing to the truth. I have chosen to present the material using the metaphor of ritual and the play in a group setting. I return to Winnicott's (1971) use of the word "play" as a way of describing how creative enactment mobilizes the authentic encounter. Paolo Knill (2000) suggested that "situations of change for individuals and communities usually have ritual containers within which they are framed in space and time" (p.6). Here ritual recreates the holding and empathetic environment in which the "authentic self" can come forward.

The "play" presented here is made up of eight acts which take place in a group setting. Each person invokes and develops a "character," which takes her into her wounded part and its attending story. Each act occurs over the duration of a day or two. As the group works together, the "temenous" space is created, the magic or sacred circle spoken of in ancient Greece, in which the most serious play and symbolic acts of purification unfold (Nachmanovitch 1990).

The intention of this work is to guide people to:

1. Identify the wounded part of the self and its attending attachments, negative emotions, and conditioned responses so that the debilitating imprints it holds can be clarified and the grip that they have released.

2. Confront past events that have had a destructive impact and continue to affect life experiences. The adult part is encouraged to contribute new ideas to resolve old conflicts, and to make connections and applications between associated conflicts in the past and the present.

3. Discover the essential and valuable qualities of this part which might contribute to the healthy expression of the individual.

4. Create a vision and a symbolically enacted "healing" to acknowledge the past, affirm a positive outcome in the present, and provide a healthy model for the future.

5. Create a collaborative "play space" in which the individual can explore this theme in community with others. This supports the individual in moving from isolation toward interrelation with others and the world.

The facilitator of this piece of work must be skilled and trained in working with the material. Much discussion has taken place in the field concerning how to work most effectively and constructively with trauma. In general, it is wise to emphasize building, or rebuilding, the person's sense of safety in connecting with her own body, as well as connecting with or reinforcing a positive connection to life here and now rather than focusing exclusively on the traumatizing experience.

The eight acts of the play are organized around the following phases:

- creating the circle, setting the stage
- invocation
- developing the character
- the costume of the character
- contemplation
- ritual
- vision
- closing.

Through the play, the nature of the wounded part is explored on all three levels of awareness and response – physical, emotional, and mental. Within each act, the structure encourages a movement through the five-part process that begins with identification and continues into confrontation, release, change, and growth. In addition, the entire play can be seen as a progression through the five-part process, in which each act mobilizes energy in a primary way for the exploration of a particular step. In Acts One and Two, the group identity is built and the identification of the wounded self is begun. Acts Three and Four focus on the confrontation with the shadow material. In Acts Five and Six, the qualities of release and change are called forth. Acts Seven and Eight focus on images, which can strengthen and stabilize options for change and growth.

Throughout the play, we use repetition, development, and shifting in working with movement, images, and contemplative questions. Repetition enhances the ability to identify clearly and cultivate more awareness of the personal shadow and its mechanistic responses. Development is a way of enlarging and breaking through the initial constrictions that became crystallized in defensive armoring around projected negative aspects or disowned parts of self. Shifting reinforces the adult part in its ability to make healthy choices, which are empathetic to the true experience, exactly as it is in the present.

Act One: setting the stage

In Act One, we establish the circle as the symbolic container for the community.

The facilitator introduces herself and talks about the structure of the experience, establishing a sense of what people can expect and an overview for the work. This introduction can include the reading of a poem, quotations, or a teaching story to set a collective metaphor and to ritualize the opening of the "play." We use objects to mark the space, including candles, cloth, things from the natural world, and art materials.

The facilitator reviews relevant "ground rules" for the experience, including common understandings about confidentiality and creating a safe container.

On the first day, the intention is to build a sense of community among the people who will be working together. Movement activities give

people a chance to warm up their bodies in ways that are enlivening, interesting, and fun. Before directly confronting the challenge of the theme the group will encounter, we first create an atmosphere of warmth, trust, and safety to anchor the experience.

Moving in partners, in small groups, and then all together establishes rapport and an environment in which nonverbal communication is strengthened. Movement activities using a variety of different musical accompaniments keep explorations spontaneous and improvisational. First people get to know one another without going into personal stories. In taking a portion of the first day to improvise and play, anxiety and pre-conceived notions about what the experience will be like are dispersed.

Warm-up movement activities for the day fulfill several intentions: getting people comfortable with one another, getting people comfortable in the space, getting people comfortable with the style of the facilitator, and getting the group familiar with nonverbal forms of communication.

The following are resources for movement activities to begin with:

THE NAME-GAME

Each person introduces herself by name and with a gesture or movement. The group in unison mirrors back each person's name and movement as a call and response. This can be repeated a number of times until the names and movements are well established.

DEVELOPING THE NAMES AND GESTURES INTO MOVEMENT LOGOS

Each participant leaves the circle and has a few minutes to repeat and develop her name-game movement on her own. As indicated by the facilitator, people begin to make contact with one another using the movements that they have developed from the circle as the material for partner dances. The facilitator calls out when to shift to the next partner for the next partner dance. The facilitator may use the modes of repeating, developing, and shifting to encourage a return to the original gesture, a growing of the gesture into a "dance," and the possibilities for the movement to shift and change as people come into contact with the movements of the various partners.

INNER SPACE WARM-UP

The facilitator instructs group members to close their eyes. Moving with eyes closed and paying attention to the feeling and sound of the breath, each member slowly activates the various body parts in movement one at a time, responding in movement to whatever sensation, feeling, or image presents itself. This is an introverted tuning in with self on the three levels – physical, emotional, and imaginal – and thus a chance to explore the inner landscape.

OUTER SPACE WARM-UP

The facilitator calls out one body part at a time. With eyes open people lead or initiate with that body part and move through space. Once people get their individual movements going, the facilitator calls for making contact in a duet with a partner. Every time a new body part is called out, a new partnership is formed. Focusing on one body part at a time increases the range of movements and images. Making contact with others through movement led by an identified body part gives some relief from thinking about what to do when we engage with someone else. This warm-up is an extroverted activity which helps people articulate all the different parts of the body while exploring a wide range of movement and the geography of the room and other people.

After the warm-up experiences, the circle reconvenes, and each person shares something about herself and what brought her to the group. At this time, the facilitator may choose to say something more about the work to establish a collective overview. There might be questions or concerns to address or an open group discussion on the theme. A group "think tank" considers what values or community ethics participants would like to commit to as a group to create a good learning environment. The facilitator documents these agreements on a flip chart or drawing paper.

The building of the group or community using the circle as the container sets the stage for the very private and personal work that will follow. The circle is formed, dissolves as people leave it to develop solos and partnerships, and then reconvenes as a place for community sharing. This ritual of forming and dissolving the circle, moving from solo to part-

nership to group, provides a recurring movement throughout the eight acts; it serves as a powerful metaphor in the healing of the wounded self.

This group dynamic is a positive recapitulation of the phases we pass through developmentally; it should be noted, then, that the group and the circle can bring up both positive and negative projections as it reminds people of their experiences with their families, with their parents, siblings, and significant others. The circle of the group becomes another powerful element in the play space and can give people an opportunity to enter into the play space by enacting old ways of being in "the family" as well as being a place in which people can express themselves differently from before. For some, the group circle will become like the family that they felt they never had.

As the first act closes, each person is asked to enter the circle to speak aloud with another gesture a dedication of her work to something or someone in her life.

Act Two: invocation

The invocation of the wounded self is performed by the facilitator, as she guides participants through a creative meditation. By way of this inner visualization, participants identify an image of the wounded part which will be the inspiration for a drawing and for the development of a character.

CREATIVE MEDITATION, IDENTIFYING AN IMAGE
OF THE WOUNDED PART

The facilitator speaks:

> Find a comfortable place where you can sit in an upright position with your back supported. Have your writing tablet, pencil, drawing pad, and pastels nearby. Begin by closing your eyes. Focus your attention on your breath, inhaling through your nose, exhaling through your mouth. Notice the sensation of your breath passing through your throat and nostrils as you inhale and as you exhale. Take a long series of deep and full inhalations and exhalations, allowing your chest to expand and release, and the muscles of your belly to relax.

Begin to imagine that your breath is like an elevator or a pathway down which you are traveling into a very deep, dark, central place inside you. Imagine that you arrive in this core place inside you. Notice what it looks like and how it feels here, allowing any images that arise to take your attention. How are you feeling? What are you doing? What do you see?

Gently call out to your wounded part. Ask this part to join you. Stay open to whatever arises. Accept all of your images and feelings without trying to figure them out. Imagine you are breathing into the body of your wounded part. Stay with this experience for as long as you want.

Now imagine that you are moving back to the part of you who traveled down to this place. See yourself as separate from the wounded part. Imagine that the two parts of you stay in contact and relate to each other. They can move together or speak to each other. They can explore an imagined environment together. Watch and listen with careful and caring attention.

Now it's time to prepare to leave. Take a few moments for this preparation. When you are ready, enter the imaginary elevator again, or step back onto the path. As you begin to ascend, call your wounded part with words or gestures. Ask it to come with you. You may want to imagine reaching out and taking her hand or even carrying this part with you as you begin your return. Focus on your breath until you imagine you have reached the top. With your body still in a sitting position and your eyes closed, make a gesture/movement that expresses what you are most in touch with now.

In the next few minutes, open your eyes.

Now, make a drawing working with any images which came up as well as with new images that unfold in the act of drawing.

ENTERING AND EMBODYING THE IMAGE BY WORKING "AS IF"

The facilitator instructs participants in using what I call keys to get into the drawing: color, shape, texture, symbols, body parts, or postures depicted. Moving the qualities of the various keys in the drawing helps the mover enter the image without interpreting or trying to tell a preconceived story. The facilitator calls out elements one at a time: "Choose a color. Move as if you are that color, or with the quality that the color holds for you. Choose a second color [symbol, shape, texture, body posture]…"

The facilitator then instructs participants to write a short story, a poem, or a dialogue between them and the drawing, or between elements in the drawing. People partner up to share their invocation experiences, look at their drawings, and read their writings aloud.

This exchange process can take place between two partners or in small groups of three. Due to the nature of the theme, it is important to give each person enough time to share her material and be with her own responses. Partnerships and smaller groups allow each individual more time for detailed sharing. Once this has taken place, reconvene the circle and invite each person to share something with the whole group. This could include movement, showing the drawing, or reading a piece of writing. It is important to shift the sharing configurations to meet different needs, from the intimacy of a partnership to the building of the whole group and the individual's sense of belonging and caring inside the community.

The facilitator may also ask participants to place their drawings on the floor or walls around the room, like a group gallery. Next to the drawing, ask each person to write several key sentences clearly, on a separate piece of paper. The person may choose sentences from the previous writings done, or a name/title or statement she chooses for her drawing. The facilitator then invites participants to circulate around the room to look at everyone's drawings and writing. In this way, group awareness is built and the whole group gives each person symbolic acknowledgment without a lot of talking. This also gives each participant an opportunity to be empathetically affected by every other member of the group. Since there is the potential for raw and vulnerable material to come up during the invocation, the facilitator moves slowly and gently with the directions, carefully following the energy of the group.

TIME OUT

A process, which involves an intense focus on a specific theme, can get overwhelming and a narrow view on "the problem" can be created. So, we shift the activities involving serious reflection to activities that focus on improvisation and play. This provides a necessary distancing and a release of energy, allowing people to tap into new resources and solutions. With this purpose in mind, it is important to engage in art activities that involve

us in the "here and now" of our lives and in making contact with others. Activities might include turning on rhythmic music for free dance time, group ball tosses, "follow-the-leader," or making music or singing together.

Act Three: developing the material

The intention of this session is to guide people in identifying a life script associated with a wounded part and to bring this part "onstage." Naming the wounded part through a character who has a story to tell offers a "ritualized" or ordered way to immerse in the material and provides the potential for getting some distance, thereby allowing participants to develop new resources, options, and understandings. The three parts of the script are defined according to the underlying suffering, the desire, and the potential to mobilize. The material and experience of the invocation are used as resource material for the development of the "script."

The group sits in a circle around a flip chart. The facilitator asks each person to develop a graph that will be written on the board. The graph looks like this:

Figure 11.1 Storylines

ESTABLISH THE BASELINE STATEMENT

The baseline statement may be taken from the previous writings participants have done on the theme. This statement expresses a primary theme by which the identified wounded part lives – a belief, a fear, a self-image. Some examples are:

- The world is not a safe place for me.
- I do not have the right to be here.

- I am not good enough.

- I must be quiet.

- I can't express my feelings.

- If I show myself, I will be hurt.

- I am not loved for who I really am.

- I am a failure unless I do important things.

ESTABLISH THE WANT STATEMENT

The want statement expresses what the wounded part desires or wishes for, and what may not have been possible, allowed, or respected in the past. Some examples are:

- I want to find a safe place.

- I want to feel that I belong.

- I want to know that I am good enough.

- I want to be heard and accepted.

- I want to express my anger.

- I want to show my vulnerability.

- I want to feel that I'm OK just the way I am.

- I want time to find new directions.

ESTABLISH THE NEED STATEMENT

The need statement expresses the qualities the individual must use in order to implement the want statement. Some examples are:

- I need to let go of my fears from the past.

- I need to tell people in the moment when I feel threatened.

- I need to reach out to connect with people.

- I need to forgive myself for what wasn't my fault.

- I need to love my body.

- I need to give myself chances to enjoy life.

- I need to develop the courage to speak up.

- I need to take risks.

- I need to slow down and stop judging myself.

The facilitator's role is to feed back and help the participants clarify each of the three statements based on material that emerged in previous sessions. The facilitator may want to refer to the drawing of the wounded part or to the creative writings done during the invocation. Sometimes it takes time for participants to grapple with the material before they can come up with one, two, or three concise statements for each branch of the graph. This is part of the process of developing the character and getting to the essence of the "script."

The facilitator instructs participants to write their sentences from the first person and to put abstract ideas in spoken dialogue form. In other words, she asks them to consider this question: If you were actually to say your sentences in a real conversation, how would they sound? After a few participants have established model statements, the remaining participants get clearer on identifying their own statements.

MOVEMENT EXERCISE

This will be a three-phase exploration, developing the posture and movement of the character around the baseline statement and the want and need statements. Each participant explores by herself.

Baseline statement

The facilitator speaks:

> For five minutes, move in response to the baseline statements of the wounded part you identified by adopting a body posture which reflects the statement. Amplify or exaggerate this body posture. Move through the space with this exaggerated body posture. Explore how each body part responds inside the posture. Develop the posture into a series of movements.
>
> When you are ready, begin to verbalize your baseline statements as you continue moving.

This can get quite noisy. If the facilitator feels it is necessary to balance loud sounds with the need for quiet in the room, she can designate when it is time to verbalize and when it is time to do all the expression in the form of nonverbal movement. The facilitator can point out that the intensity of feelings can be expressed in the force of the movement and in the use of space rather than all in sound.

The facilitator rings a bell or calls out when it is time to switch to the second phase.

Want statement

The facilitator directs participants to switch into expressing the want statement by finding a way in movement to break out of or drop the posture and movements of the wounded part. The facilitator directs participants to start by finding a second body posture that reflects their want statements. They then build from the posture into gestures and movements.

When participants have developed the posture and movement repertoire for the second phase, the facilitator gives them the prompt to begin to verbalize or vocalize their want sentences as they continue moving.

The facilitator rings a bell or calls out when it is time to switch to the third phase.

Need statement

The facilitator instructs participants to switch to the third phase, exploring the need statement in posture, gesture, and movement.

Then she encourages them to add spoken sentences and vocalizations.

SUGGESTIONS FOR FURTHER FACILITATION OR COACHING

Through coaching, the facilitator encourages participants who are having difficulty developing movements that express the qualities of their statement. For instance, someone exploring the quality of courage in movement might be given feedback to develop large, strong, grounded movements, focusing on the use of the legs, pelvic girdle, and arms.

Practice through repetition

The facilitator encourages participants to:

- revisit the three phases in any chosen order, repeating, adding to, or dropping previous postures, gestures, movements, and spoken words

- add a focus around exploring and developing the movement transitions between each phase

- create one way of moving through the three phases which they want to stay with.

Completion

The facilitator gives participants a period of several minutes to make closure with their material in movement and with words. She keeps the choices open by giving this simple direction, "Take a few minutes to create a closing or completion movement for your exploration."

Updating the image

To explore the question "How do you see your wounded part now?" participants make a second drawing in which they move from the original image of the wounded part into a second image, working with the new resources of the baseline and the want and need material.

Having had the experience of scripting in three parts – from distress to desire to mobilizing – and exploring the script kinesthetically in posture and movement, it is time for participants to imagine the wounded part in a new way. How does it look now? The image may be clearer or more intense, with developments or changes. The facilitator asks participants to take a few minutes with eyes closed to visualize the second image.

When the drawings are finished, participants title them.

Participants are then given time to write another dialogue or story. A framework might be for them to dialogue with the image, have the image dialogue with someone else, or have a dialogue between the baseline, want, and need voices.

Sharing and feedback

The group breaks into partners, and each person is given twenty minutes to "show and tell" her work:

- Each partner begins first with a replay of the dance of her three movement phrases condensed to two minutes for each phrase and two minutes for completion.

- The partners take ten minutes to look at the drawing together and speak about it, or to speak from the voice of the drawing.

- The partners take five minutes to read the writing.

- The partners take ten minutes to receive empathic and aesthetic responses from each other.

These responses can be in the form of a movement response, an improvised poem from witness to mover, or a talk about using the following points: "As your witness I saw.../I felt.../I imagined..." Empathic responses ensure that the dialogue between partners is nonjudgmental and remains closer to the realm of feeling and intuition than interpretation. "I see," "I feel," and "I imagine" statements orient feedback to the physical, emotional, and mental without falling into the trap of giving advice or analyzing.

Depending on group size, this sharing can also occur within the group circle, where each person enters the circle to perform her work in progress.

Boundaries

All of us develop what we might call *defensive armoring* in order to protect, deflect, and compensate around our particular areas of sensitivity. Such defensive systems are reflected in our physical bodies – in our posture or in our emotional and mental responses to external reality. I use the general term *boundaries* to refer to the various aspects of these defensive mechanisms. Just as the immune system, the skin, the mucous membrane, and the liver protect, deflect, and sort out the pure from the impure to help the organic body function properly, we also need boundaries to help us function on the emotional and mental levels.

The development of such boundaries begins in childhood, influenced by the nature of our interactions with those upon whom we are most dependent. Boundaries act as the psyche's mediator, attempting to help us sort out and compensate in relation to how our needs are met. When the system is working well, boundaries play the part of the intelligent negotiator, helping to provide useful dialogue between the private self in her interior experience, and the relational self as she interacts with the environment and others.

When boundaries are not functioning well, we become locked into patterned ways of reacting reflective of past traumas and disappointments. As we grow and change, and the old defensive boundaries continue to exist, our experiences of reality and our ability to express ourselves in our changing world is limited. When boundaries remain fixed on the conditions of the past, we find it difficult to live creatively and expressively in the present.

The ability to discern, sort out, and reject external input that does not contribute to our well-being serves a valuable and important function. Like the skin or the immune system that can fight off invasion when necessary, and yet relax and take in and absorb good nutrients when all is well, we need a psychic mechanism that does the same. Learning about the healthy and the unhealthy ways we attempt to establish our integrity and get our needs met allows for good contact with the self, with others, and with the world. When we make these mechanisms conscious, we can begin to change how we protect and defend the integrity of our instincts and basic needs in ways that support our growth.

When working on changing boundaries to suit the present, rather than recapitulate the past, we enter into an imaginal discourse to identify and encounter our old defenses just as they are, while challenging ourselves to experiment and try new things. We do this by involving our physical bodies through movement, and our imaginative and reflective minds through drawing and dialogue, as our practice for cultivating awareness, revisiting our stories, and changing our posture. As our range of resources expands, we can discover different ways of responding when we feel threatened, hurt, misunderstood, or frustrated.

In general, unhealthy boundaries are either so weak that everything gets through or so strong that nothing gets through. Healthy boundaries allow for a wide range of contact and intimacy, support us in expressing

ourselves honestly and meeting challenging circumstances without fear, and enhance spontaneity. We think of the boundary around the wounded part as its way of dressing when it goes out to meet the world.

Act Four: the costume of the character

Act Four helps participants develop the character of the wounded part further. In the following exercises on boundaries, an image of the old boundary is developed. Participants explore the old boundary through posture and movement. Then the old boundary is challenged through interaction, and participants create a new image to try out. First the group forms a circle and begins to develop resource ideas in response to the theme of boundaries. The facilitator uses the flip chart and collects ideas from the group. Reflective questions may include:

- What images and recalled experiences come up for you when you think of "boundary"?

- What do you think are the qualities of an unhealthy boundary?

- What do you think are the qualities of a healthy boundary?

Table 11.1 shows some examples taken from the input of one workshop's participants.

Table 11.1: Examples of Qualities and Images for Boundaries	
Unhealthy boundary	**Healthy boundary**
Too thin or too thick	Firm
Overly permeable or impenetrable	Flexible
Torn	Has the ability to filter
Invincible, like a fortress	Has a door which can be opened from the inside
Smoky	Clear
Overly sensitive	Supportive
Barbed wire	A fence with a gate in it

People spontaneously call out any associations they make in the moment, with words and images that relate to their personal experiences with boundaries. It is a kind of free-for-all discourse.

Next, the facilitator guides participants to a deeper exploration in the form of an open improvisation. The group explores the range of images generated in random ways, using the results of the brainstorming as resources. These resources listed on the flip chart are written down on small pieces of paper and folded over. Each person chooses three pieces of paper and plays in movement and sound with the surprise resources. This improvisation includes interactions with others, so that participants can explore all the resources generated on healthy and unhealthy boundaries.

The folded pieces of paper are left in a pile so that if an improviser wants to play with a new collection of resources she simply returns to the pile and picks out new pieces.

FOCUSING IN

In this part of the exercise, each person identifies and explores an image of her old boundary.

The facilitator speaks:

> Before you begin this drawing, spend some time with your eyes closed, imagining and recalling your life from your childhood to the present in relation to people who have been primary influences: parents, siblings, lovers, husbands or wives, and children. Focus on the theme and image of your boundary, work with whatever images appear and hold your attention as you draw.
>
> When you have completed your drawing, write some sentences as if from the voice of the boundary.

JOURNAL WRITING

In this part of the exercise, the facilitator guides participants in journal writing, asking them to reflect on the following issues:

> What are all the things you know about your boundary? Think about your self-image, your relations with others, and how you "move" in the

world. Make your own personal list of qualities and images that belong to this boundary.

In solo, explore your boundary drawing in movement, incorporating some of the qualities from your journal list and imagining some of the significant people in your life as you move.

Now share your old boundary drawing, journal writings, and movement experience with a partner.

CHALLENGE THROUGH INTERACTION

Next, partners work with each other. One person is the protagonist, and the other is the antagonist. The protagonist works with her old boundary and assigns the antagonist to be a particular person from her life. The protagonist must give her partner a brief list of certain primary qualities and sentences to improvise with, such as an overbearing mother who speaks the sentence, "I need you to take care of me."

The play can be expanded to include other key figures with a built-in signal for the antagonist to switch to another role; for instance, from the overbearing mother to the sister who takes up all the space and says, "Look at how wonderful I am." The partner interactions take place in movement improvisations. The protagonist stays within the limitations of the old boundary while the antagonist provides the challenge, but the improvisation may evoke a break-out into new directions along the way.

Before the partners switch roles, when the antagonist will become the protagonist and work with her old boundary, there is a fifteen minute time-out for partner dialogues, where both players reflect aloud with each other on their improvisation.

After both partners have had their turns, people return to the group circle for sharing time. Partners perform duets, or there is a go-round where each person has a few minutes to talk about her discoveries.

CREATING THE IMAGE FOR A HEALTHY BOUNDARY

Now, the facilitator reviews the qualities of a healthy boundary:

Focus on any of these qualities which are particularly associated with your experience of your defensive boundary, your past experiences, and your wants and needs now.

Make a second drawing of a new and healthy boundary that you would like to try out.

Create a written narrative, a poem, story, or dialogue that will attend this new image.

Write in your journal about how you would like to embody this new boundary in some specific relationships and situations.

Take 1

The facilitator speaks:

Explore the new boundary image with its attending qualities in movement. Start with a new posture, then develop gesture and movements. There may be key words or sentences that you want to work with as you move. Imagine real situations and people in your life as you explore.

Take 2

In partners, each person will have five minutes for a solo boundary dance. In this dance, the mover switches back and forth between the qualities, postures, and movements of the old and new boundary images. After five minutes, the witnessing partner gives feedback and a new resource which the mover incorporates into the dance. The resource given is to be a movement, a sentence, a sound, a quality of movement, or an image. The purpose of a new resource is to support and strengthen the new boundary in relation to the old boundary.

Take 3

The mover reenters the boundary dance working with the new resources given by the partner.

The partners switch roles; the witness becomes the mover, and the mover becomes the witness.

THE CHALLENGE OF INTERACTION

The group works as an improvisational ensemble, playing with the images, postures, movements, and sentences of their old and new boundaries in a variety of encounters with one another.

The group can be divided in half so that some are audience members while others are performers.

Smaller groups of three can work together in improvisation while the rest of the group observes.

Act Five: reflection and contemplation

TIMELINE

Creation of a small mural helps participants recall key events and images over a time period from early memories to the present and into a vision for what is next. The past is brought forward from the point of view of the drawer as she recalls and sees it now. Images brought into the timeline allow the drawer to both shape and see the thread of connection, disconnection, continuity, and change in tracking the wounded part and its story through chapters of her life. Events and experiences are imaged in a series of mini self-portrait studies which focus on the felt posture of the particular time rather than on the myriad details of any particular event. Images may be literal or nonliteral. The fragments of isolated pictures, existing on one plane together and in the same time frame (the present), give the person the task of piecing together the fragments in a way that can be seen at once. The pieces of personal history can then be seen and made sense of with a view to the whole picture.

The facilitator speaks:

> Create a mural in which you visually recall key times and situations in your life with your wounded part. Shape approximately five to seven images that connect with the past, present, and future – from early childhood, middle childhood, adolescence, young adulthood, middle adulthood, to the present, along with where you'd like to be next. Let all of the previous work be resource material in your creation of the images. Use words under or around or through each image in your mural to connect the image poetically with your story.

TIME TO REFLECT AND ASSIMILATE

The facilitator speaks:

> We will begin by using the timeline mural as a kind of documentary storyboard to help us retrace our steps. Looking at your mural, do some journal writing as you "visit" each image and recall the circumstances and feelings associated with each time in your life. We want to review the past, take a look at the present, and imagine what could be possible in the future. We will use a process of journal writing in which we respond to a series of reflective questions as our primary means for contemplation. However, I encourage you to continue making drawings, writing poetry, and going back into movement and meditation as you feel called to do so.

David 1

David 2

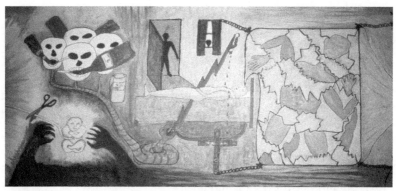

David 3

David 4

David 5

Figure 11.2 David's Mural

Some possible reflective questions include:

- What experiences occur for you on the physical, emotional, and mental levels that are associated with the wounded part of you? When you look at this question, you want to think about physical symptoms and distress; emotional states that are familiar; beliefs, ways of thinking, and judgments about self and others; and behaviors. You can make a list and simply jot down associations, with one column for the physical level, another column for the emotional level, and another for the mental level.

- In what ways have you attempted to defend or protect yourself?

- In what ways have you projected your unhappiness or discomfort onto others?

- In what ways have you held back or blocked yourself?

- What are your experiences in significant relationships? Begin with your parents and siblings, and consider any of the following dimensions: respect, echoing, understanding, participation, mirroring, safety and security, sense of belonging, affection, self-actualization.

- Beginning with parents and siblings and tracking through any significant relationships, in what ways have you adapted in order to meet the expectations of others?

- In what ways have you resisted the expectations of others?

- In what ways have you felt authentic, and in what ways have you felt inauthentic in your life?

- List some repetitive patterns you would most like to change in yourself.

- What do you imagine you would need in order to make these changes?

- In reflecting on your wounded part, which qualities, memories, and experiences would you most like to let go of?

- Which would you like to keep?
- Is there a gift, a blessing, a special motivation, or a calling that you imagine your wounded part has contributed to your life?

Write a letter or poem to your wounded part.

GROUP SHARING OF THE MURALS

In partners or groups of three, the participants talk about the timeline murals. This phase allows a time for reflecting and assimilating together. It is important now, following the intensity of the expressive work in previous acts, to give people time to clarify the meaning that can be seen in the connections between the metaphoric work on the theme and the life circumstances that are associated with the wounded self.

PERFORMANCE

The group gathers around each mural. Each participant has a few minutes (depending on group size) to move through the images of the mural from past into present, ending with the image for the future.

Act Six: a ritual enactment

This burning ritual can be done alone or with a group. If performed with others, the group co-creates the place in which the burning takes place and designs how the ritual will take place. On a piece of paper, each person write the events, feelings, and beliefs which she wants to let go of or transform. The group creates a special place where each participant burns this piece of paper. As each person burns her paper, she voices a dedication or prayer aloud, as the facilitator has instructed:

Dedicate this burning to a new way of being that you would like to embody.

Say your dedication, or create a prayer to say aloud as you burn your paper.

Burn your paper with the attitude that the fire is a symbol for release and purification. As your paper burns, stay connected to the experience by watching the flames, the smoke, and the old form of the paper

disappear. When the fire has gone out, take the ashes that are left and decide what you would like to do with them. Perhaps you will sprinkle them, bury them, or keep them in a container or use the ashes in an art piece as a reminder of this ritual.

Act Seven: creative meditation

In this phase, the facilitator guides the participants in a creative meditation to help with the assimilation and integration of the material:

Sit quietly with your eyes closed, focusing all of your attention on your breath. Imagine that your breath is like an elevator, and you are riding this elevator down into a very core place in yourself. When you feel you have arrived in this core place, imagine that you open the door to the elevator and step out into an environment. Imagine that you look around this environment until you see your wounded part.

Imagine that you move toward your wounded part and surround her and yourself with your healthy, new boundary. Imagine that you take this part of yourself back into the elevator with you. Imagine that you breathe together and slowly begin to ascend in the elevator.

When you are ready, imagine that you open the door and step out. As you do this, open your eyes. Imagine that the part of you that holds your wound is with you, and that you are both surrounded by your new boundary.

Begin to move, imagining that this part is moving with you.

Allow your feelings and images to become part of this dance. Make a closure. In stillness, listen to what you and your wounded part have to say to each other now.

Make a drawing that includes the image of your new boundary and any other elements from your creative meditation.

Write a poem or a letter to yourself or someone else acknowledging the new images which you would like to take into your life.

Act Eight: closing and departure

Pointing toward further integration and growth, the facilitator guides participants in the creation of a final drawing depicting a vision for the future.

Figure 11.3 Roberta

The self-portrait is the theme for the final drawing in which each partici-
pant shapes a new vision for the future of how she would like to move
into her life next. The facilitator encourages participants to incorporate
any images, themes, or metaphors from previous explorations. The literal
image of the body serves as the basic outline for this self-portrait. The
body outline serves as the container through and around which all of the
nonliteral images of the drawing unfold.

RECONVENING THE GROUP CIRCLE

This is the final circle. The facilitator should allow plenty of time for it. It
may be appropriate for participants to have input into the form this
closing activity will take, and even to design their closing activity
together, with suggestions from the facilitator. The facilitator establishes
the basic parameters around time, focus, and activities, and, with input
from the participants, chooses a way to guide the group through comple-
tion and departure. The final circle should include any final words,
readings, or ritualized acts of completion which the facilitator wants to
perform in service of helping participants complete their work and
prepare for departure.

Each participant is given time in the circle to show her final drawing,
do a final dance, and make some final statements, which could include a
spoken poem or the telling of a final story.

After each individual has had time, the group shares a closing activity
to acknowledge the group as a community. Exchanges of gifts, song, or
music, a group dance, a gathering in an outdoor setting, or a celebratory
meal are examples of final activities in which everyone takes time to
prepare for the dissolving of the community.

DEPARTURE

The following text is the closing story of a workshop participant:

I see myself in a boat going down a river. There are rocks in the water, obstacles in my way. It's not really helpful to be angry at them, because while I look back at that huge rock that I had to work hard not to crash into, I run straight into the next rock.

I find a shallow, sandy riverbank where I can rest and leave my boat. I climb up to the top of the river canyon, where I have a nice view over a large part of the river. I recognize the curves and the rough parts that I've passed through: "There's the rock I nearly crashed into" and "Ah, that's the one I did crash into when I was still looking back."

What is so clear to me from this view up above the river is that I won't come back to this part of the river again. It may even be my last look on it. Tomorrow I will take my boat and go back out onto the river. I see that now I am at a place in the river that is not so turbulent as it was in the past. I meet other people in their boats on the river. We travel together. At night-time we rest, sit around the fire, and tell each other stories. And based on the river that each person has come down, we will decide who has the skills to lead us during the next day. We all know that at some point the river flows into the ocean – and we don't know when or where this will be.

Again we travel at daytime and rest at night, and we sit and talk by the fire before we sleep. When I tell the story of how I crashed into the rocks too often, my friends get bored. "We know that one already," they tell me. Sometimes when we are on the river, it's wide and smooth. We tie our boats together like a big raft. We have more room to move around in, and it's less work for each person. When the water gets rough, we untie our boats.

One night I climb the riverbank again, in the moonlight. I can't see the early rough parts of the river and those old rocks anymore. But I remember it all. I remember how it all started, the skills I needed and what I learned, and I feel a little sad. I don't know why, maybe because all that time is gone and I have come such a long way.

I return to the river. It becomes broader. There are more and more people on it. I'm no longer just going from one rock to another. I have the experience of what it's like to go all the way, and that we are just in this particular part of it now. In this knowledge there is both sadness and happiness. There is a little bit of everything in it. Knowing about the river, with its beginning and its end, is the beginning of what it means to be an adult.

Putting it all together

Being committed to remembering, exploring, investigating, and clarifying our relationship to our own wounding allows its larger pattern to be revealed. The capacity of the arts to tend to the myths of affliction brings the "poisons" to the surface the way a homeopathic cure does, and releases our attachment to the ways in which we are gripped by our suffering. In creative encounter and in the play of imagination, the innate wisdom of the body and psyche is freed. Embodied healing takes us beyond the sort of knowledge that is based only on information and ideas, for even the best diagnosis and latest technologies do not give us relief from our pain. The whole person, made up of the physical, emotional, and mental body, soul, and spirit, must be awakened so that transformation can take place.

With the right guidance, old patterns, traumas, and illness become the base material for an alchemical process through which suffering can lead to wisdom. Movement and the arts take us into the aesthetic realm of the soul, where this transformational process is possible. The alchemical property of the arts can be likened to the element of fire, which burns away all that is old and impure so that the new can arise. The fire of creative art making also warms us along the way as we struggle out of old skins and old costues.

We might say that the arts in such a process bring us closer to the messages of the gods and to the myths of the human narrative. Thus, the arts provide a way of reexperiencing our human conditioning which opens us to the messages and visions that call us to become more authentically and creatively ourselves.

Like Jonah in the belly of the whale, we dive into the ocean of our own body, psyche, and soul. We do so trusting the arts to work their mysterious and powerful alchemy. The calling is to come alive, in spite of our stories and because of them; to create new stories, new ways of being, new ways of communicating, and new ways of relating which honor the gift of life in ourselves and in all beings everywhere.

Case Studies

In the entrance the client leaves the troubled logic of everyday life and enters the logic of imagination…

Creativity is sometimes explained as an ability that allows people to discover a new solution to an old problem.

Paolo Knill (2000, p.9)

The following transcripts demonstrate my approach to movement-based expressive arts therapy within the context and practice of actual therapy sessions. Each case study approaches the issues that the client has chosen to address from a slightly different angle. In the first case, we investigate a physical expression and body posture followed by movement exploration and spoken dialogue. The second case focuses on working with a drawing and integrating dialogue and movement in relation to what the drawing reveals.

Case Study A

Background

Often in group work a client identifies a central theme of disturbance which she then works on in greater depth in personal therapy. In this example, we can see the three levels of awareness and response at work in a very clear way. Something gets identified on the physical level, which then triggers revealing correlations as it ascends to the emotional and mental levels.

I first worked with this client in a training group. Partners did an exercise working with the theme of boundaries. Two people sat facing

each other and observed their internal responses while making eye contact. The next phase of the exercise was for each person to create some kind of circle around herself on the floor with nearby materials, then to reestablish eye contact and notice any changes.

The client and her partner both had very strong responses to this exercise. Two aspects were most relevant to the client's therapy. One was the statement by her partner that she imagined the client was feeling quite critical of her and angry with her. The client was startled and hurt by this response. It was not at all what she was experiencing, and she felt misunderstood. Upon further discussion, she discovered that her partner was responding to a rather intense "scowling" expression on the client's face. The client was completely unaware that she was scowling. What she reported was that she actually felt shy and nervous in making contact. She acknowledged that the facial expression was an old and familiar pose that she assumed in relating to others.

The second revelation from the partner work was a statement made by the client that she loved putting the symbolic boundary around herself. She identified two issues: that something is being communicated through her physical expression which she is not aware of and which is not aligned with her internal experience, and that she has a need to create very strong, visible boundaries.

The client identified a connection between her relationship with her mother and these two issues. She revealed that her mother had been verbally and physically abusive to her throughout her childhood and continued to harangue her now she was an adult. She stated that she felt a need to defend herself at all times, and was in a fairly constant state of anxiety that others might overpower her.

As the group observed, I suggested that the client hold a dialogue with her mother. In words and movement, she expressed her outrage and sadness. We did a dance together in which she played the vulnerable, soft child and I played the supportive mother she never had. I encouraged her to explore letting go movements while I stroked and held her head. This was a particularly important new physical message, since her mother often hit her on her head. In our duet, she began to lean her body against mine, giving over her weight. We rocked gently, and she cried.

After this duet, her face looked soft and open. Her way of relating to the other members of the training group began to change. She was able

to talk more about her pain and her feelings of intense vulnerability, and the channels of communication were opened up between her and the members of the group.

Continuing to work on it in therapy

Now we will observe the process as it descends in the opposite direction through the three levels of awareness and response, from mental to emotional to physical.

IDENTIFYING ON THE MENTAL LEVEL

The client has organized herself around a belief that the world is not a safe place, that people are likely to dominate her, and that she will not get the affection that she wants. She has a history of physical and emotional abuse by a mother who constantly told her to shut up. She married a man who, like her mother, was domineering and critical. She got divorced after eighteen years and continues to struggle with her fear of being overpowered.

IDENTIFYING ON THE EMOTIONAL LEVEL

The client consistently reported how uncomfortable it was for her to feel exposed to any intense emotional responses from other people. She also found it difficult to open up emotionally to others. It was interesting to note that her primary role in life had been to function as a caretaker of others. She was a counselor, and in this role she found a way to be in contact with strongly expressed feelings while being able to maintain a certain degree of distance and control.

IDENTIFYING ON THE PHYSICAL LEVEL

We continued to notice how her face was almost frozen in a scowling expression, which made it appear that she was feeling angry and critical. She recalled that this was her mother's facial expression. Her body posture was caved in around the chest, with shoulders drawn forward and hunched.

IDENTIFYING HOW TO WORK WITH THE ART MODALITIES

We started therapy sessions by focusing on the client's predominant body postures and went right into movement expression as the medium for working through. The physical logos served as entry points which helped the client identify, confront, release, and change feelings and attitudes which locked her into patterned responses.

Expressing herself in movement proved most effective for this client, as it bypassed the old "shut up" imprint and encouraged a physically based confrontation with her internalized abusive mother. This helped her to get into the otherwise overwhelming feelings associated with confrontation. The client had done a fair amount of therapy on this issue in the past; however, she reported that she had not experienced the changes in old patterns she had hoped for. She said, "I've got to get it in my body. If I can move it, than maybe I can live it."

We reinforced the creative will of the client by paying attention to exactly where she was at, following her as she became more aware of the tension with the internalized mother, creating a duet in which the therapist was the supporter rather than the dominator, and following her inclination and interest in using movement as the way to work on the issue.

First progression through the five-part process

IDENTIFICATION PHASE

> *Therapist:* Return to the scowling face. Exaggerate it a bit, pulling in your forehead, eyebrows, and the area around your mouth. Notice what is happening in the rest of your body while you scowl. Exaggerate the body posture that supports the scowl so that it can happen more.

> *Client furrows her face, draws her shoulders up, and her chest is drawn back.*

> *Therapist's commentary:* Heightening awareness of the scowl and beginning to notice the conflict between the external expression and internal feelings, or what is actually under the appearance.

CONFRONTATION PHASE

This entails setting up an enactment situation so that the conflict can be fully experienced and expressed.

Therapist: What kind of sound happens from this scowling posture?

Client purses her lips and growls.

Therapist: Stay with this for a moment until something else wants to happen.

Therapist's commentary: What I notice and imagine in the facial expression, posture, and sound is that there is a fair amount of held-in tension happening, and that if she stays with this for a bit she will start to feel uncomfortable with it and there will be an organic impulse for a physical shift, which will connect her to the impulse for an emotional shift and a shift in the internal script.

Client explores it and after a while looks like she is running out of steam, like it will be hard to keep on going with it.

Therapist: What is happening for you? How does this movement and sound feel?

Client: I can't stand it anymore; it's too much.

Therapist: So, if the scowling face and posture could speak, what would they say?

Therapist's commentary: Switching to spoken dialogue as a way to let the imploding tension out and challenge the "shut up" mother voice.

Client: I hate you. I don't trust you. I don't get what I need.

Therapist: OK, now develop a body posture and movement that supports those words.

Client closes her eyes tightly, draws her head down, and wraps her arms around her shoulders.

Therapist: If this posture could move in space, where would it like to go?

Client: [*She slowly sinks down into a curled-up posture on the floor, with her eyes tightly closed. She covers her head with her arms. She becomes frozen in this posture. After a few minutes in this place, she speaks.*] I feel so lonely, I want to find a way out of here.

RELEASE PHASE

At this point, I suggest that the client begin by releasing her arms and extending her legs. Then I suggest that she explore the space of the floor around her. She opens up, beginning to use her legs and arms in stretching movements. After a few minutes, she begins to roll on the floor. Her movement becomes more fluid. She curls into the floor and then unfurls along the floor.

Recalling her standing posture, where I noticed that her shoulders were drawn up and inward around a collapsed and drawn-back chest, I imagine what movement possibilities might be added to what is already happening to expand the accompanying release. I suggest she add the audible sound of her breath. Her inhalation and exhalation and the sound of her breathing deepen. Her mouth and face soften.

As she continues rolling and playing with the sound of her breath, I suggest that she become aware of her ribcage as she moves. She begins to extend her ribcage forward and lifts herself up off the floor. I suggest that she continues to explore opening up and extending out from her ribcage, using the floor and her legs to support the movement so that she can free up her arms even more.

She begins to reach her arms out in various directions. I suggest that, when she is ready, she explore standing up and continuing the movement standing and walking through the space. She continues to reach through the space as she imagines different situations and people in her life. I encourage her to add sound if she would like and she screams, "These are the feelings that my scowl has been holding back." As she reaches, she makes strong statements that express what she wants and what she does not want.

CHANGE PHASE

I notice that the client is beginning to reach out as she moves through the space. I suggest that with each step she takes, she also begin to expand her chest, leading slightly from the sternum. As she continues reaching her arms and hands forward, she takes time with each step as she lifts her chest. I notice that her breath becomes fuller and deeper, and her face relaxes into a smile.

I suggest that when she feels ready and secure in this movement of reaching from a widened chest and relaxed face, she experiment and

play around with different speeds as she moves through the room. This acts as a metaphoric practice for sustaining the new posture in varied circumstances.

I ask for a final sentence from the "new" posture.

Client: I can live through the risk. The world is scary, and I can bring my fear into the world with me!

Second small progression through the five-part process

IDENTIFICATION PHASE

I notice at this point that although the client is reaching out and forward with her arms, it seems as if she is leaning onto the backs of her heels. This gives the strong visual impression that she may, at any moment, fall backward. What appears to me is the presence of an opposition between her forward actions and the old tendency to draw back. I imagine that there is a part of her that wants to move forward and other parts of her that are not yet in unison with this new impulse as it is trying to be born.

Therapist: I notice that your hands and arms are reaching forward and that you seem to be leaning back on your heels. Take a moment to see if you notice this too.

Client: Yes, I feel it now.

CONFRONTATION PHASE

Therapist: OK, for just a moment, intensify that dual direction that is happening.

Client keeps reaching forward and draws back at the same time.

RELEASE AND CHANGE PHASES

Therapist: Now, let's explore a new posture. Shift your balance forward onto the balls of your feet. [*This redistribution puts the whole weight of her body, the strength of her whole self, behind her movement.*]

Client explores stepping forward into space with this new body posture. She is hesitant and a bit unsteady. She remarks on how this new stance challenges

her to lean forward slightly and that this movement feels like the risk she took in exploring her scowl, confronting her mother, and releasing her old posture.

Therapist's commentary: I suggest that the client stand still and explore a kind of rocking backward and forward movement, shifting the weight between the balls and heels of her feet, and, whenever she is ready, take a few steps forward. As she moves throughout the studio room, standing, rocking, and stepping forward, she begins to cry and laugh at the same time.

Therapist: If the tears and laughter could speak, what would they say?

Client: The space in this room is like the world. I'm moving forward, and I'm stumbling. I don't want to go back, but I don't know how to go forward yet. I'm trying to find my footing. I'm trying to find my footing in the world.

Third major progression through the five-part process

It is important to guide a client slowly through a piece of work, not to push the client prematurely into release or change. This allows us to keep working with it, to reinforce and sustain as well as uncover the many layers associated with a core struggle. Here we loop back through the five phases so that the client has further opportunities to uncover and enact other chapters. We are working with the identified opposition between reaching forward and drawing back which has shown up in the body postures and in the expressive movement.

IDENTIFICATION PHASE

Based on my observation of the client as she shifts her weight forward and explores stepping out into space, there is still quite a bit of stumbling and hesitation alongside her powerful declaration that "I'm trying to find my footing in the world." What else, I wonder, might the "drawing back" or "scowling" part hold for her? I want to give her more time to explore the old posture and its history, as well as to explore the new posture and perhaps the transition or space in between. I assume that there may be more to work with and express. First I share my observations with the client, and then I invite her to begin a dialogue in movement and words. I suggest that she "replay" or revisit some of the

primary movement moments of the previous session and work her way through again.

CONFRONTATION PHASE

> *Therapist:* Where in the room do you want to start?
>
> *Client:* [*She curls up in a corner of the room.*] This is how I spent my childhood. And this is what I carry around inside me still! [*She asks me for permission to express her rage.*]
>
> *Therapist:* What if I say no?
>
> *Client:* I'm going to do it anyway!
>
> *Therapist:* OK.
>
> *Client stomps and hits and yells with great force and gusto.*
>
> *Therapist:* Imagine some of the people from your life are here in this room with us.
>
> *Client imagines some people from her life in the room as she moves out of the corner. She names them and tells each one of them off. She dances throughout the space. Then she turns back to the corner.*
>
> *Therapist:* Is there something still in the corner for you?

RELEASE PHASE

> *Client:* [*She extends her arms and reaches toward the corner. She calls out to what she names the frightened, distrusting child.*] Come out from the corner. [*Her child part tells her that she wants to be taken care of. She asks this part to come play and dance with her. She makes a commitment to be like the good mother who will protect this part when needed.*]

CHANGE PHASE

I suggest that the client find a new posture and a new way of moving that brings her to this image of protecting and playing with her child part, and that she use something in the room to help her make this shift.

The client takes her sweatshirt off and cradles it in her arms. She returns to the rocking movement, shifting her weight from the heels to the balls of her feet. She sings a song to the imagined child. She begins to

play with stepping forward through the space. She lets the sweatshirt come undone, and she begins to throw it up into the air and then catch it. As the tempo of her movement increases and she uses more space, she becomes more excited. I suggest that she explore different ways of using her arms in the movement, working with her image of protecting and playing.

She adds arm swings, thrusts, pushes, and cutting gestures. She shifts back and forth between these qualities, using varied tempos and rhythms. She begins to let her whole body follow the momentum created by the swinging arms. Soon she is jumping, turning in circles, and laughing.

Therapist: And what does this dance say to you now?

Client: You can have both. You can move forward and backward, you can play and protect and laugh and cry. And instead of scowling, you can yell when you need to. This is my new footing; she moves.

GROWTH PHASE

The client's closing phase on this theme occurred during a series of group presentations. She made this presentation as a self-portrait ritual in front of an expressive arts training group whose members acted as her witnesses. She wove together all of the resources she had explored in her therapy and in group work, going back to the very first group meeting when we worked on the theme of boundaries and the first encounter with her scowl.

Her life-sized self-portrait painting included images of a child embraced, protected, and supported in the center of her body. Her anger and sadness were symbolically drawn in different body parts, especially her hands and her face. Her solar plexus, shoulders, and arms were drawn opening outward, extending and radiating upward. Her "ritual" was enacted with her painting on the wall behind her as she danced and spoke to her witnesses. In her piece, she acknowledged her conflicts and reaffirmed her commitment to move forward, to express what she is feeling, to ask for what she wants, and to be open to receiving from others and from the world. The script that follows served as the narrative for the ritual.

Client: When my children were young, I used to tell them to make "wish lists," and we would hang them on the refrigerator door. I feel that I have come here with my wish list. My life is on the line. It must change and now. There is an old belief that the world out there is dangerous. That is linked to an old fear. Look out! You'll get hurt. This has been solidified in an old body posture or body position.

THIS WILL BE MY DANCE OF TRANSFORMATION. I WANT NO LESS THAN THAT!

This is a solo dance, but I cannot do it without your help. Each one of you is very important to me. You bring intensity and focus to a loaded situation.

AND THAT IS JUST WHAT I NEED. I NEED YOUR ATTENTION TO MAKE THIS LEAP!

I repeat, so you will hear me. I intend to transform my body posture and therefore my posture in life. I intend to experience a new space. It's scary, or I would have done it long ago. And I don't know how to do it so my body will have to do it for me – my body and my enigmatic self-portrait. You see, it is not the vertical planes that I have a problem with. Reaching toward God is a joy to me. It's the horizontal plane that gives me problems. How to navigate in life with openness, truth, wisdom, and joy. It has an element of risk in it. Well, I'm going for it!

Case Study B

Background

The client is a young woman in her early thirties. Some of the core issues explored in previous therapy sessions included her sense of powerlessness and her inability to speak up and articulate herself verbally. She traced the theme of losing her voice and feeling mentally confused in intimate relationships back to her relationship with her father. Over time, she identified this feeling of confusion as a reaction triggered by any relationship with a powerful authority figure.

Enacting gestalt dialogues was both challenging and potent for her, as much of her work involved confronting her anxiety about speaking out strongly and articulating her thoughts and feelings. The key images in her drawing which will be used in this example are: "a diffuse

white-gray-pink cloud," "a blue girl" inside the cloud, and "a snail." The client gave the names for these images.

The session opens with a dialogue between the therapist and client as we look at her drawing together.

Therapist: What words would you give to this drawing? [*Focusing*]

Client: Confusion – no voice – hiding. [*Identifying*]

Therapist: How do you feel about the drawing? [*Connecting the feeling response to the image*]

Client: Actually, I don't feel confused when I look at the drawing now. I kind of like it. I like the snail.

Therapist: So, the feeling of confusion has shifted?

Client: There are parts I like and parts I don't like.

Therapist: You like the snail. Which parts don't you like? [*Getting clear what she likes and what she does not like as a theme, as well as getting to know her feeling for the drawing*]

Client: I don't like the "losing my boundaries" part.

Therapist: What part of the image feels connected to that experience of losing boundaries?

Client: The cloud and the blue girl.

Therapist: OK, are you ready to go into the drawing now, talk with it in words, and experience it in movement? [*Mobilizing and choosing the confrontation*]

Client: Yes.

Therapist: So, instead of you and me talking, talk to the drawing. [*Forming an imaginal relationship with the drawing*]

Client: I don't feel confused when I look at you. In a way, I like you. I like you, snail.

Therapist: What do you imagine the snail might say to you? [*Starting where she is and with what she has identified as the positive images; as if the drawing is its own self and world that has a message for her*]

Client [*as the snail*]: I move very slowly when I feel confused. I feel safer, I take my time, and then I can get clearer. I have my shell around me if I need it.

Therapist: How do you imagine the shell feels?

Client: Like protection.

Therapist: And what part of the drawing don't you like, or isn't so clear? [*Returning to meet the tension of confusion*]

Client: This gray and pink cloud in the sky feels confused and unclear.

Therapist: Take a few moments to move as if you are the confused unclear cloud. [*Shifting the medium of dialogue into movement; connecting with images, which evokes feelings*]

Client [*as the cloud*]: I'm not grounded, I'm floating. I am slow too, too slow. Now I feel as if there is something around me. I can't hear and I can't think with this around me – it feels like a cottony fog. This feels familiar, like the way I feel confused in relationships with men. I go cloudy and I hide in my shell. [*Bridging the experience of encountering the art to a life situation*]

Therapist: OK, let's look at the drawing again. I am curious about the blue girl in the clouds. If this part of your drawing could speak, what would she say?

Client: She's happy – that's strange. [*She is surprised by this unexpected statement she has made, and moves physically closer to her drawing as if to listen to it or understand it.*]

Therapist: Explore this unexpected statement as an "I am" sentence.

Client: I am happy, but I don't like to talk.

Therapist: Stay with the "but" a little bit. Repeat the "but" in words, play with it, and explore any movement responses that the word evokes.

Client: But, but, butttt, bu, bu, bu, but, bbbbb… I feel so sad. [*Tears. She does a falling movement toward the drawing, almost falling on top of it.*]

Therapist: Develop this movement of falling into the drawing.

Client: I want to get very close to you, drawing. [*More tears; release.*]

Therapist: Begin to sense in your body what wants to happen next in your relationship to the drawing. [*Connecting her images, feelings, and body impulses, the three levels of awareness.*]

Client: I'd like to pick her up. [*She picks up the drawing.*]

Therapist: So dance with your drawing using your hands and arms. [*She presses the drawing to her heart and cries softly.*]

Client: I want to have her close to my heart.

Therapist: What do you imagine it would be like for you in your relationships if you had her close to your heart?

Client: I could relax more in situations that I feel confused in. I want to take her with me — not push her away. [*Entering the change phase*]

Therapist: What do you imagine would be possible if you have her with you?

Client: I could feel myself more.

Therapist: And if you could feel yourself more, what do you imagine would be possible?

Client: I'd feel more visible and more relaxed. I'd feel that I have clearer boundaries, more strength and power, I could speak up.

Therapist: Explore some different movements which feel relaxed and powerful to you. [*Strengthening by embodying the change possibility*]

Client: My body posture would be different.

Therapist: How would your posture be?

Client: More upright and open, my head on top of my spine. I would feel connected to my pelvis, and I wouldn't feel so afraid all the time. I'd feel like things can happen and I could respond in the moment without fear. My voice would be different.

Therapist: How would your voice sound?

Client: More clear and loud.

Therapist: Explore your clear, loud voice. Explore your different posture and voice. [*Developing change*]

Client: [*She stands upright; she experiments with rotating her head on top of her spine until she finds the "right" position. She opens her arms and expands her chest. She bounces slightly downward with her legs, bending at the knees and placing her feet firmly in different spots on the floor. She rotates her pelvis.*] Now I feel like I can respond in the moment without fear.

Therapist: OK, look back at your drawing as you continue playing with this new posture and these movements. Imagine if the blue girl in the drawing could speak to you in a new voice; what would she say?

Client: I want to be with you. If you hold me next to your heart, I will be able to come out of this cloud of fear and confusion.

Therapist: And is there any other part of the drawing that wants to speak to you in this new voice?

Client: The snake.

Therapist: The snake?

Client: Oh, funny, yes, I want to call the snail a snake! Now I need the snail to be a snake. I want to come out of my shell. [*Paying attention to the unexpected surprise, so that the hidden message can be heard and incorporated; reinforcing change with a new image*]

Conclusion

CHAPTER 13

Art as a Healing Force
in the World

> To interfere with the life of things means to harm both them and
> one's self. He who imposes himself has the small, manifest might: he
> who does not impose himself has the great secret might... The
> perfected man does not interfere in the life of beings, he does not
> impose himself on them, but helps all beings to their freedom.
>
> *Martin Buber (1957, pp.54–55)*

Inspired by the words of philosopher, mystic, and teacher Martin Buber,
we return to perhaps the most compelling question of our times: How are
we to live artfully in a fragmented world? Buber's illumination of what he
called an *I–Thou* philosophy points us toward an empathetic way of
relating to ourselves, one another, and the environment. Buber strove to
articulate what he called the *unfolding* of a true human being, unbound by
dogma and convention, expanded rather than limited by personal and
social suffering.

For Buber, the *I–It* mentality results in the treatment of people and
things as objects to be manipulated. Buber's *narrow ridge* offers a way of
living which honors surprise, mystery, and authenticity, and affirms a
balance between limitation and freedom, personal prerogative and empa-
thetic responsibility to the other.

The I–Thou relationship is a participatory relationship which fosters
attunement to and equal valuing of experience. The I–Thou relationship
becomes a mirror which reflects, reveals and opens us so that we see and
feel more deeply and broadly both the self, the other and the world.

In the approach we have explained in this book, we have discovered art as a process, as a piece of work, as a language and as a metaphor which fosters the capacity for the I-Thou relationship, helping us to unfold, transform, and participate more fully in life.

We live in a world challenged by a widening gap between those with great resources and those with few. Conflicts over economic, educational, racial, and religious differences threaten our shared earth and humanity. With technological forms of communication and information increasing exponentially, and the ever-growing ecological waste of our precious natural resources, we must ask ourselves how we can live differently.

Now more than ever before the interface of art and healing is of paramount importance. The healing arts must be fostered, protected, and passed on as one of humanity's most significant legacies and bodies of knowledge. When so much of our communication and learning occurs through computer technologies, disembodied living seems ever more inevitable. As our technological capacities grow, we are looking for ways to reconnect with our bodies, our creativity, and our spirits. The field of expressive arts therapy has a great deal to offer in response to these needs and longings.

Using movement in expressive arts therapy is essential to embodied learning and change. No healing art or therapy promising to touch the whole person can relegate the body and movement to a secondary position. Nor must we allow the arts to be relegated in our culture to a secondary position, an extracurricular activity or commodity measured by its value in the marketplace.

Art is as essential to our survival as food, shelter, medicine, and the natural environment. It offers a powerful way of learning and communicating knowledge. The principles and practice of the arts give us ways to enact symbolically the most destructive impulses in our beings, and create new forms of truth, beauty, and inspiration.

We are physical, emotional, and mental beings, driven as much by our desire to create as by our tendencies to destroy. We are individual selves and also interdependent selves, dancing between the call to be with others and the need to create a solo expression of who we are and who we want to be. The body, movement, and art all call us into an active and creative relationship with ourselves, with one another, and with the

world. The integration of the body, movement, art, and healing is rightly part of our ethical criteria for a sustainable life.

An embodied life–art process that teaches us how to identify and integrate our physical, emotional, and mental levels, clearing the way for spiritual awakening, would meet these ethical criteria. At the same time, it could change our lives for the better. As we learn how to live artfully with our wounded selves, families, and communities, our respect for the interdependency of all living things will grow. Perhaps then, we can draw closer to the gods – or to the spirit in ourselves and others – and, in the midst of our suffering, celebrate the life we have been given, and become the human beings we are meant to be.

References

Adler, A. (1927) *The Practice and Theory of Individual Psychology*. New York: Humanities.

Antze, P. (2001) "The other inside: memory as metaphor in psychoanalysis." *Poesis Journal 3*, 103–104. Toronto: EGS Press.

Arnheim, R. (1972) *Toward a Psychology of Art: Collected Essays*. Berkeley: University of California Press.

Assagioli, R. (1965) *Psychosynthesis*. New York: Penguin.

Assagioli, R. (1974) *The Act of Will*. New York: Penguin.

Bartenieff, I. (1963) *Effort-Shape, Analysis of Movement: The Unity of Expression and Function*. New York: Albert Einstein College of Medicine.

Binswanger, L. (trans. J. Needleman) (1963) *Being-in-the-World*. New York: Basic.

Bly, R. (trans.) (1971) *The Kabir Book: Forty-Four of the Ecstatic Poems of Kabir*. Boston: Beacon.

Boss, M. (trans. L. B. Lefebre) (1963) *Psychoanalysis and Daseinanalysis*. New York: Basic.

Briggs, J. (1992) *Fractals: The Patterns of Chaos*. New York: Touchstone.

Briggs, J. and Peat, F. D. (1989) *Turbulent Mirror: An Illustrated Guide to Chaos Theory and the Science of Wholeness*. New York: Harper and Row.

Buber, M. (1957) *Pointing the Way*. New York: Harper and Row.

Chodorow, J. (1991) *Dance Therapy and Depth Psychology: The Moving Imagination*. London and New York: Routledge.

Chodorow, J. (1997) *Encountering Jung on Active Imagination*. Princeton, NJ: Princeton University Press.

Corsini, R. J. (1989) *Current Psychotherapies*. Itasca, Ill.: F. E. Peacock.

De Mille, A. (1951) *Dance to the Piper*. Boston: Little, Brown.

Dewey, J. (1934) *Art as Experience*. New York: Minton, Balch.

Dychtwald, K. (1977) *Bodymind*. New York: Pantheon.

Einstein, A. (1961) *Relativity: The Special and General Theory*. New York: Crown.

Eliot, T. S. (1988) *The Four Quartets*. San Diego, CA: Harcourt Brace Jovanovich.

Feldenkrais, M. (1972) *Awareness Through Movement.* New York: Harper and Row.

Feldenkrais, M. (1985) *The Potent Self.* San Francisco: Harper and Row.

Frazer, J. G. (1922) *The Golden Bough.* New York: Touchstone/Simon and Schuster.

Freud, S. (trans. A. Tyson; ed. J. Strachey) (1901/1960) "The psychopathology of everyday life." In *The Standard Edition of the Complete Psychological Works of Sigmund Freud, Volume 6.* London: Hogarth, 1953–1966.

Freud, S. (trans. J. Strachey) (1915) "The unconscious." In *The Standard Edition of the Complete Psychological Works of Sigmund Freud, Volume 14.* London: Hogarth, 1953–1966.

Freud, S. (trans. J. Strachey) (1923) "The ego and the id." In *The Standard Edition of the Complete Psychological Works of Sigmund Freud, Volume 19.* London: Hogarth, 1953–1966.

Freud, S. (trans. J. Strachey) (1952) *An Autobiographical Study.* New York: Norton.

Freud, S. (1963) *Therapy and Technique.* New York: Collier.

Fromm, E. (1941) *Escape from Freedom.* New York: Holt, Rinehart and Winston.

Fromm, E. (1955) *The Sane Society.* New York: Holt, Rinehart and Winston.

Gendlin, E. (1978) *Focusing.* New York: Bantam.

Giannini, J. (1987) "Welcoming darkness." *Creation Magazine 3,* 5, 8.

Goldstein, K. (1940) *Human Nature in the Light of Psychopathology.* Cambridge, Mass.: Harvard University Press.

Halprin, A. (1995) *Moving Toward Life: Five Decades of Transformational Dance (Interviews With Anna Halprin).* Hanover, NH: Wesleyan University Press.

Halprin, D. (1989) *Coming Alive.* Kentfield, CA: Tamalpa Institute.

Halprin, D. (1999) "Living artfully: integrative movement." In S. Levine and E. Levine (eds) *Foundations of Expressive Arts Therapy: Theoretical and Clinical Approaches.* London: Jessica Kingsley.

H'Doubler, M. (1925) *The Dance and Its Place in Education.* New York: Harcourt Brace.

H'Doubler, M. (1940) *Dance: A Creative Art Experience.* New York: Appleton, Century, Crofts.

Heidegger, M. (1971) *Poetry, Language and Thought.* New York: Harper and Row.

Hillman, J. (1975) *Revisioning Psychology.* New York: Harper Perennial.

Hillman, J. (ed. T. Moore) (1989) *A Blue Fire: Selected Writings.* New York: Harper and Row.

Horney, K. (1945) *Our Inner Conflicts.* New York: Norton.

Jahner, G. (2001) *Embodying Change.* Available through Kentfield, CA: Tamalpa Institute.

James, W. (ed. J. J. McDermott) (1977) *The Writings of William James.* Chicago: University of Chicago Press.

Jung, C. G. (1957) *The Undiscovered Self.* New York: Mentor.

Jung, C. G. (1961) *Memories, Dreams, Reflections.* New York: Vintage.

Jung, C. G. (1964) *Man and His Symbols.* New York: Doubleday.

Jung, C. G. (1979) *Word and Image.* Princeton, NJ: Princeton University Press.

Kaufman, W. (1982) *The Portable Nietzsche.* New York: Viking.

Khema, A. (1991) *When the Iron Eagle Flies.* London: Arkana Penguin.

Kierkegaard, S. (trans. W. Lowrie) (1957) *The Concept of Dread.* Princeton, NJ: Princeton University Press.

Knill, P. (2000) "The essence in a therapeutic process: an alternative experience of worlding?" *Poesis Journal 2,* 9–10. Toronto: EGS Press.

Knill, P., Barba, H. N. and Fuchs, M. N. (1995) *Minstrels of the Soul: Intermodal Expressive Therapy.* Toronto: Palmerston.

Laban, R. (1960) *The Mastery of Movement.* London: MacDonald and Evans.

Lamb, W. (1965) *Posture and Gesture: An Introduction to the Study of Physical Behavior.* London: Gerald Duckworth.

Levine, S. (2000) "Researching imagination – Imagining Research." *Poesis Journal 2,* 88–93. Toronto: EGS Press.

Levine, S. and Levine, E. (eds) (1999) *Foundations of Expressive Arts Therapy: Theoretical and Clinical Perspectives.* London: Jessica Kingsley.

Levy, F. (1988) *Dance Movement Therapy: A Healing Art.* Reston, Va.: National Dance Association, American Alliance for Health.

Lowen, A. (1975) *Bioenergetics.* New York: Coward, McCann and Geoghegan.

Maslow, A. (1954) *Motivation and Personality.* New York: Harper and Row.

Maslow, A. (1968) *Toward a Psychology of Being.* New York: D. Van Nostrand.

May, R. (1969) *Love and Will.* New York: Dell.

May, R. (1976) *The Courage to Create.* New York: Bantam.

May, R. and Schneider, K. (1995) *The Psychology of Existence: An Integrative Clinical Perspective.* New York: McGraw Hill.

McNiff, S. (1981) *Psychotherapy and the Arts.* Springfield, Ill.: Charles C. Thomas.

McNiff, S. (1992) *Art as Medicine.* Boston: Shambhala.

Meerloo, J. (1968) *Creativity and Externalization.* New York: Humanities.

Miller, A. (1981) *Drama of the Gifted Child.* New York: Basic.

Nachmanovitch, S. (1990) *Free Play: Improvisation in Life and Art.* New York: Jeremy Tarcher/Putnam.

Pallaro, P. (ed) (1999) *Authentic Movement: Essays by Mary Starks Whitehouse, Janet Adler and Joan Chodorow.* London: Jessica Kingsley.

Perls, F. (1969) *In and Out of the Garbage Pail.* Lafayette, CA: Real People.

Perls, F. (1971) *Gestalt Therapy Verbatim.* New York: Bantam.

Perls, F. (1973) *The Gestalt Approach: Eye Witness to Therapy.* Palo Alto, CA: Science and Behavior.

Piaget, I. (1972) *Theory and Methods in Dance-Movement Therapy.* Dubuque, Iowa: Kendall/Hunt.

Prigogine, I. (1996) *The End of Certainty: Time, Chaos and the New Laws of Nature.* New York: Free Press.

Prigogine, I. and Stengers, I. (1984) *Order Out of Chaos: Man's New Dialogue With Nature.* New York: Bantam Books.

Rank, O. (1936) *Will Therapy.* New York: Knopf.

Rank, O. (1958) *Beyond Psychology.* New York: Dover.

Reich, W. (1960) *An Introduction to Orgonomy: Selected Writings.* New York: Noonday.

Rogers, C. (1951) *Client-Centered Therapy.* Boston: Houghton Mifflin.

Rogers, C. (1961) *On Becoming a Person.* Boston: Houghton Mifflin.

Smuts, J. (1926) *Holism and Evolution.* New York: Macmillan.

Todd, M. E. (1937) *The Thinking Body.* New York: Dance Horizons.

von Franz, M. (1980/1983) *Inward Journey: Art as Therapy.* London: Open Court.

Whitehouse, M. (1999) "The tao of the body." In P. Pallaro (ed) *Authentic Movement: Essays by Mary Starks Whitehouse, Janet Adler and Joan Chodorow.* London: Jessica Kingsley.

Winnicott, D. W. W. (1971) *Playing and Reality.* London: Routledge.

Further Reading

Alexander, A. (1931) *The Use of the Self.* England: Methuen.

Bernstein, P. L. (1972) *Theory and Methods in Dance-Movement Therapy.* Dubuque, Iowa: Kendall/Hunt.

Bohm, D. and Peat, D. (1987) *Science, Order and Creativity.* New York: Bantam.

Brown, G. I. (1977) *Human Teaching for Human Learning.* New York: Penguin.

Brown, M. Y. (1983) *The Unfolding Self.* Los Angeles: Psychosynthesis Press.

Campbell, J. (1973) *Myths to Live By.* New York: Bantam.

Campbell, J. (1988) *The Power of Myth.* New York: Doubleday.

Capra, F. (1977) *The Tao of Physics.* New York: Bantam.

Capra, F. (1982) *The Turning Point.* New York: Bantam.

Crouch, J. E. (1978) *Functional Human Anatomy.* Philadelphia: Lea and Febiger.

Deikman, A. J. (1982) *The Observing Self.* Boston: Beacon.

Doosey, L. (1982) *Space, Time and Medicine.* Boulder, Colo.: Shambhala.

Ferrucci, P. (1982) *What We May Be.* Los Angeles: Tarcher/St. Martin's.

Goleman, D. and Speeth, K. R. (1982) *The Essential Psychotherapies.* New York: Mentor.

Greenough, H. (1947) *Form and Function.* Berkeley: University of California Press.

Guerin, P. J. (1976) *Family Therapy.* New York: Gardner.

Haley, J. (1973) *Uncommon Therapy.* New York: Norton.

Harvey, D. (1990) *The Condition of Postmodernity.* Cambridge, Mass.: Blackwell.

Jung, C. G. (1961) *Collected Works of Carl G. Jung.* New York: Bolligen.

Kandinsky, W. (trans. M. T. H. Sadler) (1977) *Concerning the Spiritual in Art.* New York: Dover.

Kohler, W. (1947) *Gestalt Psychology.* New York: Liveright.

Lerner, H. G. (1985) *The Dance of Anger.* San Francisco: Harper and Row.

Levine, S. (1992) *Poesis: The Language of Psychology and the Speech of the Soul.* London: Jessica Kingsley.

Lonsdale, S. (1982) *Animals and the Origins of Dance.* London: Thames and Hudson.

Moyne, J. and Barks, C. (1984) *Open Secrets: Rumi.* Putney, Vt.: Threshold.

Perls, F., Hefferline, R. F. and Goodman, P. (1951) *Gestalt Therapy.* New York: Julian.

Poesis Journal: A Journal of the Arts and Communication, Vols 1–3 (1999–2001). Toronto: EGS Press.

Restak, R. M. (1979) *The Brain: The Last Frontier.* New York: Warner Bros.

Sahakian, W. S. (ed) (1965/1974) *Psychology of Personality.* Chicago: Rand McNally College.

Satir, V. (1987) *Conjoint Family Therapy.* Palo Alto, CA: Science and Behavior.

Sheldrake, R. (1981) *A New Science of Life.* Los Angeles: Jeremy Tarcher.

Wilber, K. (1983) *Eye to Eye.* New York: Anchor/Doubleday.

Contacting the Tamalpa Institute

For further information on this work, you may contact:

Tamalpa Institute
P.O. Box No. 794
Kentfield, CA 94914
USA

Phone: 415-457-8555
Fax: 415-457-7960
Email: info@tamalpa.org
Website: www.tamalpa.org

Subject Index

Buddhism 53

California Institute of Integral Studies
 (CIIS) 9, 11, 74–5
Cartesian dualism 37
case studies 211–25
 case study A 211–21
 background 211–13
 continuing to work on it in
 therapy 213–14
 identifying on mental
 level 213
 identifying on emotional
 level 213
 identifying on physical
 level 213
 identifying how to work
 with art modalities 214
 first progression through
 five-part process 214–17
 change phase 216–17
 confrontation phase
 214–15
 identification phase 214
 release phase 216
 second progression through
 five-part process 217–18
 confrontation phase 217
 identification phase 217
 release and change phases
 217–18
 third major progression
 through five-part process
 217–18
 change phase 219–20
 confrontation phase 219
 growth phase 220–1
 identification phase 218
 release phase 219
 case study B 221–5
 background 221–5
centered posture 112
challenge through interaction 199,
 200–1
change 122, 126–7, 216–17, 218,
 219–20
 exercise 142–3

images 144
character armoring 56
Christianity 38, 68
 esoteric practices 53
circular shape 112
client-centered therapy 48
closing and departure 206–8
coaching movement 116
collapse 89
collapsed posture 112
collective unconscious 42
Coming Alive (Halprin) 13
communication modality 75
complementary medicine 72
confluence 52
confrontation 122, 125, 144,
 214–15, 217, 219
 and enactment exercise 142
Confronting (drawing) 144
confronting the shadow 177–82
congruence 47
constrict 89
contemplation and reflection 201–5
contracted posture 112
core self 53
creating image for healthy boundary
 199–200
creation moments 88
creative courage 79
creative dance as therapy 63
creative meditation 206
 identifying image of wounded part
 187–8
creative process, uncovering
 psychological metaphor in 98–9
creativity 21
 art and therapy 83–101
 metaphors 95–101
 as life force 84–6
 as process 88–95
 aesthetic experience 93–5
 art as process and artifact
 90–2
 blocks in as metaphor 88–90
 restriction, breakthrough and
 free flow 99–100

Author Index